D0911448

DISCARD

WET-WALL TATTOOS

Wet-Wall Tattoos

BEN LONG
AND
THE ART OF FRESCO

Richard Maschal

VISUAL & PERFORMING ARTS
CHICAGO PUBLIC LIBRARY

John F. Blair, Publisher Winston-Salem, North Carolina

VISUAL & PERFORMING ARTS
CHICAGO PUBLIC LIBRARY

Copyright © 1993 by John F. Blair, Publisher
Printed in the United States of America
All Rights Reserved

Quotations from *Vasari on Technique*, by Giorgio Vasari, translated by Louisa S. Machlehose, are used by permission of Dover Publications. Quotations from *The Craftsman's Handbook*, by Cennino Cennini, translated by Daniel V. Thompson, Jr., are used by permission of Dover Publications, copyright 1933 and 1934 by Yale University Press. Quotations from the Revised Standard Version of the New Testament are used by permission of the Division of Christian Education of the National Council of Churches of Christ in the United States of America, copyright 1946, 1952, and 1971. Images of the St. Peter's fresco, the NationsBank fresco, and *The Last Supper* at Glendale Springs are used by permission of Benjamin F. Long IV, copyright 1989, 1992, and 1993. Photographs of the St. Peter's fresco are used by permission of Mark B. Sluder, copyright 1988 and 1989.

Book Design by Debra Long Hampton
Printed and Bound by R. R. Donnelley & Sons

Library of Congress Cataloging-in-Publication Data

Maschal, Richard.
Wet-wall tattoos : Ben Long and the art of fresco / by Richard Maschal.
p. cm.
Includes index.
ISBN 0-89587-105-X
1. Long, Ben. 2. Painters—United States—Biography. 3. Jesus Christ—Passion—Art.
4. Jesus Christ—Resurrection—Art. 5. Holy Spirit—Art.
6. St. Peter's Catholic Church (Charlotte, N.C.)
I. Title.
ND237.L699M37 1993
759.13—dc20 93-18887
[B]

R01181 98745

To Polly

Contents

Acknowledgments

One of the most satisfying aspects of this project was the amount of help I received, most of it from within my own city and state. I am deeply grateful for it.

I needed money to travel to France and Italy and in North Carolina to do research and to take time to write. The following foundations, businesses, and individuals generously supported those efforts: the Culbertson Foundation, the Mary Duke Biddle Foundation, the *Charlotte Observer*, two anonymous North Carolinians, Pan American Airlines, the Dickson Foundation, Max and Sally Jackson, Dr. Francis Robicsek, Sally Robinson, Dr. Reed Gaskin, Reynolda House, W. D. Cornwell, Steve and Libba Griffith, Joe King, Erskine Bowles, Lynn Lineberger, Natasha Bechtler, Kitty Gaston, and Anne McKenna.

Billy O. Wireman, president of Queens College, generously made Queens my partner in applying for and receiving grant money. His help was

x WET-WALL TATTOOS

key. Thanks, too, go to Lidia Figiel, Dr. Wireman's secretary, for her kindness and efficiency.

I am fortunate to work for a newspaper that believes in supporting its writers. I would especially like to thank editor Rich Oppel for his timely support of a sabbatical giving me time to write. Managing editor Frank Barrows, former managing editor Doug Clifton, and former assistant managing editor Foster Davis took a personal interest in this project.

My immediate editors worked with me on the stories I wrote on the St. Peter's fresco for the newspaper and helped me get time and resources for the book. They are Caroline Beyrau, Tom Tozer, and Steve Snow.

Polly Paddock, who is my wife as well as my colleague, brought her sharp eye and word skills to bear on the entire manuscript and made it a better read, first page to last.

Assistant managing editor Bob De Piante, a computer whiz with a generous heart, was an inexhaustible source of information and advice. Other technological aces helped: Jim Hardin, Jamie Braswell, Phil Drake, Ron Grumbles, and Hank Durkin. John Daughtry and his staff at KPC Photography did likewise.

Former reporter Louise Lione helped with translations from the Italian.

My colleague Mark B. Sluder generously allowed his wonderful photographs to be used. Thanks for photographs also to Don Sturkey, Fred Wilson, the *Charlotte Observer* Library, Max Jackson, Bob Servatius, and NationsBank.

Research for this book took me to several libraries, one of the most enjoyable aspects of the project. My thanks to librarians at the North Carolina Museum of Art; the Department of History, Presbyterian Church (USA); the University of North Carolina at Charlotte, Stewart Lillard in particular; the Iredell County Public Library, especially David Bunch; and the Public Library of Charlotte and Mecklenburg County. I'm grateful to Pat Ryckman and her staff at the Robinson-Spangler Carolina Room at the PLCMC, main library. I appreciate the use of the Mary Brevard Alexander Howell Room for Mecklenburg Research, where most of this book was written.

The staff at John F. Blair, Publisher, was a pleasure to work with, supportive and professional throughout. Thanks go to Carolyn Sakowski, president, and Margaret Couch, Steve Kirk, Debbie Hampton, Sue Clark, Lisa Wagoner, and Heath Simpson.

My thanks go to the people of St. Peter's Catholic Church. Without their efforts, there would have been no fresco and no book. Father John Haughey was, as always, patient and helpful. I also thank Father Gene McCreesh and parish secretary Mary Ann Sullivan. The church also cooperated in securing the photographs for this book.

Through the research and writing, I came to know five wonderful artists. I'm grateful for that and for the cooperation of Ben Long, Chuck Kapsner, Anthony Panzera, Laura Buxton, and Joshua Rosen. They all suffered my presence and patiently answered my questions.

I am most grateful to Ben Long for agreeing to cooperate and for his courage in letting his art and his life be examined and written about.

Anne McKenna and Kitty Gaston, Long's agents, gave me their time and cooperation.

Many others offered moral and other forms of support. Thanks go to Bob and Peggy Culbertson, Dick and Meredith Spangler, Jerry Bledsoe, Jan Steever, Marilyn Perlman, Mary Kratt, Edythea Ginis Selman, Gary Jones, Gene Thornton, Myron Schwartzman, Diane Suchetka, Connie Grosse, Lew Powell, Dannye Romine Powell, John Vaughan, Hunt Williams, Dan Clodfelter, Bob Gibson, Pace Lineberger, Betty Chafin Rash, and Mark Legett. Joe, Gabriella, and Sulamita Ciceri extended warm hospitality on my visit to Italy.

Frye Gaillard is the godfather of this book. A former newspaper colleague, the author of several books, and a friend, he shared everything he knew about writing and publishing a book. He believed in this book even when I was unable to, and I thank him.

Because it was researched and written for the most part on nights, weekends, and vacations, this book took more than four years to complete. During that time, I was sustained by the love and support of my family: my wife, Polly, and our children, Laura and Ben. They good-naturedly lived

with a sometimes distracted and often absent husband and father, giving up fishing trips, nights out, and beach time so I could work. This book could not have been done without their help. I hope it in some way repays their faith in me.

My wife, Polly, especially was a pillar of support over these years, helping me with doubts and fears and offering sage advice, editing skills, patience, and good humor. Dedicating this book to her seems scant acknowledgment for all she has done for me and all she means to me. But I do so with all my heart.

The following sources proved particularly helpful in learning about fresco: *The Great Age of Fresco: Discoveries, Recoveries and Survivals*, by Millard Meiss (George Braziller); *The Mural Painters of Tuscany: From Cimabue to Andrea Del Sarto*, by Eve Borsook (Phaidon Publishers); *The Great Age of Fresco: Giotto to Pontormo*, Thomas P. F. Hoving, Millard Meiss, and Ugo Procacci (Metropolitan Museum of Art); *History of Italian Renaissance Art: Painting, Sculpture, Architecture*, by Frederick Hartt (Prentice-Hall); *Youth* (vol. 1) and *The Sistine Ceiling* (vol. 2) of *Michelangelo*, by Charles De Tolnay (Princeton University Press); *Leonardo Da Vinci*, by Kenneth Clark (Penguin Books); *The Sistine Chapel: the Art, the History and the Restoration*, by Carlo Pietrangeli, André Chastel, John Shearman, John O'Malley, S.J., Pierluigi De Vecchi, Michael Hirst, Fabrizio Mancinelli, Gianluigi Colalucci, and Franco Bernabei (Harmony Books); *Giorgio Vasari: Lives of the Artists*, translated by George Bull (Penguin Books); *Vasari on Technique*, by Giorgio Vasari, translated by Louisa S. Machlehose (Dover Publications); *The Craftsman's Handbook*, by Cennino Cennini, translated by Daniel V. Thompson, Jr. (Dover Publications); *Fresco Painting: Modern Methods and Techniques for Painting in Fresco and Secco*, by Olle Nordmark (American Artists Group); *Pietro Annigoni: An Artist's Life*, as told to Robert Wraight (W. H. Allen); and *Pietro Annigoni: A Retrospective Exhibition*, by Thomas S. Buechner and Donelson F. Hoopes (Brooklyn Museum).

WET-WALL TATTOOS

Introduction

One day in February 1988, I stepped through the door separating the sacristy and the sanctuary of St. Peter's Catholic Church, turned, and looked up at the altar wall. On assignment for my newspaper, the *Charlotte Observer*, I'd come to write an article about a unique art project at the church. It took my eyes a minute to adjust to what I saw.

A large, curving slice of deep blue covered the upper part of the wall, the plaster seeming to project out about half an inch. Barely visible through the pipes of a scaffold was an artist intently painting on a small patch of plaster. Around him were others busily working to grind colors and do other chores. Together, they were painting a fresco. I was intrigued.

I had seen Diego Rivera's great fresco at the Art Institute of Chicago, done in the 1930s when Rivera and his fellow Mexican artists José Orozco and David Siqueiros revived fresco painting for a time. I had read about Michelangelo's heroic effort to cover the ceiling and altar wall of the Sistine

Chapel at the Vatican in Rome more than four hundred years ago. But I assumed that by the 1980s, fresco had largely disappeared, and I was surprised to see it surface in a rather out-of-the-way place, a small Catholic church in Charlotte, North Carolina.

Fresco—the word is used to refer to both the technique and the finished painting—seemed very different from the contemporary work I had seen as a newspaper art critic. Much of that seemed superficial and inward-looking, often a cynical manipulation of technique and materials concerned with small gestures and made for an elite audience. Fresco, however, has great rhetorical power and is by its nature a public art. Unlike much of contemporary art, fresco requires craft and skill. It harkens back to older ideas about the artist as craftsman, something that especially appealed to the artists gathered at St. Peter's. Finally, while many contemporary artworks are made with little sense that they will last, fresco *is* made to last. The labor and time required are balanced by a finished artifact made for the ages.

The ethic inherent in the process stood astride the trends in contemporary art. How, I wondered, had this technique survived? Who was the artist carrying on this ancient tradition?

I wrote my article for the *Observer* and over the next year did several more on the fresco. I got to know Ben Long, the artist leading the effort, his crew members, the pastor at St. Peter's, Father John Haughey, and others involved in the project. I decided there was enough there for a book.

What attracted me was what every writer looks for: a good story. The fresco involved a rich one, a difficult project that brought together a diverse group of people and caused more than a little conflict. I wanted to understand Long and the process of fresco from the inside, to tell what happened when he and others worked in St. Peter's from February 1988 to August 1989.

At first, I was drawn to the making of the fresco itself, the technique and the history behind it. I soon realized Long's personality and character were equally important. So the narrative at the heart of *Wet-Wall Tattoos* moves on two tracks: the making of the fresco and the making of Long as an artist and a man.

The story is told in real time, as it happened. It begins with what I saw on that day in February and continues through the other portions of the fresco, through its completion and the aftermath. I was there for much of what I describe. When the project ended, I did in-depth interviews with all the principals, traveled to Italy to see frescoes by Long and Renaissance artists, and consulted other sources to flesh out the narrative.

As with any such book, what follows is a reconstruction of what happened based on my search for the truth and my understanding of what I learned. It is as factual as I could make it.

None of those involved in this story asked for or were given any special concessions or treatment that might have hindered my search for the truth. I am grateful for their confidence and hope I have repaid it with an honest account.

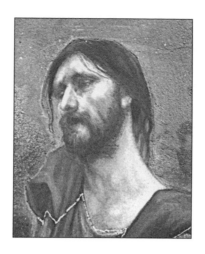

The Face

Most of the face is there, the lank hair matted with sweat, the dark eyes under a fevered brow. But Ben Long is not satisfied. He dips a sable-tipped brush into a spot of flesh-toned pigment. With his left hand, he makes a series of strokes less than an inch long. Slowly and steadily he paints the nose, and suddenly it takes on the roundness of flesh.

Long leans back and to his left to look at the face, holding onto his knees. He squints at a nearby drawing of the face, hung on a nail and pushed out from the wall and into his line of sight by a roll of paper towels taped behind it. With a few more strokes, the beard becomes fuller, the jaw stronger. In the waning light of a February afternoon, the face looks less masklike, more real.

PHOTOGRAPH BY MARK B. SLUDER

Long bends forward. His face and the face he paints are inches apart. The face's eyes are dark, Long's bright blue; the hair straight and brown, Long's wavy and sandy gray. The face is contorted in agony. Long is so intense that when he paints the mouth, he involuntarily parts his lips in the same attitude of despair. Both have beards, but Long's is almost white.

This is the face of a younger man the artist paints. It is the face of Christ.

When they first talked about a work of art for St. Peter's Catholic Church, Long, forty-two, told the priests that he wanted to draw on his experience in Vietnam. As a combat platoon leader in the Marine Corps, and later as a combat artist, he had seen men face fear, suffering, and death. He thought he could bring some understanding of that to this image of Christ at an extreme moment.

"Here comes the night," wails Van Morrison's husky voice through the church's sound system. Long whistles soundlessly and taps his feet. Sunlight pouring through the windows on the southeast side of the church turns a stained-glass figure of Christ revealing his Sacred Heart into jeweled reds and blues. Another window holds a figure of St. Benedict with a crook. The order he founded supplied priests for St. Peter's for most of its 137 years. For the past two years, the church has been staffed by the Jesuits.

The church stands at the southern end of downtown Charlotte on its main street, Tryon Street. When the first St. Peter's was erected in 1851, what is now the downtown was the entire city, and the church was near the boundary line. The business district of three-story hotels and stores clustered several blocks north around Tryon Street's crossing with Trade Street, an intersection called "The Square." Few from a pre-Civil War vantage would have predicted a prosperous future for Charlotte.

But the city survived the war with its people, homes, businesses, and go-getter spirit more or less intact. By the time the present St. Peter's was built in 1878, the city was a shining example of the New South creed, growing rich on the strength of cotton and banking. Gracious homes with side porches and beds of flowers were St. Peter's neighbors. By 1988, when Ben Long and his crew set up shop in the church, the city's boundary was miles away. Charlotte had grown to be North Carolina's largest city, a rival, at

least in its own mind, of Atlanta, four hours down the interstate. The city, more suburban than urban, had spread over what had been rolling farmland, red-clay hills, and stands of oaks. The gracious homes around St. Peter's, the porches and flowers, were gone, replaced by the glass and steel of towering office buildings.

Unlike Charleston or Savannah, Charlotte does not worship its past. What is new is celebrated. What is old is left to the bulldozer. This second St. Peter's, with its red-brick facade, cross-topped steeple, and stripped-down Victorian Gothic look, is the sole survivor from its era on South Tryon Street.

The first St. Peter's was an indirect casualty of the Civil War. As hostilities drew to a close, a Confederate ammunition dump nearby exploded, cracking the walls and causing a fire. A new church went up on the same site a decade later. When the restoration of St. Peter's began in 1987, workers stripped off the old plaster covering the altar wall, revealing the handmade brick. It was a rosy color, lighter and warmer than the exterior brick. A few members of the parish liked it so well they considered leaving it exposed. It was a fleeting thought. The energy parishioners had put into the restoration of their church propelled them into another ambitious project, covering the wall with a work of art, a religious painting.

By the time Ben Long began his work, the entire brick wall had been replastered. Some forty-four feet long and thirty-five feet high, the wall is shaped like the top half of a spade, its rounded lobes curving upward to a point in the center. At the base of the wall beneath this summit, right behind the marble altar table, is the door to the sacristy, its pointed Gothic arch echoing the shape of the wall. Viewed from the back of the church, the wall is immense.

From Long's perspective now, only inches from it, it rises like a mountain, with deep plaster valleys and high ridges.

He sits on an overturned bucket on a scaffold sixteen feet above the altar. The artist wears a tuniclike green shirt and a pair of tan corduroy pants tucked into the tops of his black boots. Long grew up forty miles north of Charlotte in a smaller city called Statesville. A statue of a Confederate

soldier stands in front of the courthouse where Long's great-grandfather, a judge and the first Benjamin Franklin Long, once presided.

Long now lives in Paris and bought the shirt and pants there, at a flea market not far from his flat in Montmartre. The clothes are tough and simple, warm in the raw Parisian winter, and he likes that. They also impart a certain artistic air; he likes that, too. Sitting on an improvised cushion made of a folded gold cloth, Long paints on wet plaster, a technique known as "fresco," from the Italian word *affresco*, meaning "fresh." Above him, covering almost one-third of the left side of the wall, is a smooth coat of plaster about a half-inch thick already painted dark blue, the color of the night sky. The subject of this, the first third of the fresco, is the Agony in the Garden, when Christ confronts his fate the night before his Crucifixion.

Taped to the scaffold on Long's right is a charcoal drawing on gray paper of the full figure of Christ as he will appear in *The Agony*, on his knees, his arms in front of him stiff as pistons, his fists pressed to the ground. Long did this cartoon, as such preparatory drawings are called, months earlier in his Paris studio and made a tracing to transfer the image to the wall. He occasionally consults the cartoon, looking past the smaller studies of the face.

————————

To make a painting, an arrangement of color on a surface, an artist needs two things: a support, or ground, on which to paint and a medium to carry and fix the pigment. With oil painting, the technique most people are familiar with, the support is a piece of stretched canvas attached to a wooden frame. The medium is the oil in which the pigment is mixed. As it dries, it holds the pigment in place. Oil applied to a canvas—it can be exciting to see that wafer-thin layer of color, thicker if, like Van Gogh, the painter uses a rich impasto.

Fresco, thousands of years old before painting with oils became common, is different. With fresco, the support is a wall or ceiling. This is the painter's "canvas," and it can be huge, as large as Michelangelo's Sistine Chapel ceiling or Long's altar wall in Charlotte. The medium is the water in which the ground-up earth pigments are dissolved. Unlike oils, however,

the medium, the water, does not fix the color. The wall does that. The paint is applied to the still-damp lime plaster and absorbed. As the plaster dries, a chemical reaction takes place, and a skin of calcium carbonate forms on the wall. These crystals lock the molecules of pigment in place, forming a nearly indestructible surface.

"Wet-wall tattoos," Long once called frescoes. It's as good a description as any.

The appeal of fresco for the Greeks, the Romans, and the Renaissance masters who brought it to full flower was that it could be used to cover large areas with durable patches of color. You could make a big statement in fresco, and also a lasting one. The West's oldest known artworks, the cave paintings made by the reindeer hunters of Lascaux in southern France seventeen thousand years ago, are frescoes painted on limestone walls.

Fresco has another attraction. As the lime plaster dries and ages, it gives off a subtle glow. Light doesn't just reflect off the picture as it does with an oil painting. With its own built-in source, a fresco gives off light. The tangerine oranges and aquamarine blues in the frescoed tombs of Egypt are as bright today as when they were painted.

Differences in the media of oil painting and fresco control how the artist approaches his task. With oils, an artist can work at a leisurely pace over a long period of time. Oils dry slowly, enabling the artist to leave the work for days or weeks and make virtually endless revisions. Wet plaster allows the fresco painter no such leeway. The plaster will take color, "pull pigment," as long as it is wet. When the plaster is dry, it cannot be worked. So, when painting a fresco, the artist has to get it right the first time. He cannot stop. He cannot wait. He cannot leave the wall for any length of time. He also cannot revise. If he makes a mistake or does not like what he has painted, or if heat dries the plaster too fast or shifts the color, he must scrape off what he has done and start over.

It's as if a clock is ticking. Only the artist, as he works, can hear it. Typically, he has several hours, the "ora d'orato," the "golden hour," as the Italians call it, when the plaster pulls just right. The artist has to paint quickly, with confidence and assurance. He needs stamina to endure the

long hours on the scaffold. Because the colors dry lighter than they appear when brushed on, he must see into the future as he paints. And because he can never see the whole composition until he is done, he must measure each stroke of the brush against the larger whole he carries in his mind and his imagination.

Painting a fresco is to the artist what performing *Hamlet* or *King Lear* is to the actor: a tour de force. Long fits the challenge perfectly, not only with his skills, but also with the thick, muscular body of a former high-school halfback and the lightness of a dancer. He commands the stage of the scaffold with confident ease.

Because of the demands of the drying plaster, a fresco is painted in sections, called "giornate," meaning, in Italian, "the work that can be done in a day." The size of the giornata depends on what the artist is painting. The night sky above Gethsemane in *The Agony in the Garden*, filling the entire left lobe of the wall, took one session. Long and his crew worked nonstop, painting the sky and coming down the extreme left side of the wall, below where the figure of Jesus would be painted. There, Long painted a small scene: a zigzag road, Judas coming up the road toward Gethsemane, the temple guards and Roman soldiers, their torches white against the night sky.

This large area was one giornata, painted in a single feverish night, Long and the fresco crew high with the exhilaration of putting the first color on the wall. For the face of Christ, requiring more of the artist's skill, the giornata is the size of a dinner plate. When the late-afternoon light begins to warm St. Peter's windows, Long has already been at work for almost eight hours. Perpetually late for appointments, undisciplined at times about some aspects of his career, Long is a horse when it comes to the wall, breaking only for meals. The wall will let him go for that long. But before a lunch break, he must spray the wall with water to keep the plaster fresh and also lay a wet paper towel over the face, an improvised shroud for Christ.

With these separate patches, or giornate, a completed fresco is like a giant jigsaw puzzle, with the lines, called day marks, between the giornate visible.

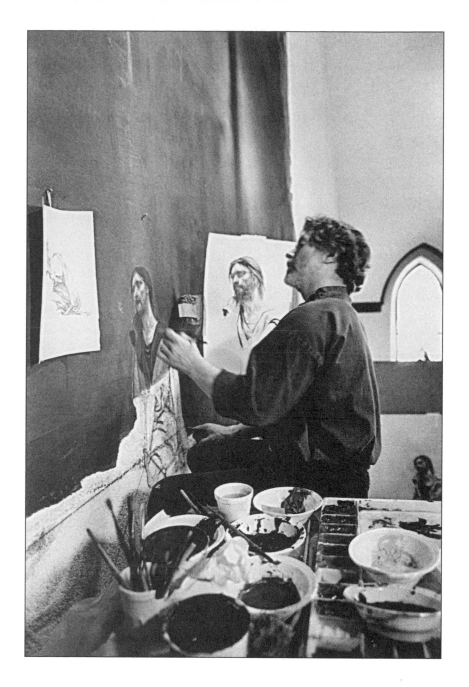

The face of Christ in The Agony *was one giornata, taking an entire day to paint.*

MARK B. SLUDER

They are part of the charm of fresco and the character of some of the greatest paintings Western art has produced: Giotto's *Driving the Money Changers from the Temple* in the Scrovegni Chapel in Padua, Masaccio's *Expulsion from the Garden* in the Carmine in Florence, and Michelangelo's *Creation of Adam* in the Sistine Chapel in Rome.

All of these are frescoes. Leonardo da Vinci's *Last Supper* in Milan, although painted on a wall, is not, one reason it has deteriorated so badly.

Giotto and other artists in the fourteenth century used "secco" techniques when painting frescoes, applying some colors to the wall after it was dry with tempera, pigments mixed with wine and egg whites. By the time Michelangelo began the Sistine ceiling in 1508, the favored method was working only in wet plaster. This most pure and demanding technique is called "buon fresco," or "true fresco," or, more aptly, "the real thing." Long does buon fresco.

His task is to cover the altar wall with patches of plaster and paint, with emotion and meaning, all 1,540 square feet of it, the size of a small house. Painting in three two-month stages, with time in between for preparatory studies, drawings, and cartoons, and a final month to do the retouching, he will be consumed by the St. Peter's fresco for almost three years.

Long makes his living primarily as a portrait painter. Just before starting the fresco, he began a portrait of mega-novelist Danielle Steel, her husband, and nine children that will parallel his work on the fresco. But Long disdains categories such as "portrait painter," "fresco painter," or "painter of religious art." He believes an artist, like the masters of the Renaissance, should do it all. He saw that in his teacher, Pietro Annigoni, from whom he learned fresco while studying in Florence. And he has a connection to that older tradition in art through his grandfather, McKendree Robbins Long, a painter turned preacher, turned evangelist, turned painter again, who, like his grandson, followed his own drummer and parted his hair straight down the middle.

Facing the vastness of the wall, his eighth fresco and his first in eight years, Long is happy. "To attack a wall that size is a joy," he says. "Talk about the pure pleasure of painting."

Over the months, the wall will be Long's ally but also his adversary. On the *Agony* section, it will be pliant and yielding, the work going swiftly and the color taking evenly. On the next section, *The Pentecost*, on the far right side, the wall will turn hostile in the summer heat, the plaster drying too quickly and the colors bleaching out. On the final, center section, *The Resurrection*, the wall will endure the eruption into the open of a long-simmering conflict between Long and Father John Haughey, the priest at St. Peter's, over their different ideas about the fresco. In a battle of wills, they will play the roles of their more famous prototypes, Michelangelo and Pope Julius II.

On the scaffold one level above and behind Long and to his left, Charles "Chuck" Kapsner crouches, smiling as he watches the artist paint.

Kapsner and Long are old friends, going back to the early 1970s and their days as students in Florence. Kapsner assisted Long on frescoes in Italy at a Franciscan church in Montecatini, west of Florence, and at Montecassino, the Benedictine abbey south of Rome reconstructed after being destroyed by Allied bombing in World War II. Kapsner also worked with Long on *The Last Supper*, a fresco in a small Episcopal church in the North Carolina mountains.

With his stone-washed-jeans jumpsuit and his skull ring, Kapsner looks like an aging rock-'n'-roller, which he is, a former drummer. He brings to mind one of those resourceful types out of Woodstock who, in cutoffs and boots and with a utility belt strapped on, could rig a sound system, hang lights, and then sit back and enjoy the music. A Minnesotan with a flat Midwestern accent and a deep baritone voice, Kapsner makes things work.

Before the painting began, Long was anxious about whether the lime had been sufficiently aged and whether he would be able to find any hot sauce in Charlotte. After living abroad for seventeen years, his tastes had shifted, and he liked his food spicy. But chiefly, he wanted Kapsner, who was what Long was not: organized and efficient.

The only paid member of the crew, Kapsner is the foreman. But he is much more to Long: confidant, sounding board, drinking buddy, buffer

with the public, advocate with the priests, interpreter of moods to the rest of the crew. Kapsner is also one of the few people who can tell Long he is wrong.

On this day, Kapsner is "palette man." His job is to free Long from secondary tasks so the artist can concentrate on the wall. Anticipating Long's needs, he cleans the palette and makes sure it has enough color. And there are brushes to wash, sponges to rinse, buckets of dirty water to empty.

At the base of the scaffold is the support crew. At two tables, lime is ground into a creamy consistency so it can be painted on the wall as the color white or mixed with some of the other colors. The process is called "grinding white."

Anthony Panzera, who teaches art at Hunter College in New York, wears a brown apron over his jeans. The oldest member of the crew, he is the only one here for religious as well as artistic reasons.

Laura Buxton, a Scot who studied with Long in Florence, has a flair for color. She's wearing orange socks.

Joshua Rosen, who grew up near San Francisco, grinds.

"How's the white coming on, Josh?" asks Buxton.

"Beautiful," says Rosen.

"That's not what we're asking," Kapsner yells from the scaffold.

Rosen, wearing a black tank top, is almost as muscular as Long. The youngest member of the crew, he's already comfortable as the teasing younger brother.

He sneezes.

"Just clean that snot out of the white," says Kapsner.

"I'm giving it a little binder," says Rosen.

Once, apprentices and assistants did much of this work. These are unpaid volunteers, all artists in their own right, all with their own lives. They are drawn to St. Peter's by the unique opportunity to work on a fresco, to learn the technique. And they are drawn by Long.

For the kind of art they do, representational art based on the human figure, he is the best they've seen. They're also attracted by his intensity, his

energy, his heat—even his dark side and his raging. Long also can be charming. The focus of his charm is his smile, a beautiful smile composed of two even rows of strong, white teeth. To refresh them, Long sometimes removes the toothbrush with the plastic cap over the bristles from his pocket, uncaps it, and brushes while walking down the street.

"Kill the lights so I can see it!" Long hollers. As he climbs down, the scaffold shakes. He walks down the center aisle of the church to see how the face he has painted looks from a distance. It's late. Without light, the colors in the stained glass are dull.

Standing among the pews is Anne McKenna, one of Long's agents and a member of the St. Peter's congregation.

"I'd like a glass of wine," says Long.

"There's wine," says McKenna.

"We drank it," says Long, smiling.

Kapsner cuts out the plaster below the face of Christ to make the day mark. Tomorrow, a fresh patch of plaster will be spread and the painting continue.

Long's shoulders ache. But he is pleased.

"It's about reached its limit. It's not pulling any more color. It's telling me it's time to quit. It's over. It beat us. It was quicker than we were today."

CHAPTER TWO

An Appetite for Beauty

In 1966, Anne McKenna and a friend, Eleanor Carson, drove from Charlotte to Anderson, South Carolina, in search of a sideboard. In an antique shop run by a Mr. Williams, they found a wall hung with paintings, mostly nineteenth-century oils. McKenna and Carson forgot about the sideboard and bought four or five pictures for fifty-five and sixty-five dollars each.

The next week, they went back and bought twenty-eight paintings, called five friends when they got home, and sold the lot in one afternoon at a markup of fifteen to twenty dollars apiece.

When they returned the following week, Mr. Williams showed them a warehouse filled to the rafters with eighteenth- and nineteenth-century English paintings, landscapes and seascapes not likely to challenge anyone's

PHOTOGRAPH BY MARK B. SLUDER

eye or mind, but scenes that would look good over the sofa. "He said, 'Why don't you buy them all?'" McKenna remembered. "We said, 'We couldn't handle them.' He said, 'I've gotten my money out of them. I don't have that sort of demand for paintings here in Anderson.' We said, 'Well, we couldn't afford it, but what do you want?' He said, 'I'll take thirty-eight hundred dollars'—for four hundred paintings! We said, 'Okay.'"

A second-floor space renting for a hundred dollars a month in an aging mansion on the edge of the affluent Eastover neighborhood became the Carson McKenna Gallery, one of Charlotte's first. It sold the kind of representational art the two partners had bought for a steal in Anderson and that McKenna, a fair Sunday painter herself, had always loved. In 1980, Anne McKenna and her sister, Kitty Gaston, became business partners at the gallery. Until it closed four years later, the G. McKenna Gallery carried traditional art, even though the art scene in Charlotte had changed, with new galleries offering more challenging contemporary art.

In 1971, a shy young man with ginger-colored hair came through the gallery door. Ben Long was home briefly from Italy, where he'd begun his art studies. Under his arm, he carried a couple of drawings and one painting. McKenna was impressed. The young man did the kind of figurative art she liked, and, it was obvious to her practiced eye, he could draw as few could. She was also taken with him personally, drawn by his good looks and magnetism. She agreed to represent him.

As Long's agents, McKenna and Gaston were key to the development of his career. Connected socially and politically to the wealthy class in North Carolina, the two women had limited knowledge and experience of the national art scene. But hard workers and true believers in Long's talent, they were dedicated to helping him, selling his work, and finding him portrait commissions. Over time, their efforts produced Long's most consistent source of income.

Although nine years apart, the sisters were close. Blood relations and business partners, they also were best friends, a fact remarked upon by everyone who knew them. Anne, the older of the two, had been thrilled when, after two brothers, her little sister was born. Kitty, named Katherine

after her mother, adored her big sister, would do anything for her: fetch her a Coke, fetch her cigarettes. One day, Anne made the mistake of calling Kitty "Kim," from the Rudyard Kipling novel about the slave boy. "Who was that?" Kitty wanted to know. That was the end of her fetching.

Tall and thin, her blond hair turned gray, Anne was an elegant woman, polite and, in the Southern way, indirect with people when there was a risk of offending. She had a deep Tallulah Bankhead voice roughened by years of cigarette smoking, a detested habit she was unable to break. Kitty, introduced to smoking by her older sister when she was nine years old, was smaller and dark-haired. In a photograph taken when she was a young woman, wearing a bonnet and a dress puffed by petticoats, she showed a resemblance to Vivian Leigh. No Scarlett O'Hara, she was direct and outspoken. While Anne disliked confrontation and always tried to smooth things over, Kitty said what she thought with no hint of magnolias in her voice.

Their different personalities led them to different roles as Ben Long's agents. McKenna dealt with public relations and clients. Gaston handled the money, including the challenge of dealing with Long's tangled finances. When the time came for tough negotiations over whether the artist or St. Peter's owned the copyright to the fresco, Gaston took the lead.

The sisters had deep roots in St. Peter's. Their parents had been married there. Anne and Kitty had been baptized there, as had their two brothers. In the vestibule were two stained-glass windows of the Virgin and the infant Christ donated by their grandfather.

McKenna was a member of St. Patrick's, located in a leafy neighborhood called Dilworth two miles from the downtown church. Built in the 1930s, St. Patrick's was Charlotte's second-oldest Catholic church, the seat of the bishop of Charlotte. What kept McKenna there was a commitment to Father Thomas Burke. When her father was ill in the year or so before he died, Father Burke had visited him every day.

In 1986, McKenna felt the tug of past attachments. After Father Burke left St. Patrick's, she felt free to return to St. Peter's. The old church was reviving under the leadership of a Jesuit priest who had a wry sense of

humor and a sense of purpose, qualities she liked.

For a time, St. Peter's future had been much in doubt. On a Sunday morning in September 1970, the six hundred or so members of the church had received wrenching news. By order of the bishop, Charlotte's mother church would soon lose its status as a parish, its priest be reassigned. Fewer people were living downtown in the immediate area around the church. Moreover, by downgrading St. Peter's and redrawing parish lines, some of its congregation could be shifted to Our Lady of Consolation, a predominantly black church, thereby helping to desegregate the city's seven Catholic churches.

The parishioners were stunned. However worthy the bishop's intention, they had no say in his decision and no advance word. A paragraph in a petition drawn in protest asked "that those in authority realize that the people of God are the church and their feelings, needs and rights should be considered in decisions reflecting their spiritual lives."

The bishop was unmoved.

St. Peter's became a "chapel of ease," a place where mass was said, but one with none of the usual parish associations or activities. It didn't even have a choir. About 35 devoted families, perhaps 120 people, clung to their church. Catholics from other parishes attended during the week and on weekends. The five o'clock Sunday mass, the last in the city, was jokingly called "the Beach and Mountain Mass" for its convenience for vacationers returning home.

It was a low point for one of the oldest Catholic institutions in North Carolina.

Catholics were rare in the state, during colonial times and later. Unlike other coastal colonies, North Carolina did not have a large port. Immigrants before and after the Revolution came overland, many of them Scotch-Irish Presbyterians from Pennsylvania. Exceptions were the Irish immigrants who came to Charlotte in the 1830s to work the gold mines. Charlotte was the site of the first gold rush in America, preceding the California gold rush by twenty years. So great was the amount of bullion

taken out of mines with such colorful names as the Queen of Sheba that in
1832, Charlotte got a branch of the United States Mint. It was the first
indication this insignificant town, then numbering about eight hundred
citizens, would amount to anything.

For years, circuit-riding priests out of Charleston and Savannah served
the few Catholics in Charlotte. The town got its own church, in part to
serve the Irish miners thereabouts, in 1851 with the purchase of two acres
on the southern town limit for five hundred dollars. The church itself cost
a thousand dollars to build. When the faithful laid the granite cornerstone
for St. Peter's on St. Patrick's Day, only about a hundred Catholics lived
in Charlotte and the adjoining communities. Most of the several hundred
people attending the ceremony were non-Catholics. They listened respect-
fully as Father Jeremiah J. O'Connell delivered a two-hour sermon on the
infallibility of the church.

Until the early 1970s, North Carolina had the lowest percentage of
Catholics in the United States—one-half of 1 percent, or about 60,000
people. With the booming of the Sun Belt in the sixties and seventies, the
Catholic population grew, as corporations such as Gold Bond Building
Products and IBM moved divisions of their companies from the North to
the South, and their executives and managers, many of them Catholic,
followed. By the late 1980s, the state had about 140,000 Catholics, or 2
percent of the population, still a low number but growing. They began to
be numbered among the city's economic and political leaders,
although the power structure remained overwhelmingly Protestant.

In 1986, recognizing the historic church's important location in the
heart of the city's financial district, a new bishop decided to revive
St. Peter's as a full-fledged parish and give it new clerical leadership. Father
John Haughey (pronounced Hoy), S.J., fifty-six years old when he began
his work in Charlotte, was in some ways an unlikely choice. He had never
lived in the South and had never had a parish. He had devoted his entire
priesthood to teaching, research, and writing. Tall and lean, his gray-to-
white hair neatly combed, he was the quintessential Jesuit: intellectual,
witty, and reserved.

He expressed his goals for his new parish with accustomed clarity: "We want to be a people who learn both a deeper interiority and a more venturesome outreach. These are the directions we want to emphasize."

Father Haughey had been attracted to the order founded by St. Ignatius Loyola as a boy growing up in Wernersville, Pennsylvania, a small town northwest of Philadelphia. His mother and father were Irish immigrant farmers who after World War I stopped first in New York, where John, the third of seven children, was born.

Eleanor and Patrick Haughey had been educated only as far as the third grade, so while she raised the children, he mopped floors in a hospital. "Some doctor took a shine to him and said, 'You have a major intelligence. I'm going to put you in nursing school,' " remembered Father Haughey. His father became a psychiatric nurse. Searching for work during the Depression, Patrick followed a newspaper advertisement to a hospital in Reading, Pennsylvania. He almost didn't take the job because there was no Catholic church in town. A farmer he met on the road, one of the Pennsylvania Dutch who lived thereabouts, pointed out a "Catholic home" on a nearby hill. It was the Jesuit novitiate at Wernersville.

The family was devout. At home, the rosary was said every evening. On Sunday mornings, they trooped up the hill for six-thirty mass, joining the novices, priests, and staff.

"The people who taught me catechism were young men who had just entered the Jesuits," recalled Father Haughey. "They became kind of role models for my own life. And I couldn't think of anything better to do with my life than to be one of them. It was very important to me that they be athletic and that they be good-looking and that they be smart, and they were all three—whereas the kids in the little town where I lived seemed alien to my Catholic culture. They didn't seem smart, so they kind of lost by comparison."

The Haugheys were the only Catholic family for miles. "If you can have an Irish-Catholic ghetto of one family, we were an Irish-Catholic ghetto," said the priest. His parents had a pre-Vatican II faith, a pre-ecumenical view of the Catholic church as the one true means of salvation God had put in

this world. Those outside it, however sincere, ran the risk of damnation. "It was important to our Irish parents that we not get too close to the Pennsylvania Dutch kids. We were always taught to be in a relationship of edification to those kids so that they would come to know the one true church."

Patrick Haughey eventually moved his family to Philadelphia so his children could attend Catholic schools, giving up nursing and opening a delicatessen. After high school, John went back to Wernersville, to the Jesuit novitiate. While trying to stop a line drive during a baseball game, he broke a finger. On the bus to the hospital in Reading, he met an old girlfriend and spent the day with her, much to the chagrin of the novice master.

The long training required to become a Jesuit confirmed for Haughey his intellectual interests. After his ordination in 1961, he taught theology at Georgetown University in Washington, D.C., and then went to *America* magazine as an editor. In 1975, he and other Jesuits opened the Woodstock Theological Center, a think tank at Georgetown. He stayed there until 1985, when he became a visiting scholar at Seton Hall University in New Jersey for a year before coming to Charlotte.

For him, the intellectual investigations of theology always had to be connected to what was happening in the real world, grounded in everyday events. At *America* magazine, Haughey became interested in the connection between theological and economic issues. While his first book, *The Conspiracy of God*, was about the Holy Spirit, it was soon followed by one focusing on theology and economics, *The Holy Use of Money*.

The bishop of Charlotte and Haughey's provincial in the Jesuit order thought he would be a good fit for St. Peter's. Father Haughey saw an opportunity to test his ideas on theology and economic issues in a practical setting. Also, after twenty-five years in academic pursuits, he had an itch to experience the priesthood in a direct way—"the pastoral itch." He came with an enlarged sense of what the church was and with impressive credentials. He was a member of the Wall Street Roundtable for Financial Ethics, a member of a Vatican commission on the Catholic church and

Pentecostalism. His eighth book was published while he was in Charlotte.

An intellectual, he wrote and spoke in sibilant Latinisms—"enfleshment," "re-pristinate," "consinity," "pedestalization." One on one, he displayed a sharp wit and told funny stories. One was the reaction of his father, Patrick Haughey (Hoy), when asked if he was related to Charles Haughey (Hawhee), the prime minister of Ireland. "The first time I asked my father, Charles Haughey was on trial for gunrunning. My father said, 'Not a-tall,'" said Haughey, doing an Irish brogue. "When he became prime minister, I asked him again. He said, 'We were first cousins.' "

At dinner parties, or relaxing in the rectory wearing a plaid short-sleeved shirt and loafers with no socks, he could be the soul of congeniality. In the pulpit, he passionately expressed his ideas. Yet people sensed a reserve, a coolness about him. Haughey could be abrupt and aloof. Some of his parishioners called him "Father John," but such easy familiarity attached more naturally to his colleague, Father Gene McCreesh. Like Haughey, Father Gene was an Irishman from Philadelphia and a Jesuit. But where Haughey was intellectual and reserved, McCreesh was warm and outgoing.

With his Jesuit's rationality, Father Haughey analyzed how they balanced one another. Father Gene, he said, "loves by doing, and he does that with facility. I love after I figure it out. He loves with much more spontaneity than I do. So when the very poor come to the door, his first reaction is, 'What do you want? What do you need?' My reaction is, 'Why are you here? What has become dysfunctional in your life that requires this ectopic exercise on the part of the two of us?' That's the difference. And I think what's valuable is the two of us. If there were two Genes here, I don't know what we'd have. It would be more of a way station for the needy Where if there were two of me here, there wouldn't be enough of the charity of Christ exercised. So I think the combination is the good thing."

Haughey's learned homilies and McCreesh's zeal to help Charlotte's growing number of street people and urban poor attracted Catholics from all over the city, members of large suburban churches, and newcomers just arrived in the South. These and the faithful who had stuck with St. Peter's during its fallow years became a diverse and committed congregation.

Father McCreesh became the head of the city's homeless shelter. On cold winter nights, he drove his battered Toyota around the city, picking up homeless men and women. If they were reluctant to leave their places under bridges and in abandoned buildings, he would at least give them a blanket.

Father Haughey helped organize a group of Protestants, Catholics, and Jews focusing on urban issues such as homelessness and health care for the poor. When he had time, he wrote books and articles, clacking away on his word processor on the upper floor of the rectory.

In a short time, they became two of the most visible clergy in a predominantly Protestant community.

Haughey was proud of his intellect. He was proud of the Catholic church, had a deep sense of its history and traditions, its intellectual contributions, and its role as patron of some of the greatest art the West has produced. A post–Vatican II priest, his ministry at St. Peter's was ecumenical. But in a city with relatively few Catholics, in a region where the church did not have the kind of power or public position it had in cities he knew such as New York, Philadelphia, or Washington, Father Haughey was "in a relationship of edification," as he had been as a boy in Wernersville. This time, it was not to some Pennsylvania Dutch kids, but to an entire city.

———————

When she rejoined St. Peter's, Anne McKenna wanted to do something to beautify the church. "I said, 'Why don't you do a garden? I think that would be a lovely place to put a garden,'" Kitty Gaston remembered. "I don't think she ever admits it was my idea."

Begun in the fall of 1986, the garden was put in front of the 1893 rectory on Tryon Street. McKenna, her brothers, and her sister made it a memorial to their parents and grandparents.

Only thirty-six feet by forty feet, it was filled with an abundance of plants in the Victorian manner, with flowering dogwood, crape myrtle, wax myrtle, holly and cherry laurel, tea olive, two kinds of viburnum, junipers and dwarf abelia, pansies, impatiens, and chrysanthemums. Most of the flowers were white, a color chosen for the peaceful aura it gives a garden.

The most dramatic change the garden brought was a new fence. The old one in front of the rectory had made Father Haughey wince. A chain-link fence topped by coils of razor-sharp concertina wire, it had been put up for security after a nasty incident. A vagrant had come to the rectory and, not getting whatever it was he wanted, injured Father Haughey's elderly predecessor, Monsignor Michael O'Keefe, by dragging him down the stone steps.

The chain-link fence sent the wrong message, Father Haughey felt, of a church cut off and looking inward. A new wrought-iron fence, along with the garden, symbolized a new openness to the community.

Father Haughey was impressed with Anne McKenna, with her ability to get things done. And for the members of a reviving St. Peter's, the little garden, as the priest said later, "whetted our appetite for beauty." Soon, the parishioners were talking about refurbishing the church building—and about a fresco for the altar wall as well.

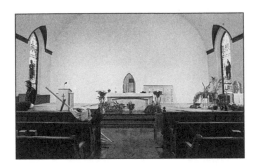

CHAPTER THREE

Death, Death, Death

In the late summer of 1987, Ben Long flew from California to Charlotte for his first face-to-face encounter with the altar wall at St. Peter's. He had been given its measurements, had pictured its shape in his mind's eye as he thought about the images he would create to cover it. But no measurements on paper or secondhand descriptions could fully satisfy. Long wouldn't know what he could do with this wall until he had seen it, touched it.

He had spent a frustrating summer in the San Francisco area. Through an agent in California, a woman he had known in college, Long had for several years done high-paying portrait commissions there: the wife of rock star Boz Scaggs, oil heir Gordon Getty and his sons, among others. A free

PHOTOGRAPH BY MARK B. SLUDER

spender, Long was acutely aware of his need for money. Besides his flat in Paris, he had a house in the south of France, along with two sons to educate. He had enjoyed California but was wearying of the long trips and feeling that what he did was not understood or appreciated. This latest experience had soured him permanently. He was in the Napa Valley to do a portrait of romance novelist Danielle Steel and her family.

Exacting about his portraits, Long disliked shortcuts. He did not like to use photographs or Polaroids as visual aids, instead preferring to build his pictures from the ground up. Before approaching the canvas, he drew studies of his subject, which required long sittings, as did the actual painting. Working wherever his sitters were, he had learned to make do with makeshift studios lacking the high northern light he preferred. But working conditions in the Napa Valley were among the worst he had encountered. His "studio" was on the open lawn, under a length of canvas hung between two ladders to keep the sun out of his eyes. His sitters, he complained, would not sit. The style of dress they wore, blue-and-white sailor-type outfits, and the pose they preferred, eleven people from a toddler to adults strung across the lawn, failed to excite him.

One other thing gnawed at him. Long had been an English major at the University of North Carolina at Chapel Hill and was a steady consumer of good fiction. After reading the first paragraph of one of Steel's potboilers, he'd closed the book in disgust. To paint convincingly, Long needed to feel some emotional connection with his subject. As the St. Peter's fresco progressed, the Steel commission became an ever more burdensome albatross.

Long had been an artist for twenty years, fulfilling the dream that had taken him from North Carolina to New York, through Vietnam, and on to his apprenticeship in Florence. In the fall of 1987, he would for the first time teach a group of college students, from Meredith College in Raleigh, who would come over to Paris. He had supported himself solely through his painting, never done any other kind of work, and that made him proud. For a top portrait commission, he commanded twenty-five thousand dollars. After some lean times, he had reached a level of material comfort.

Yet Long, beginning his middle years, felt he was not as far advanced in his career as he wanted to be. He was little-known outside North Carolina, had shied away from New York. Aware of the larger success the art capital offered, he nonetheless was wary of its greater demands and higher level of criticism, knowing his kind of art would not be viewed sympathetically. People who saw his drawings were amazed by his graphic skills and often remarked on his great God-given talent. Long's display of his abilities had become almost a performance. At a restaurant, he would choose a subject, a diner at the next table, take out his ever-present Mont Blanc pen, and in ten minutes produce a deft likeness on a table mat, finishing it off with a splash of wine spread with a finger to add some color. But his outer confidence masked deep feelings of self-doubt. His almost constant traveling kept him from his own studio and his own painting. Long had not produced the body of work he was capable of—and he knew it.

For several years, his personal life, never tidy, had been in turmoil. Estranged from his wife since 1982, he had left his beloved Florence, first for his home at Pougnadoresse in the south of France and then for Paris. He was for a time separated from his two young sons but eventually brought the elder, Angus, whom he loved deeply, to live with him. Two love affairs had ended painfully. Women were attracted to him. They found in this ex-marine with a copy of Rainer Maria Rilke's *Book of Hours* in his back pocket an appealing mix of good looks and gentleness, strength and sensitivity. These contrasting qualities met in his face, in the clear forehead and firm chin and especially in the shape of his nose. Broken when Long played high-school football, it was broad at the bridge, then narrowed to a finely chiseled point. Long liked women. The gray hairs growing out of his earlobes reinforced the image he relished: that of a satyr.

Long now had some stability in his life. For several months, he had shared his Paris apartment with Cary Lawrence, a pretty, young actress who had left Canada to study in Paris. That summer, she'd gone home to visit her family and appear in a play. She would meet Long in Charlotte, and after he saw the wall and talked with the priests, the two of them would fly back to France.

At the core of the work Long had produced were seven frescoes, about evenly divided between Italy and the United States. His last fresco, completed in 1980, was his best known, and probably the best painting he had done. His *Last Supper* filled the altar wall of Holy Trinity, a small Episcopal church in Glendale Springs, North Carolina. The popularity of the fresco, and three others by Long at an even smaller church nearby, had made that area of the North Carolina mountains a tourist attraction. A crossroads with a store, a gas station, and a Baptist church, Glendale Springs also boasts a historic inn which has one of the best French restaurants in the state.

After he finished *The Last Supper*, Long announced it would be his last fresco. He felt he needed to earn money to support his family, and his frescoes had not paid much. He'd made some money at Glendale Springs but had not benefited directly from the popularity of the fresco, and that bothered him. Yet *The Last Supper* had lifted his career. The publicity surrounding the fresco made him widely known throughout the state and brought him more portrait commissions. He also profited from the sale of preparatory drawings from the fresco. Even before he saw the possibility of a $100,000 commission to paint the St. Peter's fresco, Long thought it a good idea to try repeating the successful formula of Glendale Springs: a highly visible project that would bring in commissions and result in the sale of drawings.

Another force propelling him to Charlotte was his feeling for the medium. He loved fresco. He loved the process, the camaraderie. Long, who did not like to be alone, enjoyed working with a team. With his deep respect for craft, he saw fresco as a collaborative enterprise where the plasterer who put the mud on the wall was as important to the process as the painter. Fresco also required a great deal of drawing, Long's forte. Slow and painstaking when working with oils in the studio, Long was liberated by fresco, his energy released. The drying plaster pulled the best out of him.

His agents, Anne McKenna and Kitty Gaston, had begun looking for a fresco site in 1985. Eager to do a fresco, Long announced through them that he would paint one for free, if only the cost of his materials were

covered. McKenna and Gaston floated the idea of a fresco at a former Episcopal orphanage chapel in Charlotte and an unused Catholic church in a small town near the city, the kinds of historic settings Long felt drawn to. When these possibilities and others failed to pan out, the sisters, sheepish for not thinking of it before, and each believing it was her own inspiration, turned to St. Peter's.

———

Brimming with energy and commitment, the members of a reconstituted St. Peter's looked at their church building and, in a series of parish meetings, began to talk about what they saw and what to do about it. The altar and altar furniture were out of step with liturgical innovations in the Catholic church. While celebrating mass, for instance, the priest had to turn his back to the congregation. Neglected for years, the church building badly needed repair. Catholics in Charlotte knew better than to be late for mass at St. Peter's. The squeaking and creaking of the old wooden floor gave latecomers away.

Most of the church's interior was painted white. But the color that assaulted the eye was the sky-blue covering the wainscoting and trim; "Hail Mary blue," Charles Hastings, an architect and member of the congregation, called it. A wall-to-wall red shag carpet contrasted jarringly. Projecting from the altar wall was a "baldichino," a tentlike canopy with burgundy velvet curtains covering the door to the sacristy. Mounted on the front of the baldichino was a large wooden crucifix. In addition to several plaster statues, the church had one other decorative touch: hung on the walls were twelve representations of the stations of the cross made of molded plaster painted in neon colors.

Heavy with traditional symbols, St. Peter's represented an older era. Its dowdy look and musty air ill-matched its new spirit. With Anne McKenna's little garden going in out front, parishioners began to talk about restoring the simple beauty of their church, hidden under layers of paint and grime.

Without a congregation to answer to, the priests who supplied St. Peter's previously had looked to their own taste when time came to redecorate. This time, Father Haughey wanted everyone involved in

deciding what to do with the church. Not a dictatorial priest, his style was to listen at congregational meetings, his left arm folded across his waist and his right arm raised at a right angle, one finger resting attentively across his lips. "This is my sense of what you're saying," he would say softly, summing up a discussion and seeking consensus and clarity. The priest also had his own sense of direction. He wanted to reduce the reliance on outdated symbolism at St. Peter's, to knock away some of the traditional props of faith and worship.

The painting and fix-up parts of the restoration were easy to decide upon. A knottier question was what to do with the huge, blank wall behind the altar. Several possibilities, including inserting panels of stained glass and erecting a decorative screen in front, surfaced before McKenna, a member of the restoration committee, suggested the fresco. A preparatory drawing, or cartoon, Long had done for *The Last Supper* was put on view during Holy Week in the spring of 1987 to test parish reaction. Members traveled to the mountains to see Long's frescoes. Feeling a conflict of interest as Long's agent and a church member, McKenna took a backseat during discussions of the fresco. Father Haughey took the leadership on the project.

"I thought that the Catholic community down here needed to be proud about something—publicly proud about something," he recalled later. "They were proud of their faith, but I thought they needed to be proud about something, and I thought [the fresco] would be part of it."

From the first, the priest also conceived of the fresco as something for the community. With his understanding of business, Father Haughey realized the fresco could be a public-relations vehicle, increasing St. Peter's profile. Once the project was under way, he hired a cameraman and writer for two thousand dollars to produce a documentary later shown on Charlotte's public-television station.

Father Haughey knew, too, that the fresco was a risk for him and for the parish. The bishop made it clear the parish could undertake the project only if it could pay for it. St. Peter's was not a wealthy church and was not plugged into the business establishment, the source of money for civic and

cultural projects in Charlotte. The congregation already was committed to raising the $200,000 needed for restoration. Long's fee for the fresco was $100,000, with another $30,000 for materials and other costs, for a total of about $330,000. A fresco finance committee was formed and the decision made to canvass both Catholics and non-Catholics.

The fresco was not universally popular. Some parishioners objected on fiscal and philosophical grounds. "Are we being consistent?" they asked. "Here we are, giving almost 25 percent of every Sunday's collection to the poor and focusing on the homeless as part of our ministry. How does spending all this money on a fresco square with that commitment?" The answer Father Haughey gave was the one he used when the fresco was announced at a press conference in mid-August 1987. Quoting a Hindu poem kept by Mother Teresa on the walls of her facilities for the dying in Calcutta—"If I have two pieces of bread I will give one to the poor and sell the other to buy a hyacinth"—he added, "Unpackaged, what that means is the poverty that the street people and all of us have is a poverty that's hungry for beauty. We see a perfect continuity between our work with and for the street people and our need to meet the hunger we have for beauty. Good religious art evokes a sense of God, and our hope is that every person who goes into this church will be moved by what they see."

Finally, for some in the congregation, the fresco was a kind of insurance policy. The land under the church was more valuable than the building. Development sprouted all around it. There was talk of more—a convention center on the next block, a facility that came to be six years later. The diocese might one day decide to sell the land and take down the church. The fresco would make such a temptation easier to resist.

───────

The transformation of St. Peter's was well under way when, on an early-September afternoon, Ben Long, Anne McKenna, Kitty Gaston, Father Haughey, and Father McCreesh met at the church. The sky-blue paint had been removed and the loblolly-pine wainscoting and trim given a dark stain. The pressed-tin ceiling had been painted an off-white, as had the walls. Less visible electrical, heating, and structural repairs were under way.

Most of the pews were being refurbished. In their enthusiasm, members of the congregation staged what they called a "pew-out," carrying the pews to a nearby storefront, where they removed decades of dirt and chewing gum. The baldichino had been pulled down and the crucifix removed, a change that made some of the older members of the parish wince. The old plaster had been chipped off the altar wall, revealing the rosy bricks. The job had been done over the summer, carefully so as not to disturb the bricks. The wall was examined to see if it could support the fresco. Solid, it had never leaked, never cracked. Likely made on-site and low-fired, the bricks were absorbent and would make a good ground.

When the five people entered the church, the priests in their black suits, the prickly sweet smell of fresh paint and cut wood tickled their noses. Largely empty, bathed in light, the sanctuary seemed cavernous as they stood near the altar.

Long stepped back and took his first look at the wall, top to bottom and side to side. Its size did not intimidate him. Looking up, Long felt the wall was a challenge, but one he could meet. So he was taken aback when Father Haughey, feeling the weight of what he and his church were about to undertake, asked if Long was up to the task. Long thought the priest was questioning his skills. But he answered simply: Yes, yes, he was. This first look confirmed what the artist had concluded after studying the measurements: the wall was too large for one scene. Also, the architecture of the wall, the high peak and the sacristy door in the center, would have to be taken into account in the composition.

Before he'd left Paris for California, Long had thought about what he would paint on the wall, had shared a bottle of wine on the balcony of his apartment with his close friend Chuck Kapsner and discussed his ideas. He wanted three scenes on the wall: the Agony in the Garden, the Resurrection, and the Crucifixion. Now standing before it, he spoke softly of his experiences in Vietnam and how he felt he could bring some sense of what he had witnessed to his subjects, the Agony and the Crucifixion in particular.

Looking at the wall and thinking of what the scenes Long had in mind

represented, Father Gene responded. "Death, death, death," he said.

The time in the church was brief, the discussion low-key. Needing a place to talk, the artist, the agents, and the priests went to the rectory, adjacent to the church, and sat in overstuffed couches in the parlor overlooking the new garden.

Once the congregation agreed to a fresco, it had been faced with a vexing question: What should it be about? In meeting after meeting, church members discussed subject matter. They thought of a single scene, not realizing the figures on the wall would be so large as to be overwhelming. An early preference was for the Feeding of the Five Thousand, the scene in which Christ preaches to the multitudes and, with seven loaves of bread and two fishes, feeds them. Some parishioners liked it because it symbolized St. Peter's mission to the street people. Also, unlike Bible stories focused on Jesus and the disciples, the scene included women and children as well as men. This was no small consideration in a progressive parish where women were involved in every aspect of church life.

Another suggestion was the story in the Gospel of Matthew of Peter's reaction when he and the other disciples saw Christ walking toward them on the water: "So Peter got out of the boat and walked on the water and came to Jesus; but when he saw the wind, he was afraid, and beginning to sink he cried out, 'Lord, save me.' " This scene had the advantage of focusing on the Charlotte church's headstrong and impetuous patron saint. But no single idea caught fire. Unable to reach a consensus, the parishioners turned the matter over to Father Haughey.

He, along with Father McCreesh, had his own ideas. A focus of their ministry at St. Peter's was the Holy Spirit, that part of the Trinity active in the world. The Holy Spirit brought the people together in the church and animated their efforts to minister to one another and reach out to the less fortunate, relationships Father Haughey had explored in his first book, *The Conspiracy of God*. Moreover, a spirit of revival centered on the Holy Spirit was blowing through the entire Catholic church, evident in the charismatic movement that so interested Father Haughey. Following this trend, the church's symbolic emphasis had shifted from the Crucifixion to the

Resurrection, from sacrifice and death to renewal and rebirth. Father Haughey wanted an uplifting subject on the wall, something inspiring to those who would come off the street to see the fresco. One biblical event met all these requirements: the Pentecost.

As described in Acts, the Pentecost occurred fifty days after the Crucifixion, when the dispirited disciples, Mary, and the other women who had been close to Jesus gathered in Jerusalem. As Christ had promised, the Holy Spirit came upon them: "And suddenly a sound came from heaven like the rush of a mighty wind. And it filled all the house where they were sitting. And there appeared to them tongues as of fire, distributed and resting on each one of them. And they were all filled with the Holy Spirit and began to speak in other tongues, as the Spirit gave them utterance." Empowered, the disciples that day began their ministry of instruction and conversion, the reason the Pentecost is celebrated as the church's birthday.

Taking Long's ideas, but dropping the Crucifixion and adding the Pentecost, Father Haughey fashioned a unity out of three scenes centered on the Holy Spirit: the Agony in the Garden, representing the Spirit tested; the Resurrection, representing the Spirit triumphant; and the Pentecost, representing the Spirit pouring out on God's people. The rationality of the scheme appealed to the Jesuit's ordered mind.

Long had heard of the priest's preference for the Pentecost. He had problems with it. Its use in a triptych would give him a difficult transition, from two outdoor scenes, the Agony and the Resurrection, to an indoor scene, the Pentecost. He'd have two scenes in which Christ was the focus and one in which he was absent. The Agony and the Resurrection were dramatic and concrete. The Pentecost was somewhat diffuse. How, Long wondered, could he convincingly depict for the contemporary eye the Holy Spirit descending and tongues of flame appearing without the scene looking contrived?

Unaware of the shift in emphasis away from the Crucifixion, Long also felt the Pentecost was an insufficiently important scene for the altar, the place where believers partake of Christ's sacrifice through Holy Communion. As an artist, Long wanted to paint a subject he felt some enthusiasm

for, believing that if he was moved, he could get that feeling into his painting and move those who saw it. The Pentecost did not move him.

In the parlor, he again brought up the Crucifixion. Father Haughey noted that Long already had done a Crucifixion scene in the mountains not far from Glendale Springs, a painting, the priest said, he didn't care for. Handing Long a yellow legal pad, he asked him to draw the Agony-Resurrection-Pentecost scheme. Long quickly produced a sketch remarkably similar to the final fresco, a scheme that did not violate but neatly fit the shape of the wall. On the left is Christ on the hill in Gethsemane with the sleeping apostles spread below. In the center is Christ exiting the tomb, the figure framed by rocks reaching to the wall's peak. On the right is *The Pentecost* as first conceived. On an upper floor, Mary and another female figure sit near a window with a billowing curtain. On the ground floor are the apostles.

As the conversation proceeded, it became clear: the Pentecost was in, the Crucifixion was out. Long knew if he insisted on the Crucifixion, there would be no fresco. And he wanted to do the fresco.

As with Long and Haughey, disagreement over subject matter has run like a scarlet thread through the history of fresco. For such a painting to happen, someone has to supply a wall. And that someone usually has pretty definite ideas about what should appear on the wall. An artist doesn't just do a fresco as he would a drawing or even a painting. He is commissioned to do one. No matter how great his fame—Giotto, Michelangelo—he is hired help. Restored Renaissance frescoes, with their underpainting revealed, give evidence of apostles moved from one side of the cross to the other, angels replaced by clouds, likely not last-minute revisions by the artist but changes requested—or demanded—by the owner of the wall.

Among the scenes from the life of Christ that Giotto painted in the Scrovegni Chapel in Padua was *The Cleansing of the Temple*, when Christ drives out the moneychangers. Absent from the painting are traditional elements such as tables spilling coins, scales overturning, purses clutched by their anxious owners. The man who commissioned Giotto's work was Enrico Scrovegni, the son of a notorious moneylender. It seems likely

Giotto tidied up the scene rather than offend his patron's sensibilities.

A more recent example of owner-painter disagreement occurred in 1933, when the Rockefeller family commissioned the great Mexican muralist Diego Rivera to fresco the lobby of the RCA Building at Rockefeller Center. The rather ungainly idea the Rockefellers supplied was "Man at the Crossroads Looking with Hope and High Vision to the Choosing of a New and Better Future." Rivera, a Communist, included a portrait of Lenin. The Rockefellers asked him to change it. Rivera offered to add a portrait of Abraham Lincoln, another historical figure he admired. The Rockefellers refused and, after promising not to, had the incomplete fresco pulverized.

The St. Peter's wall did not belong to Father Haughey. But it was in his trust. He saw subject matter as a theological issue, one he felt completely competent to deal with. For him, the fresco was a religious painting, designed to make visible the mysteries of Christ. Long, a spiritual man who kept his religious feelings deeply buried, as he did much else, approached the subject matter as an artist. The fresco had to mean something, yes. But he wanted it to work as a painting, with subject, colors, and composition cohering into a statement. On all his other frescoes, he had been given a say in the subject matter, and its expression had been left to him. He expected as much as the artist's prerogative. But he had done most of his frescoes gratis, receiving in Italy all the wine he could drink and, when the work was done, perhaps a purse with several hundred thousand lira from a grateful priest. For the St. Peter's fresco, he would be paid a hundred thousand dollars, and attached to that large sum were the expectations of Father Haughey and the parish. Feeling responsible for what went on the wall of his church, the priest asked for and received a commitment allowing him to review the preparatory drawings for each segment and make suggestions on them before any painting was done.

Later, after frustrating disagreements and the sting of slights both real and perceived, Long began to feel he had given in on *The Pentecost*, had betrayed himself as an artist by agreeing to do it. It became like a bone in his throat, and he felt it more acutely as time went on. Such hurt would not

make relations with Father Haughey—or his work on *The Pentecost*—any easier.

The two men discussed other subjects in the parlor. Concerned about the disruption work on the fresco would cause, the priest wanted it finished as quickly as possible: by spring, nine months away. On the same sheet of yellow paper where Long had made his sketch, Father Haughey wrote three dates: February 17, Ash Wednesday; April 3, Easter; May 22, Pentecost. This schedule would not only move the fresco speedily along, but also match the completion of the last two scenes with their occurrence on the church calendar.

Such a schedule, with the actual painting on the wall to start in January, was perhaps possible if the wall did not misbehave. The fresco would have to be painted in five months, possibly as one huge painting. With a scaffold covering the entire wall, Long and his crew could begin at the top, working down in horizontal bands and painting the three scenes simultaneously, rather than each separately. Such an approach was briefly considered. But to finish by spring, Long would have had to do all the preparatory drawings, including studies from life of more than two dozen figures, between September and December, impossible even for his quick hand.

Long explained to the priests what a labor-intensive process fresco is, how each step requires much work, how all the preparation has to be done before the first color goes on. He knew the wall itself would make its own demands of how it took the plaster and offer surprises that could slow the work. He felt hurried by the priests, but—wanting to be agreeable—he allowed as how it was possible to complete the fresco by spring.

Not a Southerner in some obvious ways, Long does share one regional trait: an aversion to a frank no, an inclination instead to tell people what they want to hear. "I think maybe there was a problem with communication," he later said of the conversation with Father Haughey in the parlor. "I think he absolutely understood what he wanted to understand, and I think I am guilty of that famous Southern circumlocution. I go way around not to tread on any toes."

Long has a great capacity for hard work, but he cares little for schedules.

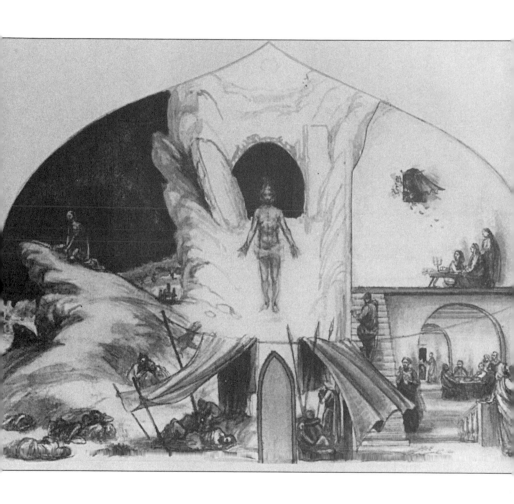

Long's first full sketch of the fresco shows a tentlike arrangement around the sacristy door to unify the composition and a focus on Mary, placed on the upper floor in The Pentecost.

MARK B. SLUDER

He does not like to be pinned down. He felt the meeting in the parlor had generally explored a possible schedule. Father Haughey believed he had firm commitments and later felt they were not kept.

Scheduling was the issue between Michelangelo and Pope Julius II, who commissioned the artist to fresco the Sistine Chapel ceiling. Concerned that the work move along, the imperious pope once threatened to throw Michelangelo off the scaffold if he did not finish. When the St. Peter's fresco was under way, and Father Haughey's superior in the Jesuit order called on the telephone, he would ask the priest, "How is Julius the Second doing?" It was a joke. Considering what happened, the words at times must have taken on an edge.

Meeting Long for the first time, Father Haughey had this impression of the artist: "He struck me as a very talented man, and he manifested that talent the longer I got to know him. He has a stubbornness: 'This is the way I see it, and I am the artist.' And he's obviously a very passionate man: deep feeling, sensuous. In some ways highly disciplined, in some ways lacking discipline."

The priest already knew Anne McKenna and Kitty Gaston, and personal relationships complicated the discussion. The artist's representatives and the artist's employer were friends. They talked as friends, and few of the hard issues were hashed out. For such a complicated project, little preparation was done before the meeting. Long plucked the amount of his fee more or less out of the air, with little calculation of the time involved, the expense of traveling from Paris to Charlotte, and other costs. The schedule had not really been gone over, and it soon became clear Long would not finish in nine months. Accustomed to sealing portrait commissions with a handshake, the agents had not prepared a contract. One was not signed until January, and then it took one page—"a friendly little contract," Gaston called it—and left unaddressed major issues such as the schedule of payment. When the agents attempted to move the relationship to a more businesslike plane, hard feelings resulted.

Discussions and exchanges on the subject matter continued for some time after the meeting. When he got back to France, Long worked up a full

sketch of the fresco and sent it to Father Haughey. It was a more elaborate version of what he had done on the legal pad. *The Agony* and *The Resurrection* were substantially unchanged. A new element surrounded the sacristy door, a tentlike arrangement with one flap of cloth covering the sleeping disciples in *The Agony*, another over the sleeping tomb guards in *The Resurrection*, and yet another blowing in the great wind of *The Pentecost*. Long thought it would tie the three scenes together. In *The Pentecost*, three women were on the upper level, with rose petals blowing through the window to symbolize the Holy Spirit. On the same level of the wall as the Christ figure in *The Agony*, the women were the focus of the composition, with the disciples below. A staircase on the left connected the two levels and also served to separate *The Pentecost* from *The Resurrection*.

When he received the drawing in October, Father Haughey called in Charles Hastings, a parishioner and the architect in charge of the restoration, to discuss it. The priest had problems with Long's ideas. He found the overall effect too busy, especially the tent flaps around the sacristy door. He thought *The Agony* too sleepy a scene. He especially didn't like *The Pentecost*. He thought the disciples and the women should be in one room, as the Bible stated they were. He found the rose petals, as he said later, "hokey." Asked for his reaction, Hastings replied that he was better at drawing than talking about his ideas, and he began to sketch with a pencil. He thought the entire composition was too low on the wall, that the altar and other liturgical furniture would obscure the congregation's view of the fresco as it sat through a service. He suggested raising the scenes with a bit of fictive architecture, a painted wall on the *Agony* and *Pentecost* sides. Like Father Haughey, Hastings did not care for the women being isolated. Hastings thought *The Pentecost* should express more of a sense of joy. The priest agreed heartily. Hastings drew the apostles spilling happily out of a house into the street.

In *The Agony*, Hastings drew Christ standing next to an olive tree. In *The Resurrection*, rather than depicting the risen Christ as a standing, godlike figure as Long had, Hastings used a scene from the Gospel of John describing Mary Magdalene's visit to the tomb. She sees the risen Lord but

at first mistakes him for a gardener. Hastings drew this tender moment.

Taken with Hastings's suggestions, Father Haughey asked him to mail his sketch to Long. Hastings worked up a more finished drawing and sent it. Long viewed the architect's sketch as an intrusion on his turf and a questioning of his skills. Angry, he recorded his response in a fresco journal kept in a unlined book covered with patterned red cloth. The date of the entry is November 22, 1987. "An extraordinary gesture on the part of the architect, Charles Hastings . . . an incredibly pedestrian reaction to my rough idea of the fresco—although, surprisingly, the idea from Hastings has ability, and a sense of composition, but as a sort of proscenium, a decorative backdrop, seemingly more representative of obscure Greek mythology—I must know more about what I am up against, then what I must actually do."

Chafing at the schedule, Long fired off a letter to his agents admonishing them to stand up for his point of view and saying flatly, "There can be no deadlines." The agents, he wrote, must do a better job of explaining the complicated technique of fresco to the priests. "What I said, and will say again, is that a fresco can last as long as the wall, if it is prepared properly, so why rush work that can be made finer with time?" He asked again why he had not received, as requested, precise measurements of the wall in meters. He peppered the agents with questions about what was being done to prepare the wall and the lime pit.

Feeling pressured, and unsure of how his ideas were being received in Charlotte, Long nonetheless adopted some of Hastings's suggestions. In a new drawing, he raised the fresco higher on the altar wall by using the fictive architecture, dropped the tentlike element around the sacristy door, and eliminated the isolation of the women in *The Pentecost*, along with the rose petals. To better balance the composition, he moved the staircase from the left to the right side of *The Pentecost*. He made no changes on *The Agony* and *The Resurrection*, feeling in his gut he had those scenes right.

He was in a better frame of mind when he wrote Hastings from Paris about his continued wrestling with the composition: "We have been talking about some new ideas for the *Pentecost* side—mainly in the top half,

which we will share with you when we see you. Basically, the compositional struggle is with flow; the liturgical confines allow little space for even artistic license, but we have few options. . . . Fortunately, we have some time before we tackle that side—we may all be feverishly rattling different tongues by then."

In December, Long and Father Haughey discussed subject matter face to face when, on his way to Budapest on church business, the priest stopped in Paris. Long lived on the fifth floor of an apartment in Montmartre, quite a climb. On the third-floor landing was a chair where the two elderly women who lived on the sixth floor stopped to rest. Long, whose joy it was to walk the streets of Paris and especially hilly Montmartre, handled the five flights with ease.

Over the past few months, between his sessions teaching drawing to the college students, he had worked late hours in his living room, books spread on the floor, researching and writing in his journal, chiefly about *The Pentecost*. In the same room, he spread out sketches of his ideas on the fresco for Father Haughey. He discussed his compositional problem of fitting *The Pentecost* into his scheme, how putting the disciples in one room would leave a blank space on the upper part of the wall and hamper his effort to tie the three scenes together. Father Haughey talked about his view of the Pentecost, of the joy it represented, and about his discomfort with Long's idea of isolating the two women. Disagreements remained. The priest told Charles Hastings when he got back to Charlotte that he thought Long still did not understand the Catholic conception of the Pentecost. But the two had moved toward each other and were able in the meeting to patch over their differences.

Long wrote about the encounter, and his estimate of the priest, in a journal entry dated December 14, 1987:

> Met Father Haughey at the airport and marched the poor man from Gare du Nord to my home through cold rainy crowded streets and up the steps to Sacre Coeur and up the five flights to the apartment—a healthy walk before lunch—we talked about our two different ap-

proaches to this fresco, his liturgic; mine aesthetic, and I think I was able to come up with some happy changes that satisfied him without compromising my feeling for the work. Father Haughey is a gentle man with a fine sensitive intelligence; his short visit has definitely rekindled my enthusiasm and has sharpened my interest in a subject matter that so obviously holds a profound meaning beyond my expression—something that I want so badly to understand.

Long began to feel excited about facing the wall. Father McCreesh sent him a card: "Ben, let's make something beautiful for Christ." Long tucked it into his journal.

Another journal entry in late December, after he and Cary Lawrence had gone to Venice for Christmas, mentioned the painter Long loved best of all and his hope for the fresco: "Titian and Titian and more Titian! The incredible paintings in the Frari—and the very sad over-cleaned Pentecost in the Salute—How I want to approach my work with such a wonderful *clean* power—pure, simple paint to pull the spirit right out of the viewer and send him heady back into the everyday!"

———

While Long and his agents met with the priests in the rectory parlor, Chuck Kapsner, who had also flown to Charlotte, went with Charles Hastings to look at the work of a plasterer named Hoyle Brawley. Joining them was Charles Carmichael, the contractor for the church renovations. A small man with bright eyes, a lifelong Catholic, Carmichael, after years with the Federal Aviation Administration as an air-traffic controller, had a second career. He was one of several people who, drawn by the enthusiasm surrounding the fresco, contributed more than called upon. A few years earlier, while looking for someone to stucco a house he had built for his daughter, Carmichael had discovered Brawley and realized his talent went far beyond such a simple job. Kapsner, Hastings, and Carmichael went to a restored historic bank building in which Brawley had done the ornamental plasterwork. Kapsner realized immediately they had found a crucial member of the team.

Since the spring, Kapsner and Hastings had exchanged letters on technical matters, in particular the need to put in a lime pit. Few steps in the fresco process are as important as preparing the lime plaster, the "white" endlessly ground by the fresco crew. The best lime plaster is aged for at least a year, six months at a minimum.

The process that takes place in the pit is called slaking, virtually forgotten in the building trades with the advent of plasterboard and ready-mixed plaster. The process begins with quicklime, sometimes called "hot lime," prepared by heating carbonate of lime: chalk, limestone, or marble. This calcium oxide is slaked, combined with water to form calcium hydrate. Mixed well and aged, the resulting plaster putty will spread like butter. Any particle not thoroughly slaked will absorb water and crack the plaster. Slaking is a simple process but a dangerous one. It is exothermic, meaning that it produces great amounts of heat. Lime pits can explode.

Brawley understood the danger. Now in his seventies, he had followed his grandfather and his uncles into the trade. Tending a lime pit as a teenager, he had developed a healthy respect for the caustic quality of slaked lime. Some of the old plasterers he knew, having been hit by a speck of exploding lime, were blind in one eye. Many of them kept a bottle of borax water on the job to flush out their eyes in case of an accident. Greatly skilled, a crusty character, Brawley was the kind of craftsman for whom Long had immense respect and affection, a feeling shared by the other members of the fresco crew. To them, he was always "Mr. Brawley."

On a Saturday in October, Brawley and Carmichael got together to put in a lime pit, which meant the lime would be aged only three or four months when the fresco began. Long, typically, wanted a true pit dug into the ground. Finding that impractical, Carmichael used the bases from two 2,500-gallon concrete septic tanks, lined them with two inches of Styrofoam insulation so the plaster wouldn't freeze and be spoiled, constructed wooden covers for them, and set these improvised vats in a narrow alley next to the rectory.

Wearing goggles and protective clothing, Brawley used a plastic container about three feet high and eighteen inches across, tapering at the top.

Into it, he poured distilled water and then half of a fifty-pound bag of powdered lime. Within seconds, the mixture went from air temperature to over two hundred degrees. The container shook and rumbled—boom, boom, boom. A plume of steam rose toward the church steeple. When the lime cooled, Brawley stirred it and emptied it into a vat before starting the process again.

It was hot, hard work. Sweat gathered under Brawley's protective clothing, covering his arms. Some of the powdered lime worked its way under his sleeve, and the same chemical reaction taking place in the container took place on the inside of his right wrist. Looking at the old man, Carmichael winced as he imagined the pain. But Brawley, who would be left with a white, patchlike scar, another souvenir of a long life of hard labor, said not a word.

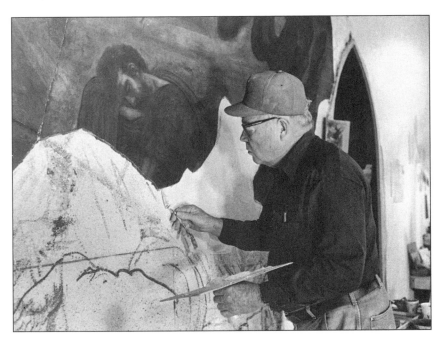

Hoyle Brawley could tell by the sound of his trowel when the plaster began to firm up.

MARK B. SLUDER

CHAPTER FOUR

The Ecstasy
in *The Agony*

The painting of the first part of the St. Peter's fresco, *The Agony in the Garden*, began with a crisis. On a Wednesday morning in mid-February, a chunk of plaster about the size and shape of a flattened football fell off the wall. Chuck Kapsner, doing color tests to the left of the sacristy door, lightly brushed the wall, and bits of plaster clattered to his feet. He was astonished. So was Ben Long.

The two had arrived from Paris four days earlier to begin the work: a matter of purchasing supplies, erecting the scaffolding, unrolling drawings and cartoons, and preparing brushes and bags of powdered pigment. As they waited for the other members of the crew to arrive in Charlotte, Long

PHOTOGRAPH BY MARK B. SLUDER

and Kapsner worked steadily toward Saturday, when they planned to put the first color on the wall. They were together on a fresco for the first time since *The Last Supper* in Glendale Springs eight years before, and had spent a month in Paris on final preparations. Standing next to the wall, with a renewed sense of its immensity, they hoped the twenty-seven-day schedule they'd drawn up in Paris would be sufficient. They knew the other crew members had never worked together, had never done a fresco. Much would depend on how quickly and how well they came together as a team. The wall, bare and white, pulled at Long and Kapsner; feeling, as Kapsner later put it, "hyped to the max," they were anxious to start. Now, it looked as if the fresco might end before it began.

The problem with the wall, Long thought, was what had concerned him for months: the plaster was too young and wasn't adhering properly. He planned to hose down the wall as part of the preparations before starting to paint. Do that now, he feared, and the water might blow off the plaster right down to the bricks. He had to get out of the church, to consider the options. He and Kapsner took a long, directionless walk.

The wall had been covered with plaster only a few months before. A layer of Structolite, a commercial plaster mix, had been put on, serving as the scratch, or base, coat. Another layer, the "arriccio"—made of one part lime to two parts sand—had been put over that. It was a piece of the arriccio that had fallen off.

If this layer were weak, Long realized, he had an unstable foundation for his fresco. The final layer, the "intonaco"—made of one part lime to one part sand—would go over the arriccio. But if the arriccio had not bonded to the wall, it might loosen and fall, taking the intonaco—and the painting—with it. Weeks of work might come crashing to the floor. Given that possibility, who, then, should take responsibility for the project going forward? Long? The church? Or should the possibly unstable arriccio be taken down and the wall be replastered? How would the delay affect the other crew members, due to arrive soon? Long and Kapsner walked for more than an hour through an unfamiliar industrial area southwest of downtown. They would have to talk all this over with Father Haughey and,

most important, get in touch with Hoyle Brawley.

The plasterer came to the church later that day. He was, as always, imperturbable. He looked at the wall, scraped off a few flakes of plaster with his finger, shifted the chew of tobacco tucked in his cheek. The hole was nothing to worry about. The plaster could be patched. As the arriccio dried, it would get stronger. The work could begin. The sigh of relief—from Father Haughey and Long—was palpable.

Later that afternoon, Long, standing near the sacristy door, related his conversation with Brawley to architect Charles Hastings and contractor Charles Carmichael.

"I just wanted someone who really knew how to handle it tell me about it," Long said. "I wouldn't want to find this hole here and be the one responsible for approaching the wall with the next layer of lime.

"He [Brawley] came in and said, 'Oh yeah, don't worry. Yeah, it's a problem, it shouldn't be like this, but that's because the lime's too young.'

"I said, 'Will it hold?'

"And he said, 'Yeah, it'll hold. This other lime's older. It'll bond right away with this wall, and it'll hold. It'll take about two years to dry thoroughly, and then you just don't worry about it.'

"I said, 'That's what I want to hear.'"

Said Hastings, "It was a bad four hours."

"A real bad four hours," Long agreed.

Now that the crisis had passed, the artist could laugh, recalling for Hastings and Carmichael the stolid demeanor with which Brawley delivered the good news. An excellent mimic, Long dropped his voice and his chin in an affectionate imitation of the plasterer. "And the way he did it was with that kind of weird look," said Long, breaking into a hundred-watt smile.

———

After his December meeting in Paris with Father Haughey, Ben Long had been busy. Besides teaching the Meredith College students, he did charcoal and pencil studies and drawings of each figure in *The Agony*. The face of Christ came from his imagination, but he used a model to strike the

pose of the doomed Savior on the hill in Gethsemane, on his knees with his fists pressed to the ground. To model Peter, who would appear prominently on the *Pentecost* side, Long used a friend from the south of France, Clive Kesterton, an English architect. Another friend from the same area, André Manin, the model for John the Baptist in one of Long's Italian frescoes, would also appear as a disciple. Other models were aspiring actors from the Ecole Jacques Le Coq, where Cary Lawrence, Long's companion, studied. Later, Long used Curtis Gaston, son of one of his agents, to model yet another disciple.

In early January, Chuck Kapsner flew to Paris for an intense three weeks of work. He and Long enlarged the preparatory studies to cartoons, making the figures the size they would be on the wall. Kapsner did tracings, laying a translucent plastic sheet over each cartoon and tracing the lines with a pencil. Using a large needle, he punched holes less than an inch apart along the lines. These "pounce holes" would be useful when transferring the cartoons to the wall. When it came time to leave Paris, the studies and drawings were packed in portfolios and the cartoons and tracings rolled into tubes. The building blocks of the fresco were assembled and ready.

After returning from a trip to his home in Pougnadoresse on February 9, Long made an entry in his journal:

> The days have caught up with me and have by-passed this account. Many things have happened rapidly. Chuck has been here nearly a month and work stepped into high gear. Roughly 2,000 francs [about $500] have gone into the final modeling sessions, then from that point all the drawings have been worked up to size. Chuck has traced and pounced them. . . . We took a trip to Pougnadoresse for a long weekend, after sending Angus off to ski on 5 Feb., to draw Clive and André as two disciples. . . .
>
> The final color studies are being done now; I want it to be simpler still, but time is now running short, so I may have to leave with this on my mind, and clear it up when I am there—but the feeling is close. Angus returns the day I leave; I long to see him. And say good-bye.

The two friends worked until their departure. Arriving in New York on February 13, Long made another entry:

> We seem to be ready. Yesterday we had time to further detail working cartoons of the tree stump and trunk, which can only make it easier later. I also managed to do a detailed drawing for the robe next to the door, another thing I thought to handle alla prima [directly on the wall], referring only to the small scale drawing. . . .
>
> Cary and Angus saw us off, Angus flush, tired, and, I think, quite happy about his future schooling in America. I do hope I can finally make him happy.

Another week of preparation in Charlotte stood between Long and the wall. As he and Kapsner worked, joined by crew member Anthony Panzera, the area around the altar of St. Peter's began to resemble a Renaissance workshop. The scaffolding was metal, not wood. The pigments were kept in plastic margarine and whipped-cream containers, not clay pots. Otherwise, it was much the same. Ghirlandaio, a fresco painter and Michelangelo's teacher, would have recognized immediately the assembled equipment and materials and understood their purposes.

Tables with frosted glass taped to their surfaces were ready for grinding lime. Another, larger table was for grinding pigments. Cartoons taped to sheets of plywood were set up where Long could see them from the scaffold. Squares of plywood and plastic protected the altar floor. Coffee cans held brushes of different sizes and shapes. For Long, each of the painter's tools was a talisman. Like a dairy farmer naming his cows, he could identify each brush: where he'd bought it, how much he'd paid for it, whether he'd made it himself.

Behind the workspace, the wall had been covered with a grid of red lines, a checkerboard of 2-foot squares. They corresponded to the 1½-inch squares on the cartoon of the entire *Agony*. Using the grid and the cartoon as a guide, Long transferred an outline of the fresco to the wall. While Kapsner held a tracing of one of the figures in place, Long pounced it, tapping it with a gauze bag filled with a powdered red pigment called

"sinopia" by the Italians for Sinope, the city in Asia Minor it came from—thus, the underdrawing of a fresco also is called the sinopia. The red powder passed through the pounce holes, leaving a series of dots on the wall, called "spolveri." Long connected the dots, holding a dripping bowl of sinopia mixed with water.

The rudimentary scene appeared on the wall: at the top, the night sky, Jesus, and the hill; to the left, Judas, the Pharisees, and the Roman soldiers; to the right, an olive tree, the stump of an oak with a single branch; at the bottom, the sleeping disciples. With the sinopia up, Long could see the correctness of his studio calculations. All the elements fit where they were supposed to.

The work toward putting on the color got a boost when the crew members arrived. They pitched in, doing whatever needed to be done. The organization of their efforts was casual, even haphazard. The crew members had no particular assignments at first because they were not chosen with particular skills in mind. Mostly, they were there because they knew Ben Long and wanted to take advantage of this rare opportunity to learn the technique of fresco. They were willing to work for free, to put aside their own work, even to dig into their pockets for the necessary means to travel long distances and support themselves. They were the functional equivalents of the apprentices who once worked under masters, as Michelangelo worked under Ghirlandaio, learning the skills that would later flower in the Sistine. Without them, the fresco could not have been done.

Anthony Panzera, Joshua Rosen, Laura Buxton, and Roger Nelson shared a love of traditional art and a connection with Florence, the center of the Renaissance, and with that epoch whose ideals and heroes remained for them a lively presence. They saw Modernism, to say nothing of the latest outpourings of contemporary art, as a dead branch on the tree of art. They put the figure at the center of what they did and believed in the importance of drawing. Technical matters engaged their interest and respect. They were on the fringe of an art world with little sympathy for them—or for Long and Kapsner—and they knew it. For some in Charlotte's small art community, the St. Peter's project was a joke. A fresco, a religious painting?

All that had been done. If Michelangelo were alive, they felt, he would be using lasers or some other cutting-edge technology to create his Sistine ceiling.

Long and Kapsner had begun discussing possible crew members in the spring of 1987. They did not want to repeat the experience in Glendale Springs, when twenty-three crew members had shown up, an organizational nightmare. They wanted a crew both lean and competent. Long mentioned Panzera, forty-six, whom he'd met in Florence in 1975 when Panzera was on leave from his teaching position at Hunter College in New York. He sounded experienced and level-headed to Kapsner.

Long had known Rosen for only a short time but liked him. Dissatisfied with art classes at the University of San Diego, the young Californian whose father was a psychiatrist had come to Florence in 1986 in search of a teacher acquainted with the Old Master technique he so admired. For a time, he studied at the Studio Cecil-Graves, begun by two expatriate American artists, Charles Cecil and Daniel Graves. He heard of Long by reputation and attached himself to him, traveling with him to the south of France and later to Paris. Kapsner, who had met Rosen briefly, had doubts about him and shared them with Long. While he liked Rosen, he felt a certain lack of seriousness in the young artist, a hurriedness to move ahead before basic skills were mastered. Kapsner felt Rosen was more interested in what he could get from the fresco than in what he could give it. But Long had taken Rosen under his wing, and the twenty-three-year-old was in.

Rosen stepped off the plane in Charlotte with a prize. Long needed olive branches to draw the olive tree in *The Agony*. Rosen and a high-school buddy, armed with shears and a saw, had appropriated some on a night mission to a suburban lawn near his parents' home in San Raphael.

Laura Buxton, twenty-six, had studied in the early eighties at the Studio Simi in Florence, a school Chuck Kapsner also had attended, run by Signorina Norina Simi along the strict lines of the French academic tradition. Buxton later studied with Long and, for a time, cared for his son Angus in the south of France while doing her own work. A Britisher who considered herself a Scot, she'd left her home in Edinburgh to spend what

turned out to be an unsatisfactory year in an art school in London. At eighteen, she'd left for Florence. She lived for a time with a *contessa* who rented rooms to young English girls, then decided to save money by sharing a flat with two young Israeli men.

Buxton had been interested in fresco since Florence. She had heard about Glendale Springs but would join the St. Peter's crew only if there was plenty to do and if the work was hard. "Are you sure there's going to be anything for me to do if I come over? Because I'm not going to sit around and watch everyone work," she told Long. He said there would be enough to do, although he wasn't especially encouraging. Buxton felt it didn't matter much to him whether she came or not. As it turned out, she was one of the team's hardest workers.

Roger Nelson, thirty-eight, a Minnesotan, had planned to study in Florence but instead took the money he'd saved and bought a house on the side of a mountain near Blowing Rock, North Carolina. His Florence connection was his study at the Atelier Lack in Minneapolis, run by Richard Lack. There, he met Daniel Graves. Both Lack and Graves had been part of the English-speaking expatriate artists' group in Florence that included Long and Kapsner. Nelson found out about the St. Peter's fresco through a newspaper article and called Long in Paris. Long passed the telephone to Chuck Kapsner. Nelson had met him years before in Minnesota but had no idea he was in on the project. Laughing over the coincidence, they became reacquainted. With his shoulder-length hair, Nelson looked like an aging hippie. His quick wit was much appreciated in the later stages of the project, when he became more of a presence.

With Panzera, Rosen, and Buxton helping Long and Kapsner, the five were ready to put the color on by Saturday. A fresco is painted from the top down. Keeping the wet working surface below the finished dry surface prevents the frequent dribbles and runs of paint from marring the completed work. So, brimming with excitement, they began with the blue sky at the top of the wall, starting at seven-thirty Saturday morning and finishing at three-thirty Sunday morning, working straight through with only two meal breaks.

They used a good deal of the two and a half pounds of cerulean blue, the $150 worth of pigment Kapsner had bought for the undercoat and the sky in *The Agony*. It had been ground and mixed into a ropy pile of goop that looked like blue mud. They made it in two shades, light sky and dark sky. Somehow during that first frantic and fantastic day and night, with the music blaring and the crew scampering up and down the scaffold, Long inadvertently was handed the wrong bowl and painted two rectangular patches on the right side of the *Agony* wall with the darker blue instead of the lighter blue. Those spots bedeviled him through the retouching the following summer.

Anthony Panzera led a good life. He knew it and was grateful for it, although before he arrived in Charlotte there was something missing, an experience he'd sought for twenty years. He wanted to work on a fresco. Yet when the opportunity came, the decision to take it proved difficult.

Born in Brooklyn, he lived with his family in a white house on the main street of Mendham, a suburban New Jersey town whose quiet streets Panzera jogged most mornings. Two mornings a week, Panzera drove into Manhattan to Hunter College, where he taught drawing. The schedule left ample time to paint and draw in a studio he'd built over the garage.

Before building the studio in Mendham, Panzera had for years maintained one on Twenty-ninth Street in Manhattan. A life-drawing group, common in the city in the eighties but rare in the seventies, met there on Thursday nights. When Panzera ran across a model he liked, he'd hire her to pose for his own work. In 1979, he found through an agency a young, dark-haired woman named Madonna Ciccone. Working with her for over a year, he learned she had studied at the University of Michigan but had abandoned her hopes of being a dancer to pursue a music career. Most nights, she rehearsed or performed with a rock band. Her dedication impressed Panzera, who paid her seven dollars an hour and did drawings of her as the five sibyls from Michelangelo's Sistine ceiling, along with a nude painting titled *Madonna of the Bittersweet*, a play on her name. Later, after her music career clicked, she became know as, simply, Madonna.

Among the several models he'd used, Panzera found her one of the good ones. "There's a way they can sort of get lost within themselves so that you can find a way into them," he said. "They allow themselves to become absorbed by you. She had that quality."

Panzera grew up loving to draw. One of his grade-school teachers in Brooklyn kept a row of easels in the back of the room and let him spend more time there than anyone else. Proud of his ability, his mother encouraged him, brought home books on Rembrandt and other artists. When he was ten years old, she bought him his first oil-paint set. Perhaps because of her support, "Buddy," or "Bud," as friends and family called him, had a balanced and calm character. It would enable him to play a crucial role when the fresco project hung in the balance during the painting of *The Resurrection*, when a compromise between Long and Father Haughey was much required. Panzera also was steady, never in a hurry, rarely out of sorts, soft-spoken, not the type to put himself forward. He had soft hands, had a bushy corona of black hair surrounding a growing bald spot on top, and, for close work, wore a pair of half-glasses perched on the tip of his nose.

He studied art at the State University of New York at New Paltz and got a master's degree at Southern Illinois University in Carbondale. In the 1960s, few members of the art faculty at New Paltz or Southern Illinois— or at any college or university in the country—had much sympathy for the kind of figurative art Panzera wanted to do. The reigning ideology was abstraction, and its supporters saw little need for the system of training that had nurtured artists for centuries—including the first generation of Abstract Expressionists. One of his teachers had studied with Mondrian and was, Panzera remembered, a superb colorist. But he could teach Panzera nothing about how to draw the figure. At New Paltz, Panzera found a few like-minded students in the art department, and they supported and encouraged one another.

Out of college in 1963 and married, Panzera taught art in the public schools. He also conceived a powerful desire to go to Italy. Partly, it sprang

*Long's profile portrait of a sleeping apostle
in a green robe is one of the most beautiful in* The Agony.

MARK B. SLUDER

from his heritage. His family had come from Molise, a province between Naples and Rome. More than that, he wanted to experience the wellspring of the kind of art that so interested him. Soon, that desire was joined by another.

In 1968, an unusual art exhibit came to New York. In recognition of American contributions to the rescue of Italian art after the devastating flood in Florence in 1966, the Italian government sent to the Metropolitan Museum of Art "The Great Age of Fresco: Giotto to Pontormo." The exhibition featured seventy frescoes and some sinopia drawings on plaster by Giotto, Piero della Francesca, Fra Angelico, Paolo Ucello, Andrea del Sarto, and Jocopo Pontormo. A gathering of such work outside Italy was unheard of. Frescoes did not travel. If people wanted to see the great mural paintings from the early to the late Renaissance, they had to go to Italy.

But the flooding waters of the Arno had been especially damaging to frescoes. In the aftermath, Italian restorers perfected their preservation techniques. They applied a water-soluble glue to the surface of the fresco and to that a layer of cloth. By gently pulling on the cloth, they separated the fresco from its supporting wall, peeling the intonaco with the painting from the arriccio. Using the same method, they removed the sinopia, the underpainting on the arriccio, from the base coat of plaster. In New York, visitors could see a gem such as Piero della Francesca's portrait of St. Guiliano, depicted with a red cloak, blond curls, and noble expression worthy of a Roman portrait bust. They also could see how freely another artist had painted the sinopia, believing it would never be seen again, or how that artist had changed the original concept after the intonaco was put on the wall.

Panzera was taken not just with the luminous colors and the obviously high level of technique. He caught a glimpse of something more in the work of Ambrogio Lorenzetti and Andrea del Castagno, of art made not in the studio for a museum but for those spaces where people lived, worked, and worshiped. Frescoes, he thought, were "part of the order of life."

Frustrated after years of unsuccessful grant attempts and failed schemes, Anthony and his wife, Marie, held a conference in 1975 and decided to

borrow the money from her father and take their children and go. Who knew if anyone still painted frescoes, even knew how? But at least Panzera could see them in the spaces they were created for. Heady with excitement, he combed Florence for the frescoes he'd read and dreamed about. He'd already decided to focus his year on drawing, so he arranged to spend one morning a week at the Gabineto dei Disegni e della Stampe at the Uffizi, where he could study facsimiles of drawings by Raphael and Michelangelo. Wanting to get involved in a drawing group, he asked around and met an English artist named Patrick Hamilton, who generously shared with him a studio near the Piazza Santa Croce. Hamilton previously had shared the studio with a young American artist, Ben Long.

The English-speaking artists in Florence, a fairly small group that frequented the same cafes and bars, eventually ran into each other. In December, Panzera met Long at a party. After the holidays, he followed up Long's invitation to visit his studio on Via Degli Artisti. They began to share drawing sessions. "He created this sense of a very confident, very capable man," Panzera remembered. "He was never above giving you a compliment. I was impressed with that kind of generosity. He drew me to him."

After his year in Italy, Panzera arranged a program for Hunter students to study abroad so he could get back to Florence each summer. He got to know Long better, and when he learned Long did frescoes, he expressed his desire to work on one. The invitation came by postcard in late 1987. Panzera's initial excitement clouded when he realized what his involvement would demand. He would have to pay his own way, flying to Charlotte on Friday morning and back to New York on Tuesday evening to teach his Wednesday and Thursday classes at Hunter. At $158 a trip, the cost would be $632 for four weeks, no small sum for a college professor. He would have to leave Marie alone for most of the week at a sensitive and difficult time. Their youngest, Guido, had just left for college, and their oldest, Lisa, was already gone from the house.

A close couple, they had the kind of soul-searching conversation they'd had before deciding to borrow the money for the Italy trip. Panzera was

torn, and it hurt. He wanted to go, yet he felt guilty, selfish. Marie, feeling
abandoned, wondered what he would get out of going to Charlotte. His
burning desire to do a fresco won out. But the pain of their disagreement
continued. During the painting of *The Agony*, Panzera confided in his
journal, "More conflict, more disagreement, more questions about my
judgment. My initial response is anger and frustration at her inability to
understand how strongly I feel about doing this, how much I will
gain from the experience. But immediately after, I ask myself why should
she say such things to break my confidence? Self-serving questions."

As he began work on the fresco, Panzera had other emotions to deal
with. He was an experienced artist, the oldest member of the fresco crew,
yet he wasn't sure what he could contribute to the project. There also was
the jostling of egos common to artists or any group of people getting to
know each other. One day, he mentioned he used paint in tubes. Josh
Rosen turned up his nose, sniffed that he ground his own pigments. What?
thought Panzera. He's been painting for only two years and I have for
twenty. Panzera did not have as strong an ego as many artists, but he
realized he would have to swallow what ego he had to blend in and do
whatever needed to be done.

Early on, the project was disorganized, and that also troubled an artist
who kept a neat-as-a-pin studio. There was a lot of jockeying to see who
could get closest to Ben Long. It seemed all the crew members wanted to
tailor their chores so they could spend as much time as possible watching
him paint. Rosen in particular seemed to spend all his time on the scaffold.
Panzera wanted to watch Long and learn, too. Seeking a more equitable
arrangement, he suggested to Chuck Kapsner a system of rotating chores
to enable each crew member to be at Long's side at least once every third
or fourth day. Early on, Panzera's stabilizing influence was felt.

———

Bud Panzera liked to get to the church early. Sometimes, he woke up
Josh Rosen, since both roomed with the same St. Peter's family, and took
him along. With the sound system off, the church was quiet. Glowing in
the soft morning light, the sanctuary seemed timeless, and Panzera felt,

amid the pots of lime and the towering scaffold, as if he'd been transported back to the Renaissance.

By getting there early, he could help Brawley. The plasterer was a lifelong early riser who invariably rose before dawn, ate breakfast, and read the Bible. By the time he parked his blue pickup behind St. Peter's after a forty-minute drive from his farm north of Charlotte, Brawley's cheek already bulged with a well-chewed lump of tobacco, and the plastic cup for spitting, on the seat next to him, was half full.

His job was to put up the plaster for the day's painting. Each night after Long and the crew finished, Kapsner, as chief assistant, made the day mark around the finished portion of the fresco, carefully cutting away excess plaster and painting the newly revealed edge with the blue undercoat color. He then outlined in sinopia the next day's giornata as a guide for the plasterer. With Panzera's assistance, Brawley hefted a bucket up the scaffold, scooped a generous pile of plaster on his float, and applied it to the wall with a trowel, using smooth, curving strokes. Brawley worked to make the joints between the new and old patches of plaster as fine as possible. The sound of the trowel told him when the plaster was setting up. It made a sharper ring.

By the end of February, the fresco was halfway down the wall, the night sky, the portrait of Christ, the hill of Gethsemane, and one group of sleeping disciples finished. With only one level of scaffolding still up, Long and the crew could get a fairly unobstructed view of the wall. They had been working a six-day schedule and would have worked Sundays if Father Haughey had allowed it. A result of their intensity showed around the altar area: the clutter of empty water containers and other refuse. In the morning, the marble altar itself, covered with canvas, might have an empty wine bottle or doughnut box from the night before. Rosen often got ready for the day's work by doing stretching exercises braced against the altar. He had stopped sitting on it, but the crew's seemingly casual attitude toward the church as a sacred space grated on the priests, Father Haughey especially, although he said nothing.

Laura Buxton's first task upon arrival was to clean and prepare

the palette, making sure the day's colors were ready. After pinning up her long, blond hair, she began grinding colors, crushing and mixing powdered pigments with a palette knife as long as a Roman sword, her hips rocking with the effort. Working steadily, she soon managed to get smudges of color on her hands, her cheeks—even her ears.

Buxton kept the color notes, the formulas for mixing "dark earth" (desert tan, burnt sienna, and yellow ocher) or "middle earth" (thalo green, yellow ocher, lime white, red oxide, and Indian red). Fresco requires a limited palette. Only colors that will not interact with the caustic lime can be used, restricting the choices to pigments derived from earth and mineral sources.

Since no one else could read Buxton's handwriting, she became de facto chief of color grinding, a proper job for someone so conscientious and efficient. As she worked, she listened to the morning sounds of St. Peter's, among them Father Gene's daily sermonette to Anthony Sexton, a homeless black man he'd taken under his wing. "Don't drink today, Anthony," was the priest's unfailing advice, offered with a mix of sternness and hope.

Long, driven by Kapsner, usually arrived about ten. He first changed clothes in the sacristy, leaving his scent in the air. It was his custom to put patchouli, a fragrance made from the oil of an East Indian plant, on his beard each morning. The sweet smell, mingled with the sacristy's smell of candles, lingered for hours. Long might begin painting immediately or, depending on the size of the giornata, might have to wait until the plaster was ready. It had to be wet—damp, really—but standing firm. With the same feel for plaster a potter has for clay, he would press his hand to the wall to see if it was ready. The plaster, he knew, dictated the pace of the work. It couldn't be hurried.

On this day, Long worked on two figures on the left side of the fresco. One was in full profile, the other in half. The first profile was an especially beautiful portrait, a beardless young man in a green robe, sound asleep, his lips gently parted and his hands folded. After doing the portrait, Long decorated the robe with a bit of bravura painting, making flowing red

stripes that looked like ribbons of Christmas candy.

A drawing of the two figures stood nearby, tacked to a sheet of plywood. Kapsner held the plastic tracing made from the cartoon over the fresh plaster, and Long tapped the pouncing bag filled with sinopia to make dots on the wall. Bits of the crushed pigment slid down the plastic and collected in the curve at the bottom. In less than a minute, Long's hands were red.

Long began painting by applying a base coat, or "compittura," using the dark blue color to cover the white of the plaster. Then, using a small sponge, he dabbed on flesh tones, working from darker areas such as the eyes and cheekbones toward the lighter areas of the face. With a small brush, Long began to model the figure, using short hatching strokes. Working patiently, he seemed to slowly breathe life into the sleeping man.

Face to face with the wall, Long was a sure and articulate painter. He held his sinopia-stained right hand behind his back and tilted his head to one side. He looked almost jaunty as he made his eloquent brush strokes with his left hand. Panzera loved to watch him, recognizing Long had all the skills to meet the special challenges of fresco. He worked quickly and with assurance, making very few mistakes. The object of the buon fresco technique is to avoid having to retouch with secco—painting with a binder such as egg tempera on dry plaster. Long had the kind of confidence to work on that level. Not only Panzera but Buxton and Rosen felt a growing admiration for Long through *The Agony*, as they for the first time saw him do fresco and watched him put in hour after hour on the wall.

Long embodied what the great art historian Giorgio Vasari said of fresco and what it takes to create one. Briefly a student of Michelangelo, a fresco painter and architect, designer of Michelangelo's tomb in Santa Croce, Vasari published his seminal *Lives of the Most Eminent Painters, Sculptors and Architects* in 1550. In the section on technique, he accurately described the challenge of fresco. "Of all the methods that painters employ, painting on the wall is the most masterly and beautiful, because it consists in doing in a single day that which, in the other methods, may be retouched day after day, over the work already done," he wrote.

"Fresco was much used among the ancients," Vasari continued,

and the older masters among the moderns have continued to employ it. It is worked on the plaster while it is fresh and must not be left till the day's portion is finished. . . . There is needed also a hand that is dexterous, resolute and rapid, but most of all a sound and perfect judgement; because while the wall is wet the colours show up in one fashion, and afterwards when dry they are no longer the same. Therefore in these works done in fresco it is necessary that the judgement of the painter should play a more important part than his drawing, and that he should have for his guide the very greatest experience, it being supremely difficult to bring fresco work to perfection. Many of our artists excel in the other kinds of work, that is, in oil or in tempera, but in this do not succeed, fresco being truly the most manly, most certain, most resolute and durable of all the other methods, and as time goes on it continually acquires infinitely more beauty and harmony than do the others.

Long sometimes lost himself in the wall, unaware of anyone or anything except the act of painting. "There's a moment when things start working, and when they do, God, it's a joy, it's a wonderful feeling," he said. "You lose yourself somehow." Only when he stopped would he realize how tired he was, or feel the pain in his shoulders and back.

On the altar table was Long's well-thumbed copy of Cennino Cennini's *Il Libro dell'Arte—The Craftsman's Handbook*. Written around 1400, it is one of the oldest handbooks on artistic practices and outlines everything on fresco painting from mixing colors to making brushes. Cennini also instructed his fellow artists in proper behavior, under the heading "How You Should Regulate Your Life In The Interests Of Decorum And The Condition Of Your Hand":

> Your life should always be arranged just as if you were studying theology, or philosophy, or other theories, that is to say, eating and drinking moderately, at least twice a day, electing digestible and wholesome dishes, and light wines; saving and sparing your hand, preserving it from such strains as heaving stones, crowbar, and many

other things which are bad for your hand, from giving them a chance to weary it. There is another cause which, if you indulge it, can make your hand so unsteady that it will waver more, and flutter far more, than leaves do in the wind, and this is indulging too much in the company of women.

At least on this, Cennini was wrong. Long indulged, but his hand was steady. On how to paint a fresco, Cennini was on firmer ground, and Long followed his suggestions, combined with what years of experience had taught him. As Cennini recommended, Long used at least three and sometimes as many as five different shades of a color: light flesh, middle flesh, and dark flesh. He worked off the middle shade, using the others to blend, always keeping in mind that fresco dries lighter than it appears initially on the wall.

While the artist painted, crew members labored, doing a less exalted but vital job—grinding white. Long brought to Charlotte a jar of what Cennini referred to as "Bianco Sangiovanni"—"The White of St. John"—lime that had been specially aged. This sample, made for restoring frescoes in the Vatican, was fourteen years old. The lime Brawley had slaked was only a few months old. But it had to be ground to the same creamy consistency so it could be used on the wall, following Cennini's guidelines.

The crew members shaped hamburger-sized patties of lime and put them on a board on the back steps of the church to dry in the sun. When hard, the patties were broken into small chunks, sprinkled with distilled water, and ground. Then this lime putty was dampened and ground again—and again, if necessary—until even the smallest lumps were gone. If any lumps got on the wall, they would absorb water, blister, and deteriorate the fresco.

Josh Rosen, wearing a blue bandanna to hold back his long hair, spread a spot of the chalky lime paste the size of a quarter on the grinding glass and wet it with a few drops of distilled water from a Chihuahua Beer bottle. He worked for about fifteen seconds, making brisk figure-eight strokes with a muller, a granite implement that looks like a fat pestle. Sometimes, Rosen

ground for an hour at a time: about 240 spots. In spite of the constant rock tunes blasting through the church's sound system, it was the rasp of the muller, like the sound of a snow shovel scraping a sidewalk, that was the true music of the fresco.

The finished white looked like whipped cream. But it was caustic, and handling it could be painful. When mixing the lime putty with a palette knife, a worker might scrape his knuckles. Then the lime would burn his bruised skin. Bud Panzera taped his fingers for protection. Fresco is labor-intensive. And the work is monotonous. Perhaps one reason fresco declined was the lack of apprentices willing to exchange drudgery for knowledge.

Rosen enjoyed needling Long and Kapsner, who did not grind white, letting them know how hard he worked. He whistled "The Volga Boatman," a familiar accompaniment to hard work. Rosen liked to tease. From the grinding table, he called to Laura Buxton as she left the church for an errand, "Bianco San Giovanni ti aspetta"—"The White of St. John is waiting for you."

"She's afraid of developing arms like a gorilla," he added with a grin.

Shortly before noon, the music was turned off and recorded hymns were played through speakers in the church's steeple, calling Catholics working downtown to mass. Father Haughey came to the tabernacle on the altar, knelt, and removed the consecrated Host to take downstairs. Panzera often attended the service, held in the basement parish hall while the fresco was being painted, a fact noticed and appreciated by the priests. Religion was more important to him than the others, and so the project had for him a special dimension. A successful painting, he hoped, would enrich the spiritual lives of the people who would see it for years to come.

The crew sometimes took lunch in the parish-hall kitchen, with food brought by church members. This day, the crew went out for an introduction to Southern cooking at the Coffee Cup, a funky black restaurant in an industrial area near downtown, where office workers and laborers, both black and white, gathered daily in happy communion over a menu featuring collard greens and pigs' feet.

"What's cornbread?" Panzera asked, and the culinary gap between North and South yawned widely.

Long, whose years abroad had not cost him a love of home cooking, ordered fried chicken and okra.

Buxton's questions made an impatient black waitress cock her hip.

"Is it possible to have brown meat?"

"I'll have pinto beans, whatever they are."

"Is the lemonade from a can?"

"No, honey, we squeezes it," replied the waitress, twisting her hands together as if wringing water from a dripping mop.

The afternoon was a long stretch of painting and grinding, followed by the cleanup. Most nights, the group went to dinner together. Long loved to preside at a table, with his crew gathered around him. He felt that since he wasn't paying his workers, the least he could do most nights was to treat them to a meal and a few bottles of wine. The dinners were an opportunity to talk about the progress of the work and let off steam. One night early on, at a Tex-Mex joint called Nickyo's Rodeo Restaurant and Saloon, Laura Buxton confessed she'd never heard of taking out uneaten food in a doggie bag. Long, who liked to pretend to believe her proper British accent was part of a stiff personality, had the waitress bring her one at the end of the meal. Written on it was "To Laura, the doggie-bag virgin."

Most nights, Long and the crew went back to the church and, sitting in a back pew and passing around yet another bottle of wine, evaluated what they'd done that day and discussed what needed to be done the next. Long especially liked these nocturnal sessions, when he felt the painting, out of his hands, took on a certain independence and gave him its own sense of where it was.

In the morning, after a few hours' sleep, the cycle started again.

The schedule was exhausting. Asked by a visitor one night how the crew was feeling, Kapsner said, "We're falling through our assholes." Yet the comment was offered with a kind of lighthearted pride. The work was new, and there was much to learn. The crew members' desire to do a good job for Long, and their admiration for his stamina, lifted their

spirits. Accustomed to working alone in a studio, they relished the camaraderie. Early on, they looked like students with their fountain pens and notebooks. After two weeks, they were paint-smudged workers. For now, the ego-jockeying was behind them. The personal differences that would nettle the crew on later portions of the project remained beneath the surface.

The work was as hard as Buxton had hoped—harder. Yet *The Agony* was filled with a kind of ecstasy of intensity and accomplishment. Likely, the entire crew would have agreed with Buxton's assessment: "It was perhaps the happiest six weeks I ever lived."

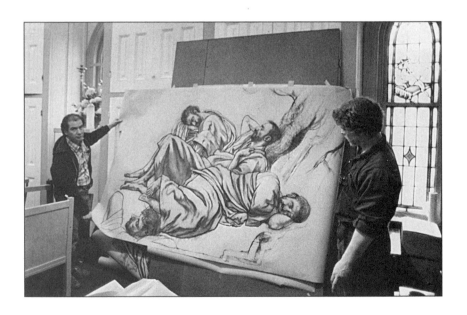

Anthony Panzera and Ben Long unroll a cartoon for
The Agony *in the St. Peter's sacristy.*

MARK B. SLUDER

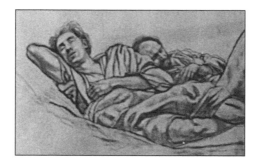

A Painter of Humanity

By March 1, Long and his crew were far enough down the wall to remove the scaffold. "This is the first day we can step back and adjust it like you would a proper picture," said Long. "The rest of it has been painted with a lot of hope." The Christ figure was finished under Gethsemane's dark blue sky. So were the hill on which Christ knelt and the road on which Judas and the rabble approached.

The sleeping apostles remained to be painted. Dabbing flesh tones to create the face of one with a big nose and lips parted in sleep, Long spoke about what he sought as an artist: "What I'd like to focus on in my work is the element of humanity. You want to explore, being a figurative painter, the most basic elements of humanity. I want to use figures, even in my

studio works that aren't religious, to cause people to sense the humanity of the thing. That's what I'm after. Always."

Back at work after lunch in the church's downstairs kitchen, the crew found a problem on the surface of the plaster. The feet of two disciples looked pitted, the colors flat. Early in his work on the Sistine ceiling, Michelangelo had found mold growing on the plaster. Pope Julius II sent the architect Giuliano da Sangallo to consult. He found too much water had been used to mix the intonaco. Long and the crew discovered that, overnight, the flint in the sand, mixed with plaster to form their intonaco, had risen to the surface and affected how the paint dried. "All this stuff has kept it from modeling," said Long, examining the pitted feet. "Cut it out."

Chuck Kapsner and Laura Buxton began scraping. "It feels strange taking off so much hard work," Buxton said. With his usual thoroughness, Kapsner set about finding out what was wrong. After washing and rewashing the sand and drying it in the church kitchen's oven, he decided it just had too much grit and looked for another kind of sand. He tested several, including sandbox sand, before finding one he liked. The flinty feet cost Long and the crew a day. It hardly mattered. They were ahead of schedule.

March 6 was Michelangelo's birthday, the 513th anniversary of that event. It was a Sunday. Since they could not work, the artists played, picnicking in a park. Remembering the birthday of a great painter was typical of Long. Rembrandt and Titian ranked higher in his personal pantheon than Michelangelo, but he felt an affinity for the creator of the Sistine ceiling. He knew the tower in Florence marking Michelangelo's hiding place from Julius, and the spot on the wall of the Palazzo Vecchio where Michelangelo demonstrated his prowess with the hammer and chisel by cutting a portrait with his hands behind his back.

Long knew, too, the portrayal of Michelangelo in *The Agony and the Ecstasy*, the 1965 potboiler movie based on Irving Stone's equally purple novel, especially all this business about paint splattering Michelangelo's face as he lay on his back painting. Long had little use for such tarted-up history.

Begun in 1508, sixteen years after Columbus sailed for the New World, eleven years after Leonardo da Vinci finished *The Last Supper*, the Sistine frescoes and the four-year effort to paint them have long passed from the realm of art history into the popular imagination. Michelangelo's art and his superhuman effort have become an immediately recognized standard for great achievement—even if the comparison is baseball. Los Angeles Dodgers scout Al Campanis recalled Sandy Koufax's first pitch this way: "It was a fastball that looked like it would hit the dirt in front of the plate. Then, all of a sudden, it rose for a knee-high strike. As soon as I saw that fastball, the hair raised up on my arms. The only other time the hair on my arms ever raised up was in Rome when I saw Michelangelo's paintings on the ceiling of the Sistine Chapel."

The electric interval between the outstretched fingers of Adam and God in *The Creation of Adam* is as recognized and reproduced an image as Mona Lisa's smile. Liberace put it on the ceiling of his bedroom. It appeared on the side of the bus novelist Ken Kesey and the Merry Pranksters drove across the country in the 1960s, a trip made famous in Tom Wolfe's *Electric Kool-Aid Acid Test*. As with the images, the stories of the Sistine are well-known: how Michelangelo, considering himself a sculptor rather than a painter, was reluctant to undertake the commission, how Julius bullied and cajoled him, how he dismissed his assistants and worked virtually alone for four years, and how he painted lying on his back on the scaffold so that the paint dripped on his face.

That last story, a fixture of Sistine Chapel lore, is bogus, the fruit of a mistranslation of the first biography of Michelangelo, written in Latin. A description of him at work *resupinus* was rendered incorrectly as "on his back" instead of "bent backward." Painting while lying on his back would have made no sense for Michelangelo, would have restricted his movements and made it difficult for him to see what he was doing. Michelangelo designed the scaffold he used to paint the ceiling, a bridgelike structure set on timbers embedded in the wall. It left the space beneath free for papal ceremonies while giving him light and freedom of movement and allowing him to stand upright. The scaffold worked so well that restorers replicated

it in lightweight metal and used the same spaces in the walls to support it when they came to clean and repair Michelangelo's ceiling 468 years after it was finished. Michelangelo also left a picture of himself at work, a hurried sketch of the artist standing and bending backward to touch the ceiling with his brush. It is in the margin of a humorous sonnet sent to a friend describing the real torment of his labors.

The Sistine ceiling was a culmination of the technique of fresco, the climax of two hundred years of development reaching back to Giotto and his crucial innovations in the art of painting. Certainly, frescoes were painted after the Sistine. Oil painting, however, already was on the ascendancy. Even for those who painted frescoes, the hold of the buon fresco technique—working with wet plaster—lessened. By the time Michelangelo came to paint *The Last Judgment* on the altar wall of the Sistine twenty-four years after finishing the ceiling, it was assumed he would work in oil or tempera, so the wall was completely plastered. He gave orders to destroy the thoroughly dry intonaco and proceeded to work in buon fresco.

Fresco was used to create some of the greatest advances in Western art, a rising line traced in wet plaster running from Giotto's work in the Scrovegni Chapel to Masaccio's in the Brancacci Chapel to Michelangelo's in the Sistine. Giotto used secco for some of the colors in the Scrovegni frescoes, blue in particular. But most of it was done with buon fresco, the technique of Masaccio and Michelangelo. The Sistine ceiling is the greatest single work of that tradition. For the following three centuries, hardly an artist expressing himself through the medium of the human figure remained untouched by Michelangelo's influence.

The list included Ben Long, even though he came along after that influence had been spent.

———

Michelangelo Buonarroti was more sculptor than painter. He came to Rome in 1505 to work on a commission beyond any stone carver's dream, the gigantic tomb of Julius II. He already was famous, the creator of the monumental statue of David that stood in front of the Palazzo Vecchio in

the Piazza della Signoria, a symbol of republican Florence. But that was one figure. Julius's tomb would have forty figures. He eagerly began the project, spending eight months in the mountains of Carrara selecting marble, not knowing the unfinished tomb would become a burden he'd carry for forty years.

Yet Michelangelo also knew how to paint. Like other artists of his day, he had been trained to work in different media. At age thirteen, he was apprenticed to Domenico Ghirlandaio, whose large workshop produced frescoes and altarpieces for churches all over Florence. Michelangelo was schooled in drawing, "the parent of all other arts," according to Vasari, and made drawings from the Florentine frescoes of Giotto and Masaccio. During Michelangelo's year in the workshop, Ghirlandaio was busy with the frescoes in the Tornabuoni Chapel in Santa Maria Novella. Michelangelo did a sketch of the scaffolding. If the young apprentice did not actually work on the frescoes, he certainly learned the process. The Tornabuoni were a prominent family, allied politically with the Medici. Wealth and a concern with status, along with other social changes, brought about a golden age of fresco during the fifteenth century, filling the walls of Tuscany with brilliant works.

Times were prosperous, particularly in a banking and trading center such as Florence. The newly wealthy were allowed to endow private chapels, a privilege formerly reserved for monarchs and princes of the church. These merchants and bankers also decorated their palaces. The increasingly influential mendicant orders, the Franciscans and Dominicans, were anxious to reach a wide audience, to teach moral truths through the drama of sacred stories. City-states such as Florence and Siena sought to proclaim their independence and civic virtues.

Fresco, able to instruct, to exalt, and to decorate, answered the needs of all these groups. Readily combining with architecture, it was flexible as well as durable, able to follow the contours of the walls and ceilings of new buildings. Fresco had great rhetorical power, could cover large surfaces with didactic statements the peasant as well as the prince could readily understand. Before television and motion pictures—which, with its narra-

tive and dramatic power, fresco in some ways resembles—fresco was one of the most effective means of mass communication ever invented. The popular taste of the time favored monumental art. Fresco brought into the church, the palace, or the town hall the bustling life of the piazza, the faces, gestures, and incidents of Italy's vivid public life.

Julius, pope from 1503 to 1513, sought to revive the papacy and the church after a period of division and strife. He was personally ambitious. The garlands of acorns and oak leaves Michelangelo painted on the Sistine ceiling were from his coat of arms, referring to his family name, della Rovere. Mindful as any Italian of his family, he was the nephew of Pope Sixtus IV, who had built the Sistine Chapel in the 1470s. Hence its name. Julius, who owed his position to his uncle, wanted to continue Sixtus's program of restoring Rome to grandeur, making it the *caput mundi*, "the center of the world."

More warrior than priest, more comfortable at the head of his troops than seated in the papal throne, Julius, with all the guile of a secular prince, sought to protect and expand the Papal States. He was also the greatest art patron of the papal line, conceiving such projects as demolishing old St. Peter's, one of the largest and oldest churches in Christendom, and replacing it with a new, more splendid basilica. His intellect and strength of character attracted to his grand projects three of the greatest artists of his time—not only Michelangelo but also Bramante and Raphael.

The demands of the new basilica were such that Julius suspended work on the tomb and asked Michelangelo instead to decorate the Sistine. Disappointed, the artist proudly refused and fled Rome for Florence. Julius pressured the Signoria, the ruling body in Florence, for the artist to return and eventually got his way. Michelangelo—with, as he said, "the rope around my neck"—reconciled with the pope at Bologna. Decoration of the Sistine had begun under Sixtus IV. Florentine artists including Botticelli, Ghirlandaio, Perugino, and Cosimo Roselli had frescoed the walls with scenes from the life of Moses on the left and the life of Christ on the right, following early Christian practice. The ceiling was painted blue and covered with stars. Besides wanting to complete the program for the chapel, used

for important ceremonies such as conclaves of the Sacred College of Cardinals, Julius had a practical reason to act. The building's settling foundation had caused a large crack in the vault. It could be repaired and then frescoed.

Over the next four years, as the painting progressed, Michelangelo and Julius continued to conflict. The issues dividing them were those constants of human endeavor, time and money—the same that bedeviled Ben Long and Father John Haughey. Julius pressured Michelangelo to finish his work, once threatening to throw him off the scaffold. Michelangelo wrote his father to complain of the pope's late payment. However, these more famous and more grand prototypes of the antagonists at St. Peter's in Charlotte did not disagree about subject matter. Julius fully approved of the ceiling. Doubtless, he would have felt the same about *The Last Judgment*, painted after his death on the Sistine's altar wall. But in 1564, during the Counter Reformation, a lesser pope, Pius IV, ordered the nudes on the altar wall covered. The job was done by Daniele da Volterra, a talented follower and friend of Michelangelo, earning him the sobriquet "Il Bragghettone"—"The Breeches Maker."

The relationship between Michelangelo and Julius was more complex than popular ideas about it allow. As well as his patron, Julius was Michelangelo's friend and collaborator. Much of the strain between them resulted from their similar personalities. Each was hot-tempered, sure of his vision, determined to have his way. Both were considered almost superhuman by their contemporaries, Michelangelo called "divine" and Julius "terrible." Conflict also flowed from their status. Pope and patron, Julius had the upper hand. Michelangelo's evident genius would render him rich, famous, and godlike in his lifetime. But his status when employed by the pope was that of craftsman or artisan. Michelangelo's father, a member of the gentry and a minor bureaucrat, objected to his son's becoming an artist, believing it lowered his social standing. Painters in Florence belonged to the guild of physicians, druggists, and shopkeepers; sculptors to the goldsmiths' guild. Michelangelo came out of a tradition where artists were hired hands, collaborative workers whose shops opened to the street,

connecting them to everyday life. Giving in to his violent temper, Julius once struck the artist with a cane as one might a recalcitrant servant.

Thirty-three years old and in his prime when he began the ceiling, Michelangelo did work without assistants, even, Vasari says, grinding and mixing his own colors. Early on, he sent to Florence for more experienced painters to help him, among them Francesco Granacci and Giuliano Bugiardini, who had also been in Ghirlandaio's workshop. But once he became more confident with the technical demands of fresco, he dismissed them.

It was a stupendous undertaking. Michelangelo painted the lunettes, spandrels, and pendentives as well as the vault, covering the ceiling—132 feet by 44 feet—with more than three hundred figures of various sizes and in a great variety of poses. Hounded by Julius, working feverishly to finish, Michelangelo, says Vasari, so strained his eyes he could hardly read or look at drawings for months.

The Sistine Chapel, with low benches along the walls, is one of the few places in the Vatican where it is possible for visitors to sit down. On days when the crowds are thick, people mill about waiting to sit. When not jostling for or eyeing a seat, they look up. Their mouths open involuntarily. What they see is glorious.

The images on the ceiling represent a sophisticated theological program and an incredible diversity of subjects and attitudes of the human body, brought into unity by Michelangelo's skill. The scenes on the lower walls, done by other artists, tell of the history of mankind under the Law and under grace, the Old and New Testaments. Michelangelo extended the program by depicting humanity before the Law, using scenes from Genesis, beginning with *The Drunkenness of Noah* over the entrance and ending with *God Separating Light from Darkness* over the altar. The ceiling demonstrates the perfectibility of man as he reaches for God.

To hold such diversity together, and to make the curved ceiling his ally, Michelangelo painted bits of fictive architecture—cornices and archlike bands—across the ceiling. He made of the ceiling a kind of screen, with the

nine scenes from Genesis seemingly projected on the sky above. To frame the scenes, he painted the "ignudi," muscular young men in various poses, symbols in their nudity of human perfection. Doubtless a carry-over from the suspended tomb project, the ignudi gave Michelangelo an opportunity to paint his artistic obsession, the nude male body. Even for some of the female figures on the ceiling, he used male models. Likewise, the imposing figures of the five sibyls around the upper walls, as well as the seven prophets, burst with a muscular power.

Michelangelo's conception was revolutionary, especially when compared with the older frescoes, painted in registers that essentially divided the walls into picture frames and in the old linear style that put the most important figures at the center.

But the Sistine was not without precedent. In the Scrovegni Chapel in Padua, Giotto used fictive architectural bands across the vaulted ceiling and along the walls to unify the space. Giotto completed the frescoes in the early 1300s, telling the life of the Virgin and her parents and the life and Passion of Christ in three tiers on the walls. With him, art made a great turn, and the modern era began in Western painting.

Breaking away from the Byzantine tradition, he introduced figures with weight and volume, illusionistic space, and compositions attuned to the emotional content of the subject. In Cennino Cennini's words, "Giotto translated the art of painting from the Greek to the Latin."

Like Giotto, Masaccio had the monumental instincts of a wall painter. Giotto's artistic heir, he painted his frescoes in the Brancacci Chapel in Florence's Santa Maria del Carmine a hundred years after the Scrovegni Chapel was finished. Tommaso di Ser Giovanni di Mone, called "Masaccio"—"Sloppy Tom" in Italian—was only twenty-seven years old when he died in 1428. Yet he greatly advanced naturalism in painting through his understanding of light and mastery of perspective. In *The Expulsion from the Garden*, he conveyed a mood of tragic intensity. The heads of the apostles in *The Tribute Money*, his masterpiece on a story from the life of St. Peter, are noble and serene. Like many a fresco painter, he put

himself in the picture. He is the apostle on the end, a young man in a reddish cloak with brown hair and a light beard, identified traditionally as the apostle whose name he bore, Thomas.

Leonardo, too, studied the Brancacci frescoes, although his art went in another direction from Michelangelo's. He was more concerned with space than form, with beauty than power. The two great men were hated rivals, different not only in their art but at the core: Leonardo the skeptic who above all trusted experience, Michelangelo the believer who struggled with faith. Some twenty-four years older, Leonardo scorned sculpture and seemed to mock Michelangelo when he warned against painting overly muscular figures lest they look like a sack of nuts. As did other great Renaissance painters, Leonardo painted murals but did not use the fresco technique.

Ludovico Sforza, duke of Milan, commissioned *The Last Supper* in the refectory of Santa Maria della Grazie. As with the Sistine, the work was revolutionary. Leonardo's wall painting extended the space of the room, making the refectory's natural light part of the composition. His portrayal of a calm Christ flanked by the wildly gesturing disciples who wonder which has betrayed him had unprecedented psychological depth. As in the Sistine, a contrasting older work shows how advanced *The Last Supper* was aesthetically, compositionally, and psychologically, if not technically. On the opposite wall, a Lombard painter named Montofarno painted a Crucifixion scene. It is a fresco and in remarkably good condition. *The Last Supper* is not and is a faded remnant.

Ever experimenting, Leonardo came up with his own mural technique, probably painting with a combination of oil and tempera on a base of two layers of plaster and white lead. Verrocchio, Leonardo's teacher, never did a fresco. Leonardo may not have known how. In any case, the demands of the technique did not suit Leonardo, who hated the labor of painting. He wanted to be able to leave the wall, sometimes for days, to think about what he had done, to make changes, sometimes adding just a few strokes. Both the Sistine ceiling and *The Last Supper* were restored during the 1980s. While restoration in the Vatican removed the accumulated gunk of candle

smoke and glue varnish, revealing the original brilliant colors of Michelangelo, work on *The Last Supper*, which took much longer, only demonstrated how little of the original remained.

Fresco almost brought these two titans together. In 1503, with the Medici deposed and Florence a republic, the Signoria commissioned Leonardo and then Michelangelo to decorate the Sala del Gran Consiglio of the Palazzo Vecchio with murals on patriotic subjects. Leonardo's subject was the Battle of Anghiari, celebrating a defeat of the Milanese, and Michelangelo's the Battle of Cascina, a victory over Pisa.

Leonardo again eschewed the proven technique of fresco, this time for the ancient technique of encaustic, painting with hot, colored wax. With a horror of war worthy of Picasso's *Guernica*, he focused on raging horses and dying men in his central scene, *The Fight for the Standard*. The coal fires he used to dry the work left the upper half too dark and the lower half melted. It was left on the wall for years, a ruin finally covered by a fresco by Vasari.

Michelangelo completed only a large cartoon before leaving for Rome to work for Julius. He did not choose to depict the battle, but an incident in which Florentine soldiers bathing nude in the Arno are surprised by the enemy.

Through the original drawings and copies made by other artists, both works influenced generations of artists. Yet the heart aches for what might have been: one frescoed room with a work by Leonardo on one wall and a work by Michelangelo on the other.

These two changed not only art but also the status of the artist. Rather than a craftsman, he became under Leonardo's influence a creative thinker. Michelangelo made the artist a hero, the tormented genius whose creative insights are supreme, the model for the Romantics and even artists today. Raphael caught the image of the moody, self-absorbed genius perfectly. While Michelangelo toiled in the Sistine, he frescoed the Stanza della Segnatura, Julius's private apartments. Michelangelo allowed no one into the Sistine, but Bramante had a key and let the younger artist in. Impressed, Raphael added the philosopher Heraclitus to his *School of Athens*, a

brooding figure in the foreground with his face in his hand and his body turned like the great figures on the Sistine ceiling. It is both a portrait of and an homage to Michelangelo.

The Florentine's influence echoed through succeeding generations of artists. Especially from the nineteenth century on, what was looked for in art was an expression of the artist's personality. That idea was even more keenly felt in Modernism, in some ways a continuation of Romanticism. Over time, studio collaboration and the old system of patronage disappeared, thrusting the artist into the marketplace. And eventually, the technical tradition of painting, the kind of knowledge Michelangelo learned from Ghirlandaio, lost all meaning.

———

Each artist chooses his lineage. He picks through what other artists have done, weighing matters of taste, influence, and personal affinity before concluding, "These are the artists I descend from, these are my spiritual forebears." Long chose Rembrandt, Titian, Velazquez, and the Renaissance masters. The chasm of Modernism separated contemporary artists from the tradition these men represented. Long was able to bridge it through his Florentine master, Pietro Annigoni, and his most important influence, McKendree Robbins Long, his grandfather. Our sense of the history of art is a construct, an intellectual convenience with movements neatly succeeding one another, of influences passed along and elaborated. But history is not so clear-cut. Movements change, but some artists stay behind. Styles and ideas cut off by the dates in the history book sometimes persist, captivating a straggler such as Long.

His tie to the past was real, not just a matter of history books or museums. He felt an organic connection with these artists, a sense that the great figurative tradition of Western art was a broad river carrying him along. He saw a unity in art up until Cezanne in the late nineteenth century, when he believed it took a wrong turn.

This attitude separated him from other contemporary artists who pursued different paths. The seventies and eighties saw a resurgence of the figure in art. Artists following the tenets of Postmodernism tried to

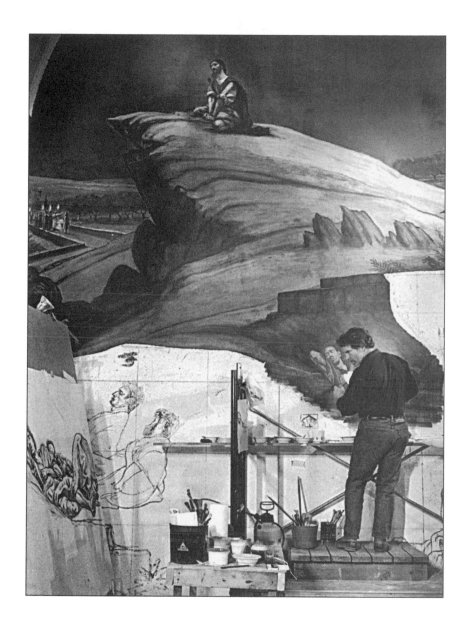

Long used a pyramidal composition for The Agony,
with the figure of Christ placed atop a hill in Gethsemane.

MARK B. SLUDER

connect with past art but for the most part could do little more than rummage through history as though it were a grab bag of tricks, picking out motifs to quote or "appropriating" artworks in whole or in part. Typically, such work was full of irony, the artist painting with a knowing wink toward the viewer as if to say, "You know and I know I'm not taking this too seriously."

Long's work totally lacked such self-consciousness. Whatever his shortcomings, he was a believer. The most important element of his art, that it be done "honestly," applied both to materials and what he tried to achieve on canvas or wall.

Decades after the tradition of the well-made object had disappeared under the assaults of Modernism, when many artists no longer knew how to create a work that would last, Long held to the tradition of the finely crafted painting. Honesty meant respecting materials and technique. Working that way was an expression of love, at the heart of Long's credo: "In my heart of hearts, I really believe that you do paint as an act of love. I really believe it or else I wouldn't do it."

When he was in Paris, Long made a point of visiting the Louvre at least once a week. He always stopped at the Rembrandt self-portraits and Titian's *Entombment*, ignoring across the crowded gallery Leonardo's *Mona Lisa*, usually surrounded by Japanese tourists taking a monocular view through their videocams. He loved how Titian, the greatest painter of the Venetian school, who died in 1576 at about ninety years of age, captured the weight of Christ's dead body, held in a cloth as it was taken from the cross.

Another favorite work was *The Madonna with Chancellor Rolin* by Jan van Eyck, a fifteenth-century Netherlander. "This just chills your bones," Long said one day, standing before it in his battered seersucker jacket. Referring to the cloak of the chancellor kneeling in adoration of the Madonna and Christ child, he remarked, "Look at this—you can literally see every thread. This guy must have had such a faith to love every little section of that picture. It had to be complete, unbridled love."

Part of working honestly is being true to the moment, trying to capture as best one can the fruits of an emotional encounter with the subject. As Long put it, "Not just the figure but the space around the figure, and

the air, and the light that comes in that's not just on the figure but in front of my eyes and in the way and moving. These are things that make me awed by how really hard it is to do that, to get it all down. And you're not doing it to win a point, or trying to say that I can do it. What I'm trying to do is say how much this moves me, or how much this strikes me this way. All I'm trying to do is elevate the everyday by simply putting human struggle into it. That to me is what my art wants to be about. Whether it is or not is part of the argument that's going to go on until you're dead. But that's the thing that inspires me."

Out of step with contemporary art, dismissed by some as a mere technician, Long scorned artists working in different veins, hotly condemning abstract painters, for instance. Partly, his hostility was defensiveness, a need to protect himself. But it also came from a kind of purity, a sense of art as something sacred others had profaned.

Because of his respect for and identification with past artists—and, no doubt, because of the influence of his master, Annigoni—Long opposed the cleaning and restoration of old artworks. On those walks through the Louvre, he pointed to canvases he thought were overcleaned or incorrectly rehung. Not surprisingly, he was against the cleaning of the Sistine Chapel frescoes. Long took a view shared by some artists, critics, and academics: that in removing centuries-old grime, the restorers also removed final layers applied by Michelangelo to give his figures form and to unify the work, changing forever the character of the frescoes. Unlike some other critics, Long brought to his view years of practical experience with fresco. However, the weight of evidence favored the restorers' position, not his own.

The restoration began in 1980, winning unlikely international sponsorship a year later when, on a trip to Japan, Pope John Paul II offered a Japanese television station the opportunity to underwrite the restoration of the West's greatest single artwork. Nippon Television Network Corporation contributed three million dollars to the project in return for exclusive rights to all photographs of the cleaning for up to three years after the process was completed.

The frescoes had been darkened by soot, smoke, and grime, but even

more by successive layers of animal-glue varnishes used to "brighten" the ceiling. These worked for a time, but then made the frescoes even darker. The varnishes, like the dirt, did not penetrate the surface of the frescoes. But being organic, they puckered and shrunk as they aged and began to fall away in spots, pulling bits of plaster and paint with them. The gradual but sure destruction of the ceiling, not its appearance, forced the Vatican to act.

The restorers used a cleaning solution called AB 57, made of bicarbonate of sodium and ammonium. An antibacterial and antifungal agent was added and the whole mixed in carboxymethylcellulose and water to form a gel that would cling without dripping. First, distilled and deionized water was sponged on the portion to be cleaned. Then the gel was brushed on and left for a few minutes before being washed off.

The Vatican workers labored slowly and carefully, led by chief restorer Gianluigi Colalucci, who wore a button on his smock recalling both the turbulent history of the Sistine and the difficulties of the present work: "Even the Pope had trouble with Michelangelo." The team constantly checked the work with sophisticated techniques that showed the successive layers of varnish and the trapped dirt, confirming what the majority of experts thought: the cleaning was valid and properly done.

The results were astonishing. With the gunk removed, Michelangelo was revealed as a brilliant colorist. The view of him as a sculptor interested in form, not as a painter interested in color, had to change.

After finishing the ceiling in 1990, the Vatican team paused for a year to study *The Last Judgment* on the altar wall before deciding how to restore it. One issue was whether to remove the loincloths added by Volterra, returning the wall to the nude grandeur painted by Michelangelo. Tests relieved the restorers of this difficult decision. They showed that before he painted his diapers, Volterra had scraped away the original intonaco. There were no nude figures left to go back to.

———

Long's sensitivity and the purity he felt about making art were visible under his charming, somewhat macho exterior. Far harder to see was his

self-doubt. Like other strongly felt emotions—his feelings about his parents and childhood, his time in Vietnam, his religious beliefs—Long kept his insecurity buried. Laura Buxton knew him well enough to see it and understood the source, common enough among artists: "You're avoiding the real confrontation, and maybe there isn't anything to say there anyway, which is the artist's underlying fear. [You fear] there's not much there, and perhaps what there is to say isn't any great shakes."

In part of his heart, Long wanted a big career, the kind fleshed out by Michelangelo. A part of him aspired to be the greatest artist in the world. He bought the romantic notion coupling creativity with torment and at times behaved accordingly. Yet self-doubt held him back. For a time, he was represented by a New York gallery, but he let the connection slip rather than work to capitalize on it. Terrified of mediocrity, he felt he wasn't ready. Doubt affected him in the studio, making it difficult at times for him to work. "I paint rather slowly because I'm so highly critical of myself and my work that I don't dare paint as much as I should," he said.

At the time of the St. Peter's fresco, he felt an added pressure. Time, it seemed, was no longer on his side. He wanted to get out what was inside, but was unsure about how to make it happen.

"I'm still working for a quality I haven't found," Long said. "You're looking for the hour when your spirit is going to burst wide open. I want to be an artist where my spirit is out there, it's released, it's out of the membrane. That's all that really matters to me. Maybe for the first time, I've started to feel a little fear about it. I never used to because I was always looking out, trying to get to the top of the hill. Like anybody else, you know, the older you get, the faster you slide back. It's like there's always been a trick of the vision: the hill always seemed closer than it really was."

———————

Long's overriding focus in *The Agony* was the humanity of Christ. He did not want to paint a figure either sentimental or remote. He wanted a human Christ, a man confronting his fate, aware at his moment of suffering. Long, whose religious feelings had little to do with the institutional church, was drawn to and moved by this human aspect of Christ's Passion.

"It's that moment when Christ himself is full of doubt and wants to remain human," he said. "It's that moment all of us have to face at some point, the agony of having to come to terms with your fate."

The moment described in the Gospels comes after the evening meal with his disciples, when, with bread and wine, Jesus institutes the Eucharist. After supper and the dismissal of Judas, Jesus and the others depart Jerusalem's walls for the Mount of Olives, for Gethsemane. There, Jesus leaves his sleepy followers and goes off alone to pray.

The Gospel of Matthew pictures Jesus falling on his face under the strain. Luke's account adds this description: "And there appeared to him an angel from heaven, strengthening him. And being in an agony he prayed more earnestly; and his sweat became like great drops of blood falling down upon the ground."

Long ignored these narrative elements, used by Renaissance artists to depict an exhausted yet somehow supernatural Jesus supported by a winged angel as drops of his blood drip into a communion chalice, a symbol reaching forward to his coming sacrifice and looking back to the Eucharist. Long sought a version more stark. To further concentrate the emotion, he eliminated the olive press found in an early sketch, a connection to Gethsemane, which means "olive press" in Hebrew. He did include to one side the stump of an oak with a single leafing branch, a traditional symbol of resurrection. Otherwise, he sought emotional impact in simplicity.

He placed the figure of Jesus at the summit of a pyramidal composition. Using gesture to reveal psychology, Long put Jesus on his knees on top of the hill, his sleeves rolled up, his arms ramrod straight, and his clenched fists pressed to the ground. His head, tilted slightly back and to one side, is a mask of suffering, its features deliberately blurred so as not to distract the viewer's attention from the figure's overall attitude.

Filling out the pyramid are the disciples, wrapped in their robes and spread below in groups of three, growing larger toward the altar floor to keep the scene in perspective. The contrasts between Christ and the disciples are telling: he is awake, they are asleep; he is conscious, they are

unconscious; he is knowing, they are unknowing; he is alone, they are not alone; he is in the light, they are in the dark.

The angles and diagonals set up by the rocks and walls on the hill push and pull the composition, adding tension and directing the viewer's attention to the figure of Christ. Off to the left are Peter, James, and John, the three Jesus invited to go with him a little way. Under a sheltering overhang of rock, Peter's sleep seems disturbed, perhaps by Jesus' earlier prediction of betrayal. A small scene to the left depicts Judas with temple guards and Romans soldiers, one of whom stands with his arms akimbo, clearly annoyed at being called out at night for such inconsequential duty. Judas points to the hill. The hour is at hand. The scene echoes with the silence that comes after a bell is struck.

Long drew on his experiences in Vietnam for the emotional content of *The Agony*, transforming those experiences to make the most compelling of the three sections of the St. Peter's fresco. Incredibly, members of the church objected to Long's depiction of Jesus, saying he was improperly clothed and the pose was undignified. But Long achieved what he wanted, a heartbreaking and compassionate vision of a man about to break who somehow does not break. He painted a path up the hill from the altar to make it appear that anyone can step into the fresco and walk up the hill beside Christ. The message is clear: like Jesus, each of us one day must confront his fate.

Toward the end of *The Agony*, Reynolds Price drove down from Durham to see Long and the fresco. The novelist and the artist had known each other since 1965, when Price had Long as a student in a writing class at the University of North Carolina. Price, who once thought he might be a painter, had been a mentor of sorts for Long.

Price saw *The Agony* as a thoroughly contemporary painting and Long, despite his devotion to the pictorial vocabulary of the Renaissance, as a contemporary artist, "not a kind of puppet worked by Renaissance hands."

Later, he had this to say about Long and his art: "The longer he's worked, especially the longer he's worked in religious frescoes, the more

I think he's found the ease and the freedom with which to make the kinds of contemporary statements about Gospel stories that Michelangelo, Leonardo, or any of the other great Renaissance painters could simply never have entertained mentally. They're very devout in some ways. They're also full of a kind of brooding, questioning air, which I think makes them for me very much contemporary pictures."

He said of *The Agony*, "No Renaissance painter could have imagined it, even one with the greatness of Michelangelo. Nothing in this world would have permitted him to see Christ as this abandoned, desolate creature. It's right there in the Gospel of Mark, which is the oldest account of the Gethsemane experience. By the time you get to Matthew and Luke, they're beginning to soften it: 'But of course he had angels there.' Not Mark, which says the disciples just slept through the whole thing; talk about the ultimate quitters.

"If Ben had offered or suggested to the Jesuits that he cover the entire wall of the church with the Garden of Gethsemane, they would have been insane to have accepted it. Because what church full of believers could want to sit and look at Christ at this unbearably painful and doubting moment of his life?

"The whole thing is an awful piece of news for Christians, which is that he didn't want to go through with this. He tried very hard to get out of it. And anyone who's ever been to Israel knows that in the Garden of Gethsemane, he could have been safe in a thirty-minute walk. All he had to do is walk over the top of the hill and he was in the Judean desert, and they would never have found him if he'd just gone and disappeared. He chose not to disappear. Something made him stay and do this. That's not something you want to sit there every Sunday of your life and think about. So anyone who says that Ben is simply juggling the works and skills of four-hundred-year-old painters just is incapable of responding to the spiritual and the narrative content of the pictures."

————

In Paris, Long and Kapsner had sketched out a twenty-seven-day work

schedule for *The Agony.* Everything went so well they finished the painting in nineteen days. Father Haughey was pleased with the speed and the finished painting. Long had not presented his preliminary drawings to the priest for approval, as he had agreed to do. But the work went so well, and the results were so pleasing to the congregation and everyone who saw it, such matters were forgotten for the moment. Long took this to mean he would have a free hand on the schedule and perhaps even on subject matter. He called Cary Lawrence in Paris and told her he thought the priests now would back off: "Baby, they're going to leave us alone now— we've got them, we've blown them away, we've blown them out of their socks. They love it."

As he worked on *The Agony,* Long kept on the altar turned into a makeshift worktable a book on the Italian frescoes of his mentor, Pietro Annigoni. Long had ended his apprenticeship eight years before. But Annigoni's influence held. Also hovering over him as he worked were the spirit and example of his grandfather. Long, as an artist and a man, was a product of the two.

As he'd done at Glendale Springs, Long designed a T-shirt for the crew. For that first shirt, he had quoted *The Creation of Adam* from the Sistine, the reaching hands of God and Adam beneath the words "Hot Lime."

For this shirt, he quoted Masaccio's *Expulsion from Paradise* in the Carmine. Long's copy of the portrait of Adam with his hands to his face seemed to confirm the joke Italians told about the image: that Adam, happy, not sad, about leaving Paradise, was laughing behind his upraised hands. Long added the slogan "Sloppy Tom's Pit Crew" on the front.

On the back was a nonsense quote from a fictitious letter from Michelangelo to Pope Julius: "You wanna blue, we gotta blue."

On the bottom front, Long used one of the sayings with which Anthony Sexton, the street person, greeted the fresco crew each morning: "The mind is a dangerous thing." Gone from the United States for so long, Long didn't recognize this pseudo-profundity as a corruption of the slogan of the United Negro College Fund.

Not only rock music was played through the church's speakers. Long particularly liked the music of Polish composer Henryk Gorecki and dedicated *The Agony* to him.

The church gave a celebratory dinner for the artists. Long and Kapsner presented the crew members with mock trophies for their contributions, presenting to Rosen "The Honky Lime Grinder," Buxton "The Whisky-Colored Queen" and Panzera "The Vatican Loose-Brush" awards. Mr. Brawley got a "Lion's Tongue," an antique trowel engraved by the crew.

On March 15, the last workday, Long and the crew gathered at the church for final touches and cleanup. Gabriella Ciceri, an Italian whose husband worked for IBM and who had become fond of the artists and interested in the project, feasted them with a lunch of salmon and fettuccini. The crew broke bread and sipped wine in the basement kitchen, joking and laughing. Then came good-bys among Ciceri, Long, and the others, hugs and tears.

Ciceri had watched *The Agony* grow from dim lines on a wall to an overwhelming reality. Sitting in a pew in the church, she explained what she felt: "I like the posture of Jesus—you can see the struggling, you can see the anguish of a human being. You can see in the apostles sleeping—they really are sleeping, with the open mouths. Something that puzzles me is the silence of Jesus in this moment. But if you read the Gospels, he doesn't say a lot of words. I believe in the silence I was present. It is lovely to think I was part of that silence—lovely and tragic."

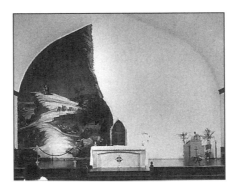

MARK B. SLUDER

PHOTOGRAPH
COURTESY OF MAX JACKSON

CHAPTER SIX

Nanny and Grandmac

The Agony left Ben Long exhausted. Returning to Paris, he stepped off the plane one March morning and that afternoon left for his home in the south of France. With him was his companion, Cary Lawrence. One person not in Paris to welcome him was his thirteen-year-old son, Angus. While Long had worked on the fresco, the boy, living in the Montmartre apartment with Lawrence, had been through a terrible time in school. The resulting misbehavior, albeit a cry for help, had been exasperating. From North Carolina, Long had directed Lawrence to send Angus to Florence to live with his mother and younger brother.

Long felt a great responsibility for getting the boys off on the right path

and pangs of guilt for the time he spent away from them. They called him "Babbo," Tuscan for "Daddy," and seemed happiest roughhousing with him, punching his muscular arms. Angus and nine-year-old Tolly later would join Long and Lawrence at Pougnadoresse. But first, Long needed rest. For a week, he slept almost nonstop, rising for the midday meal and rambling around the countryside. That Long, who suffered from insomnia, slept so soundly showed not only how tired he was but how good he felt about what he'd done at St. Peter's.

More than any other place, Pougnadoresse was home to Ben Long. West of Avignon, with about sixty rarely seen residents, the village sits on a low hill amid grape arbors and fields laid out like patches of green-and-yellow cloth. A ridge of dark red stone runs through it. Long's house, like the others, balances on this rib. The mistral, a dry, cold wind from the north, blows through Pougnadoresse. The red roof tiles are kept in place by bricks. In the early morning, the bread truck stops. You can hear the bell and later the clip-clop of a farm horse being led through the stone streets. The village has a church, a soccer field, and a small, dusty "place." There, the men, watched by the boys when on a holiday, play boule, tossing the clacking metal balls, trying to get them as close as they can to a red cork.

For a time in the early eighties, Long, newly separated from his wife, lived full-time in Pougnadoresse with Angus. After moving to Paris, he continued to visit when he could, sometimes driving around in a battered white Renault van and enjoying a favorite pastime, talking about which old house or barn would make a good studio. It was a preoccupation he exercised in Paris and even in North Carolina, as if finding the perfect workspace was the key to producing art.

Long's life has been marked by movement, from travels with his family as an air-force brat to the Atlantic crossings of his adult years. Before he was far into his teens, he'd lived on the West Coast of the United States and in France, Germany, and Okinawa. All this motion, combined with his inner turmoil, seemed to foster a restlessness in him, a difficulty staying still.

The place that became an emotional center in his early years was Statesville, North Carolina, the small Southern city that had been home to

his family for more than a century. Long was intensely proud of his large and somewhat eccentric family. He kept in his Paris apartment a yellowed photograph of the family homeplace. He carried within himself the influence of his grandparents, Mary Isabelle Hill Long and McKendree Robbins Long, with whom he'd lived during his high-school years and who had provided him a sense of emotional security and stability amid his sometimes troubled family life.

His grandparents were accomplished people. "Nanny," as his grand-mother was known, was a writer and editor. His grandfather, called "Grandmac," was an artist, minister, traveling evangelist, and, in his last years while Long lived with the couple, an artist yet again.

Once he decided to be an artist, Long hungered to learn and searched for a teacher, a search that largely went unfulfilled. For the most part, what he knew about art he'd taught himself. But he was not without strong influences. Without his grandparents, particularly without Grandmac, he would not have become the kind of artist and person he is.

————

The family patriarch, the first Benjamin Franklin Long, was a portly man, well-padded in the tradition of the late nineteenth century, with a bristling walrus mustache and an egg-smooth bald head. McKendree Long, his son, painted a portrait of him looking highly respectable in a white suit and flowing black bow tie and wearing pince-nez eyeglasses on a gold chain around his neck. A lawyer and superior-court judge, he once was described by a friend as "a nobleman, patrician and royal, in intellectualism sturdy and patient, and, in integrity, spotless and lofty." It was a picture of his great-grandfather's house in Statesville, a Victorian confection with gingerbread trim called Oakhurst, that Ben Long kept.

The judge came from a distinguished family of clergymen, educators, and politicians. He was born in 1852 near Graham, in Alamance County in the central, or Piedmont, portion of North Carolina. He was the seventh child of Jacob and Jane Stockard Long and the last born in their farmhouse on the Haw River. According to a family story, since he was the last child, his parents had no name handy for him. His siblings, studying

history in school, suggested he be named after the great statesman and inventor from Philadelphia, Benjamin Franklin.

Nearly all the children, six sons and one daughter, left a mark.

William Samuel, the second son, became a minister in the Southern Christian church shortly before the Civil War. He later bought the property of the old Graham Institute in Alamance County and opened a school. In 1890, he became the first president of Elon College in Burlington, North Carolina, using his carpentry skills to help construct the school's first building.

Daniel Albright, the third son, left home as a sixteen-year-old school-teacher to fight in the Civil War. In 1883, he became president of Antioch College in Yellow Springs, Ohio, reportedly the only Confederate veteran ever elected president of a college north of the Mason-Dixon line. He was a trustee of the University of North Carolina and a fellow of Columbia University.

Jacob Alson, the fourth son, became an attorney and for a time practiced with his son, J. Elmer Long, who after his father's death was elected lieutenant governor of North Carolina. In 1868, when the Ku Klux Klan organized in Alamance County, Jacob Long was named chief of Camp Number One. Two years later, he was charged as an accessory to the murder of Wyatt Outlaw, a black man who had been hanged near the courthouse in Graham. The charges later were dropped.

Benjamin Franklin, too young to fight in the Civil War, worked on the family farm and proved to be a good student. He studied under his brother William at the Graham Institute and was valedictorian of his class at Trinity College in Randolph County, forerunner of Duke University. After teaching Latin and history for two years, he went to law school at the University of Virginia, completing the two-year course in half the normal time. After his studies, Benjamin Long was offered the Democratic nomination for the state senate from Alamance. Instead, the future judge left his rural home and moved to a small but thriving city, Statesville, where he became the law partner of an established attorney, congressman, and

Confederate veteran, Major William McKendree Robbins. In 1879, he married his partner's daughter, Mary Alice.

Statesville was like many Southern towns after the Civil War. It had not suffered great destruction and was anxious to build a better future, although psychic wounds remained. In front of the courthouse still stands the familiar monument to "Our Confederate Dead," with a plaque that reads, "From Bethel to Appomattox, their courage, patience, fortitude, endurance and unselfish devotion to country are unparalleled in history."

Benjamin Long was one of those Southerners who prospered after the war. He was elected to several political offices, including mayor of Statesville. He authored the bill to create schools with separate grades in the city and, with two other men, organized its first cotton mill. In his first try at a judgeship in 1894, he was defeated by the Republican-Populist coalition. Eight years later, he was elected a superior-court judge, an office he held until his death in 1925, four days shy of his seventy-third birthday.

As a Democrat, the judge was a member of the party that set about undoing the progress blacks and others had made during the window of opportunity that opened after the Civil War. However, while race was then—as now—a volatile issue, Judge Long showed himself a man of courage and principle.

In 1906, six black men were jailed at Salisbury, north of Statesville, awaiting trial for the murder of a white family. The authorities took measures to protect them. Judge Long, with the sheriff, spoke with several men who seemed ready to take the law into their own hands. On the night of August 6, a mob battered down the jail door and killed three of the prisoners.

The next morning, Judge Long opened court, called the grand jury, and began his charge to its members with stirring words: "God Almighty reigns and the law is still supreme. This court will not adjourn until this matter is investigated." One member of the mob was found guilty and sentenced to fifteen years, the first white man in the state convicted in the lynching of a black.

The judge firmly established himself and his family in middle-class respectability and prosperity. He and Mary Alice had five children. The first son died in infancy. Then came Benjamin Franklin, Jr., Lois, Marie, and McKendree Robbins, named for his maternal grandfather. They formed a close-knit family, secure and socially prominent, with a kind of genteel interest in the arts. Yet a tragedy hung over the family, the horrible death of the elder son.

Benjamin Franklin Long, Jr., seemed destined to extend the family's accomplishments and good fortune. Handsome, his light brown hair parted down the middle over a broad forehead, he was bright and well-liked. In 1899, he entered the University of North Carolina in Chapel Hill as a seventeen-year-old freshman. That November, his father, the judge, was attending a session of the North Carolina Supreme Court in Raleigh, just a few miles from Chapel Hill, when he sent a telegram asking young Ben to join him the next day. The father wanted to buy his son a new suit of clothes.

At nine-thirty in the morning on the sixteenth, Ben was at University Station when the east-bound train pulled in. He stepped outside the waiting room to watch. Standing on a sidetrack, he was struck by a boxcar being backed up the siding. The boxcar knocked him down and dragged him twenty feet before it was stopped.

Trapped under the car, his left arm was wound between the brake rod and the axle. His body was mangled, his left arm, right hip, and collarbone broken. For thirty minutes, rail workers labored to free him. The boy remained conscious. In agonizing pain, he begged a friend to kill him and end his torment. Finally, the boxcar was jacked up and he was pulled free.

A special train took him to a hospital in Durham, where four doctors worked to save him. Notified of the accident as he sat in court, the judge arrived at the hospital at about five o'clock. Young Ben's mother was traveling from Statesville to be with her son when, at eight o'clock that night, he died.

The accident was news all over the state, with ringing headlines such as "Death After Terrible Agony" and "Crushed By Chapel Hill Train." One

story, under the headline "Young Long's Death Casts A Gloom Over Chapel Hill," noted, "He was a young man liked by all who knew him, stood well in his classes and his future was bright with promise. . . . It was one of the saddest deaths ever known here and the faculty and students alike sympathized most deeply with the parents so sadly bereaved."

The kind of place where everyone knew everyone, his hometown was devastated. Wrote the *Statesville Landmark* after the funeral, "The community was dazed Friday and Saturday. Sympathy tender, strong and too deep for utterance, was depicted on every face. Words are but playthings in hours of intense sorrow, and all felt how utterly impossible it was to express the thoughts that filled the heart and mind of all and made them as of one mind. Statesville has often been touched by the 'fellow feeling that makes us wondrous kind,' but it is doubtful if it was ever moved as it was by Ben Long's tragic death and at his burial."

Mary Alice Long went into mourning for her son and wore black for twenty-five years. At family dinners, a place always was set for young Ben. And when his name was mentioned, he was talked about in the present tense, as if he were still alive.

McKendree Long, the youngest child, may have been especially affected. He was only eleven years old when his brother died. With his mother in continuous mourning, he may have felt he'd lost her, too. He had an active and vivid imagination. Likely, the death and funeral and all the surrounding events had a great impact on him. McKendree later painted a portrait of his brother in the cadet uniform he wore while a student at Horner Military Academy near Raleigh. Seated next to him was his mother, wearing a flowered hat. When he became a father, McKendree named his firstborn son Benjamin Franklin Long III for his dead brother. That man became the father of the fresco painter, Benjamin Franklin Long IV.

The fourth and last Ben Long was supposed to have been born in Statesville. During World War II, while his father served in the United States Army Air Corps, his mother, Helen, lived there with the family. But in 1945, she joined her husband in Victoria, Texas, where he was stationed

while awaiting reassignment from the European to the Pacific theater. On May 9, she gave birth to a son and soon after returned to North Carolina with the baby.

A fighter pilot, Ben Long III had a deep voice. Because of that and his initials—B. F.—his buddies nicknamed him "Bullfrog." Once, he wrote home to tell the family his son, "the tadpole," was doing fine. Among family members, Ben Long was always "Tad."

An only child, he spent his early years moving from base to base with his parents. After the war, at a time when there were no interstate highways, his mother, a resourceful woman, drove with him from North Carolina to San Francisco to join his father. On such trips, he would sit in the backseat reading books and drawing. He was a quiet child and alone a lot, perhaps one source of his shyness. When he was barely out of diapers, his attraction to art surfaced. His mother, now Helen Steele, has a vivid memory of coming into the bedroom in one of the base houses—she doesn't recall where—and finding her two-year-old standing in his crib attempting to draw on the wallpaper with a pencil.

When he was in the first grade, Long made a book on dogs, copying them out of a book. Still a dog lover, Long described it forty years later: "I'd read what the dog did and why he developed that way, why he was a German shepherd, why he was a Dutch barge dog, or why he was a Doberman pinscher. One of the dogs I always liked—and no one knew about but I did—was the old Shar-Pei, which is now a fancy dog.

"And I'd draw these dogs because they all had meaning. I drew them in their situation, and there were always people with them. I would draw them next to a boat or a horse-drawn sled. And I really remember that book well because I enjoyed doing it. My mother kept it for a number of years, and after that I don't know what happened. We moved too much; she probably threw it out."

When the family visited Statesville, Long's doings were supervised by Flossie, a black woman who had been his father's nanny. Although remembered in the Long family only by her first name, she was considered in a particularly Southern way a member of the family. Grandmac did a

painting of the wisteria-framed porch of a house he lived in, and taking her place among other family members was Flossie.

"She wouldn't put up with stuff," Ben Long remembered. "She had a way of hitting you on the back of the head. It wasn't really a slap. She had a way of pulling up so it was more like a little snap. It was more like the shock value than any kind of pain. You knew you'd better watch it, or the next one would be on your bottom."

During a visit home when Ben was nine years old, his father connected him with some personal history. Growing up in Statesville, the older man had been the leader of the "Black Paw Gang." He and his youthful cronies had carved their initials in what had been the steppingstone to the judge's barn. Added to "BFL 1930," the father's initials and date, was "BFL IV 1954."

Ben Long's father showed some artistic ability as a young man but was more excited about things mechanical. He rebuilt an old Model T Ford and dreamed of flying airplanes. He left the University of North Carolina for the service before graduating. While he was still a young man, the first indications of a lifelong problem with alcohol surfaced. When he became drunk, his mother, Nanny, would not say a word but would pile the empty liquor bottles into a pyramid on his bedroom dresser.

His niece, Marie Avery Mickey, remembered him as charming, gallant. Before growing into a tall, willowy blond, she was chubby as a child and was touched by how "Uncle Ben would kiss my hand and tell me how lovely I was. This was my uncle who flew airplanes. When he was in the air force, Uncle Ben would fly low over my grandmother's house and make the shingles rattle. My grandmother always knew it was Uncle Ben."

Ben Long III served in World War II and Korea. Successful in the cockpit of a fighter, he was less so in making the kind of career moves that would advance him through the ranks. That, family members say, was a source of tension in his marriage. He died in 1980 at age sixty-one, not long after his retirement from the military. Despite his charm and accomplishments, frustration seemed to dog him. It's hinted at in an undated letter he wrote to his brother, McKendree, one his father saved in his papers: "Dear Mack:

Sometimes I wish I was as bright and smart as you are, but I suppose it is all right because you are my brother. I think the phrenologist hit it when he said I wasn't very bright, but I am not going to worry because I can't help it. You say when I am at home that I fuss at you and that I don't like you, but you never will know how much I do like you. You know I don't mean it when I speak harsh to you, although I ought not to do it and I am going to try not to do it any more."

Sports, in part, caused the younger Ben Long to spend part of his high-school years in Statesville. He wanted to play football. He also needed some stability. Near the end of his career, his father was being transferred so much that young Ben went to four high schools in four states during his sophomore year. He came to football late, but with his sturdiness and agility was so successful playing halfback for the Statesville High Grey-hounds there was talk of a football scholarship to UNC in Chapel Hill. However, a broken right foot in the next-to-last game of his senior year ended his gridiron career.

A star athlete, and handsome enough to be voted "best looking" by his classmates, Ben Long was popular and well-liked. He fell in with a bunch of guys, and they'd drive around in his banged-up red 1949 Dodge convertible. Joined by a few girls, the group would go to a nearby lake to dance and drink beer. Everyone in Statesville, as in other Carolina towns and cities, did the shag, a slow-footed, hip-rocking dance born on the coast, where many white kids got their first taste of black music. Dancing was big. On a summer night, a bunch of teenagers might drive to a country road, turn up the car radio, and dance on the macadam, their impromptu ballroom framed by dark pine trees.

A favorite teenage hangout was J. C.'s Toot 'N' Tell 'Em, a pre-generic drive-in. Small-town Southern etiquette required that the girls never come alone, but arrive with several packed in one car. They would cruise the parking lot, perhaps park, and order a hamburger from a carhop. The boys would join the girls in their cars. Within his group of friends, Long's soft, caring side showed. One Friday night when one of the girls was without a date, he made a point of calling her, making sure she was included.

One night after the older, college-age kids had a party, Ben and his high-school buddies managed to appropriate several bottles of beer and liquor. They drove around for a time wondering what to do with their loot. Looking for a place to hide the stuff until they could make proper use of it, they drove to Nanny and Grandmac's house on the edge of town. Ben and his confederates saw what seemed like an excellent hiding place and slipped the bottles under the big, leafy plants in Nanny's garden.

When he awoke the next morning, Long found the bottles of booze piled in a pyramid on his bedroom dresser. Nanny, family members knew, had Tad's number.

By his teenage years, Long was convinced he wanted to be an artist. Living under the same roof was a practicing one, his grandfather, then deep into an extraordinary series of paintings based on the Book of Revelation; he was also, as was his wont, spouting poetry and snatches of the classics in Latin, playing hymns and operatic songs on the piano, and, white-haired and white-suited in his last years, living out what seemed to be his destiny as a small-town Southern character.

———————

That McKendree Long became an artist at all is remarkable. Born on July 20, 1888, he grew up at a time when his home state had few artistic models or resources such as galleries or art schools—or even an art museum. By the time North Carolina's first public art museum opened in Charlotte in 1936, McKendree Long had given up art and become an evangelist traveling the sawdust trail.

All his life, he felt a tremendous pull between art and religion. At different times, he pursued each with equal conviction. He was intelligent and sensitive, a gifted and charismatic man who changed the dynamics of a room when he entered it. He lived well into the twentieth century but retained a nineteenth-century outlook. He could do many things but seemed unable to stay with any one. Yet by the time he died at age eighty-seven in 1976, he'd reconciled his twin passions, art and religion, bringing them into a powerful synthesis.

Likely, it was the force of his own talent that propelled McKendree

Long toward art. He began his career in 1908 as a twenty-year-old student at the Art Students League in New York. His older sister Lois, later a concert soprano and the mother of pop singer Mary Mayo, had gone to the city to study voice. He likely got the idea of traveling north from her.

He'd been given a solid education in the manner common to the sons of well-to-do Southern families of his time, and rare today among any class in any part of the country. After elementary education in North Carolina, he traveled over the mountains to board at the Webb School in Bell Buckle, Tennessee. Founded by Sawmey Webb, a former Confederate general, the school emphasized the classics in Latin and Greek. In 1906, when McKendree entered Davidson College, a Presbyterian school about equidistant from Statesville and Charlotte, he easily met entrance requirements such as being able to read in Latin the four books of Caesar and Cicero's four orations against Cataline.

Davidson was small, serious, and strict—perhaps too much so for a free spirit such as McKendree, a young man, some family members thought, who had been overly indulged by his parents. If so, that was an understandable reaction after the death of their older son. McKendree left Davidson after two years.

At the Art Students League, founded in 1875 by students at the National Academy of Design, McKendree diligently studied subjects such as drawing and painting. He was trained the way artists had been up to the beginning of the modern era in the early part of the century: with a foundation in basic skills and little concern for self-expression. That would come later.

McKendree, clearly feeling he had found his place and a challenge sufficient to match his ambition, was happy. He wrote to his father, "I feel something of a stern joy in facing new problems and multi-form perplexities. Oh I am very happy.

"Mora [F. Luis Mora, one of his teachers] seems to think that someday I will be a master and I hope that I can be 'a master of masters.'"

Throughout his life, McKendree Long was an idealist, in art and in all his endeavors. In a letter to "my precious little mother," he commented on

his studies and revealed his sense of high purpose: "This morning I began my first life drawing and have a criticism tomorrow morning. I am very anxious to meet my censor, Dumond [Frank Vincent DuMond], and measure him with that idealistic standard I have always kept for the true artist."

Always, McKendree's idealism bumped up against the realities of life, such as the need to make a living. A loving and dutiful son, he wanted to help pay for his own education. "I am going to make my own bread . . . by next summer if I have to paint sign boards," he wrote to his father. "I gave up one life class for an illustration class in order to meet the exigencies of the year."

During his student years in New York, momentous changes in American art crackled around him. For the most part, however, he was unaffected by them, much as his grandson, Ben Long, would turn a blind eye to contemporary art in his own day. In February 1908, the Macbeth Gallery hosted the first exhibition of those rebellious American artists called "The Eight"—Robert Henri, the leader, recently resigned as a juror from the National Academy of Design, and George Luks, John Sloan, William Glackens, Everett Shinn, Ernest Lawson, Arthur B. Davies, and Maurice Prendergast. They differed widely in style and were hardly up on the latest artistic breakthroughs in Europe, where Picasso already had begun his experiments with Cubism. But opposed to the bloodless aestheticism of the National Academy tradition, they wanted art to at least respond to the new urban world around them, to explore the lives of ordinary people in the cities. They seemed willing to paint anything, even an old ashcan, hence the other name by which they are known, "the Ashcan School."

McKendree likely was in New York for this show, although there's no record he saw it. He was not on hand for the huge explosion in the history of American art called the 1913 Armory Show, but he must have felt its reverberations. Among the sixteen hundred pieces of painting and sculpture were works by American artists. But what captured the public's attention and sparked a heated reaction were works by European artists such as Picasso and Cezanne, Matisse and Brancusi. Marcel Duchamp's

Nude Descending a Staircase was labeled "an explosion in a shingle factory."

The show was a modernist brick thrown through the front window of the staid American art establishment. The art experiments to follow would make pioneers such as "The Eight" seem tame by comparison.

Whatever he may have seen or read of the new art, McKendree remained loyal to the tradition embodied in the National Academy. Founded in 1826, modeled on England's Royal Academy of Arts, it was dedicated to fostering a belief in the importance of history painting and working from nature. Yet it became increasingly reactionary under the onslaught of Modernism.

He followed the traditional route of American artists, winning a scholarship in 1911 after three years of study in New York. It allowed him to travel to Europe for two years—London, Paris, Amsterdam, and Madrid—perfecting his skills by copying the Old Masters. He also was accepted into the London studio of Philip de Laszlo, a fashionable portrait painter born in Budapest. Among de Laszlo's best-known works were portraits of King Edward VII, Queen Alexandra, Kaiser William II, and Benito Mussolini.

De Laszlo was a follower of John Singer Sargent. Years later, McKendree claimed to have met Sargent. While it's possible, it seems more a result of McKendree's lifelong habit of exaggerating his experiences, a tendency inherited by his grandson, Ben Long. McKendree also claimed in interviews and publications he had graduated from Davidson College and been a member of the Royal Academy, neither of which was true.

Back home in 1914, he married his sweetheart, Mary Isabelle Hill, in Statesville. In the years before and after World War I, McKendree tried to make it as an artist. He did portraits in his home state, including those of several important judicial figures, likely securing these commissions through the contacts of his father. Briefly after the war, he brought his family to Princeton, New Jersey. McKendree commuted to a studio in New York seeking portrait work while his wife worked at the Princeton University library.

McKendree's early portraits sparkle. The kind of skill they evidence was

dismissed by modernist critics as "academic," a put-down for being dry and formulaic. But in addition to his ability with a brush, all too rare in art today, he showed a capacity for capturing and convincingly rendering a personality.

It seems McKendree left his home state only after he had tried to sustain a career there. He not only exhibited his work but also supported the organizing and building of a museum and the kinds of art institutions he thought North Carolina should have. The artist made a visit to Charlotte, and a newspaper reporter not only reported McKendree's message, but caught some sense of his personality:

> Mr. Long came forward and spoke for 10 minutes in an engaging fashion that held the interest of his audience unwavering. They were expecting an artist; they had not anticipated that he would be also a virile and polished speaker. . . . To inherited intellect and force of character, he adds the fervor of a deep-seated and intense passion for art. . . . He saw in last night's gathering an opportunity to say a word that might bear fruit in the advancement of art in North Carolina and the South, and he said it—said it spiritedly, said it in words whose earnestness flamed every syllable.

Despite all this effort, McKendree changed direction in the early 1920s and gave up his career as an artist. To explain the switch, family members used a common Southernism: "He got religion." But rather than a sudden conversion, the need for a new direction seems to have been building over time. Contributing to it may have been his inability to achieve the kind of success he hoped for. The effort to sell himself and his art may have soured this idealistic young man.

No doubt, part of his decision was a crisis of faith. The first tangible evidence of it came when he was in London. Among the papers he left after his death was a sheet headed "Metropolitan Tabernacle." This was the London church founded in 1861 by Charles Spurgeon, a famous nine-

teenth-century evangelist and fundamentalist who was in some ways a prototype for the evangelists and televangelists of twentieth-century America.

Dated July 25, 1912, and signed by Llewellyn Edwards, assistant minister, the handwritten note reads, "This is to certify that McKendree Robbins Long has today been baptized by me, on profession of his faith in the Lord Jesus Christ. . . . We have found him a loyal and earnest helper, and heartily commend him to the friendship and fellowship of any church with which he desires to associate."

Like other members of his family, McKendree had been baptized a Presbyterian. But apparently, he felt some need to reaffirm his faith. As often happens with young men, he may have strayed from it. Perhaps being far from home intensified feelings of loss.

World War I also had an impact. He was thirty years old in the summer of 1918, just after the United States entered the war. That August, his second child was born. Nonetheless, McKendree enlisted and became a sergeant with the Sixty-fifth Base Hospital in France. Reflecting on his war experiences years later, he said, "You can't see young men suffering and dying without undergoing a deep change."

McKendree became a Presbyterian minister in 1922. Always the spiritual pilgrim in search of a deeper experience, he scandalized his family thirteen years later by becoming a Baptist, joining a denomination that suited his emotional style and fundamentalist views.

After several years at Presbyterian churches in Statesville and Macon, Georgia, McKendree decided the institutional church was not for him and embarked on a career as a traveling evangelist. At least initially, he may have had in mind imitating Spurgeon's success, which was based not in the institutional church but on his skills as a preacher and writer so popular his Sunday sermons sold by the ton.

McKendree traveled through the smaller cities and towns of the Carolinas and into Georgia and Tennessee conducting revivals. Like others plying the same road, he developed a "hook," a handy label based on his life before he was saved. McKendree's hook, as one newspaper headline

proclaimed, was "A Picture Painter Of The Gospel."

And so he was. He sprinkled his literate, dramatic, and somewhat flowery sermons with allusions to artists such as Tintoretto, painting vivid word pictures of biblical passages. He delivered his sermons in a thundering style, "walking the pulpit," transmitting the word with gestures and his deep, compelling voice. Once an evangelist for art, he now sought to save souls.

McKendree was intoxicated by words, especially his own. He had been brought up in a Presbyterian tradition that eschewed religious imagery, and besides the conflict between art and religion, he felt another pull between the image and the word. Ben Long, in addition to inheriting his grandfather's drawing skills, picked up his interest in words and entered college as an English major.

Throughout the 1920s, McKendree wrote a great deal, filling notebooks with his theological ideas. While he was at Vineville Presbyterian Church in Macon in the mid-1920s, he published a pamphlet titled "A Sermon, Sermonettes and Sayings." Included were pithy epigrams such as "Men accept a worn coin if the ring is true, but the newly stamped counterfeit deceives no one but fools. Modernism is the last named coin."

During the twenties and thirties and into the forties, McKendree made little art save the drawings of animals and Indians with which he delighted his children and grandchildren. By the fifties, he was Grandmac to family and friends, a character once familiar to Southern towns. He dressed in a white suit, black tie, and old-fashioned wing collar. Once, on the streets of Statesville, thinking someone had insulted his son-in-law, he challenged the alleged malefactor to a duel. And when he walked to his studio, Grandmac, who into his seventies enjoyed hunting with a bow and arrow, carried his brushes in a quiver.

He had begun to paint again.

During the last twenty to twenty-five years of his life, Grandmac did several hundred oil paintings, primarily on two themes: the Lady in Red and the Book of Revelation.

The subject of the former paintings, numbering thirty to forty done

mostly in the 1950s, is a beautiful, buxom woman often depicted nude or seminude but usually wearing a red dress. She is almost a caricature of Victorian voluptuousness, with dark hair held at the back of her head in curls, large blue eyes, pointed features, and large breasts. The Lady in Red was a rich and complex image for McKendree. On her, he vented his sexual desires and fantasies. At times, she appears literally as "a scarlet woman," depicted in furs and jewels, representing the world's snares and temptations.

In other works, perhaps the most significant of the series, McKendree and the Lady in Red appear together, at times living with children of their own in a mountain retreat. In these works, he seems to have reimagined his life, painting what it might have been had he continued his career as an artist.

One painting, *Veiled Immensities*, shows a young, Victorian-looking couple sitting on a rock overlooking mountains and clouds. It is McKendree and the Lady in Red. The title is a pun. It refers to the mountain peaks hidden in the clouds, but also to the young woman's breasts, concealed by a modest dress, and to the rock on which they sit, deliberately shaped to represent a phallus.

Another painting, *Flying Dreams*, depicts a scene in the woods. On the left, an artist with a Vandyke beard kneels by an easel, his palette on the ground. Standing behind him is a winged angel in a red gown holding a large cross. A cherub above sprinkles flowers.

The artist looks to a vision on the right, the Lady in Red in her customary red dress, this one with puffed sleeves. She is uplifted by Father Time, holding a scythe. With a tear in her eye, she beckons to the artist with her right hand. Floating in the air around this figure are six other depictions of the same Lady in Red, richly dressed and seminude, with breasts exposed.

While the artist looks more like a representation of "The Artist" than Grandmac, the painting clearly expresses the conflict he felt between art and religion. It is infused with a sense of faith, a sense of loss, and a deep sensuality.

The Lady in Red paintings embarrassed the family, canvas after canvas filled with sometimes lurid imagery. "The 'Red Lady' is cheap," said Caroline Avery, Grandmac's daughter and Ben Long's aunt. She, like other family members, professed not to know who the woman was or what the paintings are about.

The answers lie in Grandmac's papers, left at his death to the Department of History of the Presbyterian Church (USA) in Montreat, North Carolina. On a typed page dated September 19, 1958, are five "Sonnets to S," written when Grandmac was seventy years old. The lower right-hand corner has a head-and-shoulders drawing of the familiar Lady in Red, with her pneumatic breasts exposed.

A long love letter, apparently addressed to her and dated April 10, 1951, when Grandmac was almost sixty-three, reads in part, "Ah—Dearest—Dearest—you will read this in my own city—in the year of our Lord. Perhaps at a time, in my saddest month—when, knowing you had married Charles Bryant—I literally died, as you already know, and was brought back to the land of the living by a holy man's prayer!"

It continues, "You will read this, perhaps, reclining, in your new, sweet, maid's orpulence [*sic*] of physical and spiritual perfection, my own Galatea, whom my dying arms brought to life, as, clasping Her feet in worship still—Christ made you into my own Susan Meriwether again!!"

In Greek mythology, Galatea was the statue brought to life by Aphrodite, the goddess of love, in answer to the pleas of Pygmalion, the sculptor who had fallen in love with his own creation.

Whether she was a fantasy or a real person is not clear. However, the Lady in Red did have a name.

The Book of Revelation paintings came next. In a 1961 newspaper interview as he began the series of some eighty works, McKendree said he chose Revelation because "it is the most picturesque book in the Bible." Grandmac had long been drawn to this last book in the New Testament, which describes the struggle between good and evil and the triumph of Christ and his church, filled with visions of the Apocalypse and the Last

Judgment, of monsters and hellfire. But his interest was not just in picturesque images. The Book of Revelation gave him a framework on which to hang his world view.

Grandmac, the anti-Darwin, antihumanist fundamentalist, saw the modern world as doomed. He believed the Apocalypse described in Revelation was about to happen: the impending nuclear destruction of the planet. That view was not unique to him. However, whether an artist's vision is original or not does not matter; what matters is that the artist believes passionately in his vision, with sufficient force of emotion to make the viewer feel what he feels, and that he finds the appropriate visual vocabulary to convey his passion.

Grandmac's Revelation scenes go far beyond depicting what's in the Bible. Many of them include contemporary and historic figures such as Soviet Premier Nikita Khruschev and astronaut Yuri Gagarin, Abraham Lincoln, and Robert E. Lee. Some Revelation scenes are presented in contemporary settings.

A painting of the description in Rev. 8:7 of hail and fire mixed with blood falling on the earth, burning the trees and the grass, is set in Grandmac's beloved North Carolina mountains. Blood, hail, and fire fall on a placid lake. As animals painted in the foreground flee, two couples in a canoe react. A man jumps overboard as a woman stands in alarm. But the other couple continues to kiss. Grandmac could find humor in the end of the world.

His masterpiece is an apocalyptic vision of hell, a large painting almost four feet by six feet, sometimes described as *Apocalyptic Scene with Philosophers and Historical Figures*. On the right on a ridge overlooking a fiery lake is a smiling Grandmac in a suit and tie. Next to him is Dante, the Italian poet who wrote of his travels with Virgil, the Roman poet, through the inferno of hell in the *Divine Comedy*. Below, on the edge of the lake of fire, is a line of people harassed by blue demons holding pitchforks. Here, Grandmac put a fundamentalist's cavalcade of secular enemies, among them Charles Darwin with a monkey on his back, Sigmund Freud, Karl Marx, Albert Einstein, Francis Bacon, and Marcus

Biblical scenes by McKendree Robbins Long took
a decidedly apocalyptic turn, with devils and rivers of blood.

COURTESY OF MAX JACKSON

Aurelius. The Lady in Red is there, although this time she wears a pink dress. Another female figure looks like Marlene Dietrich as she appeared in *The Blue Angel.*

In the fiery lake are Stalin with a hammer and sickle, Hitler with a huge snake wrapped around him as he grasps at a swastika, Mussolini with his bundle of rods—the "Fascisti"—and, barely visible, the mitered head of a pope. On the left is another spit of land, crowded with people trying to avoid the pit. Many are finely dressed, men and woman in evening clothes, the clear implication being that riches and status offer no passports to safety. Several climb up a steep cliff, many falling off, a passage reminiscent of Michelangelo's *Last Judgment* from the Sistine. These nude figures, male and female, are beautifully rendered. In the background are the dragonlike monster of Revelation and Calvary with its three crosses.

Grandmac, who couldn't resist a pun, has one of the secular figures holding a rolled piece of paper labeled "The Bull of the Philosophers," using "bull" in the duel sense of a papal decree and "bullshit." One of the blue devils sets the paper on fire.

However skilled, the Revelation paintings are not as polished as his early works done before and immediately after World War I. Some pictures have mistakes the young artist would have never made, such as a hand turned the wrong way. Some passages are crudely painted. Also, the colors are neon-bright and jarring, not the brown soup of the Old Masters. Family members blamed what they saw as technical lapses on Grandmac's failing eyesight and health. Perhaps they were—in part. But more likely, he had found a language suited to what he wanted to express. He no longer was concerned with technical finish, but instead with what he wanted to say. These paintings have a directness and vitality his earlier work sometimes lacks. Yet they still show the hand of a skilled artist—for instance, the ability to convincingly handle large groups of figures in space and to paint the human body.

The sense these paintings give is that their creator made them because he had to. He was under a compulsion, as all great artists are, to get outside himself and onto canvas what was inside. He worked hard, relentlessly.

Finished with one painting, he would stack it against the wall and begin another, eventually filling his attic with these hair-raising pictures. The conflicts of his life, intensity of his beliefs, depth of his passions—all of these are in this body of work, the Lady in Red and the Revelation pictures both. In his seventies, nearing the end, he secured a great achievement: he brought his feelings and the events of his life into a unity.

While family members loved and honored him, they for the most part could not recognize the greatness of his late paintings. When Grandmac's work began to get a wider audience, one family member, referring to the "redneck religiosity" they espoused, expressed the wish that they had been burned. Family members coveted the early paintings. But in one case, one of the religious paintings was not on a wall, but stored in a dusty purgatory under a bed.

———

Ben Long did his first oil painting when he was about fifteen years old, a portrait of Olympic track star Jesse Owens copied from a magazine. He watched Grandmac paint, sometimes painted alongside him, read his grandfather's glossy art books, visited art museums with him, and absorbed many an influence. But Grandmac was not a teacher. "He was too loving," recalled Long. "He was not someone who would tell you straight. He would praise everything."

As a teenager, Ben Long tried to arrange to study with a leading American realist painter he admired, Andrew Wyeth, writing him and sending him some drawings. Although not taking students, Wyeth was impressed and wanted to arrange for Long to study with his sister, Henrietta Wyeth Hurd, wife of the painter Peter Hurd. But she was ill.

The family tried to arrange lessons. Grandmac's sister, Marie Land, called "Aunt Mam-mee" by the family, offered to pay for them.

She was a formidable figure, one of several such women in the Long family known for their practicality and strength of character. Nanny, Grandmac's wife, wrote a newspaper column titled "Fitful Flashes" for many years; when the newspaper she worked for merged with another, she started her own. Aunt Mam-mee and her sister, Lois Riker, had their own

business, the Dixie Dame Company, which made jams and pickles, more particularly "Pickles with a pedigree."

Aunt Mam-mee's offer to back her nephew came with a hitch: if young Ben was to take art lessons, they had to be commercial art lessons so he could make a living. Nothing came of that, either, but the episode left a mark.

Grandmac never made much money from his art—or anything else he did. The letters he sent out to drum up revivals plainly stated, "No budget, guarantee nor public appeal for money will be made during our campaign." When he was making art in his later years and someone dropped by his studio and admired a painting, Grandmac would give it away. His wife worked to support the family.

Their daughter, Caroline Avery, had to drop out of college because there was no money. When her father died, she sold the stacks of paintings he left, some unframed and rolled up, for a few thousand dollars. She wanted to get them out of the house, but it also seemed as if she wanted to at last get some material gain out of Grandmac's art. Ben Long, however, regretted the loss of the paintings, some of which he felt Grandmac had promised to him, and would not forgive his aunt for selling them.

Some of the paintings eventually showed up at flea markets and were bought cheaply by sharp-eyed collectors. This had the effect of getting them before a wider audience, and individual works by an artist who had never tried to market them began to sell for as much as six thousand dollars. A gallery in New Orleans sold them under the fashionable rubric of "outsider art"—art made by untrained hands—which was a misnomer in Grandmac's case. The Smithsonian Institution's National Museum of American Art in Washington bought one of the Revelation paintings in the late eighties, and Davidson College and the North Carolina Museum of Art showed McKendree's work, giving him overdue recognition.

In his impressionable young years, Ben Long had conflicting feelings about art and commerce. He identified with his grandfather and felt rejected by the female viewpoint in his family, as represented by Aunt Mam-mee. He put his feelings into one of the stories he told about his family,

about how he and his cousin Marie stood at Aunt Mam-mee's deathbed and heard her say she would leave all she had to Marie but only a dollar to him. The story was fiction. As Marie related it, Aunt Mam-mee died in Asheville in the company of her black maid. But the story showed how deeply the episode of the commercial art lessons cut.

Later, when he felt the need to make a living from his art, Long's inherited sense of idealism would lead to ambivalence about money, making it difficult for him to talk honestly and openly about it and affecting the course of the St. Peter's fresco.

As an impressionable young man searching for the artists who would be his spiritual fathers, Long, through the agency of his grandfather—a nineteenth-century man who carried his personal view of art into the twentieth century—chose Rembrandt and Velazquez, Titian and Michelangelo, rather than more recent or even contemporary artists. He looked back in time, rather than at what was happening around him.

He and Grandmac were alike in so many ways. Their careers and the art they made share many similarities.

Yet Ben Long could not recognize the greatness of Grandmac's late works, the breakthrough represented by the Lady in Red and the Revelation paintings, nor achieve a similar emotional breakthrough in his own work. He preferred the technical skill of his grandfather's earlier works to the honest feeling of the later works. He received so much from Grandmac. But in his own journey as an artist, Long went in a different direction.

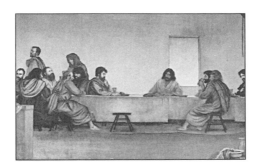

CHAPTER SEVEN

Annigoni

In August 1970, Ben Long took a commercial flight from Da Nang to Florence via Hawaii, New York, and Milan, arriving in Italy on a Sunday morning. He'd flown halfway around the world to make what he felt was a last, almost desperate attempt to find a teacher. Fresh from the field in Vietnam, his hair clipped to his skull, his two-tone face white and sunburned red from wearing a helmet, he felt out of place in a city filled with the achievements of the Renaissance.

The Marine Corps had offered him a thirty-day leave and a flight to anywhere in the world if he extended his tour. Determined to get out of his Marine Corps service the duty he'd been promised, being a combat artist, Long already had extended once but was sent back into combat. Being a combat artist still mattered. But the chief inducement to reenlist-

PHOTOGRAPH COURTESY OF
CHARLOTTE OBSERVER

ing was the opportunity to fly to Florence and meet Pietro Annigoni.

A UPI reporter in Vietnam had shown Long a book on the Florentine artist. Long could not believe someone like Annigoni existed, working with the technique of the Old Masters he so much admired. He had no idea if Annigoni would take him as a student, or even if the artist spoke enough English to understand him. But after several failed attempts at finding a teacher, and feeling that, in his mid-twenties, he already was too old to be embarking on his life's work, Long was determined.

When he arrived, Annigoni was in Ireland, so Long cooled his heels. Just two days before he was to return to Vietnam, Long wrangled an introduction through a pompous gallery owner he plied with wine. Breathless after climbing the several flights to Annigoni's studio near Santa Croce, Long anxiously introduced himself. Annigoni, in his sixties, said he no longer took students. Long showed him five or six drawings he'd done in Vietnam. Since Long was involved in a war, Annigoni said, perhaps he should wait for another time. He had no time to wait, Long countered. "You're the last chance I have to see whether I can be an artist or not," he said, adding he'd be willing to do anything—mix paints, stretch canvas, sweep floors.

"All right," Annigoni said. "If you come to Florence, I will help you."

Telling the story, Ben Long mimicked his master's voice, dropping into Annigoni's deep baritone and at the same time dropping his chin to make his face look like the jowly Florentine's. Yet his love and respect were obvious. In Annigoni, Long found the guidance he'd been looking for.

A successful artist with a reputation in several countries, Annigoni also became a second father, influencing Long in style as well as substance. But Long's coming to Annigoni held a paradox. Long wanted a teacher, but Annigoni was never his teacher in the accepted sense. Long came wanting to learn how to paint in oils, the supreme technique of easel painting. Annigoni, he found to his great disappointment, did not use oils but a different technique to make his carefully crafted paintings. However, the Florentine did know how to paint in fresco. Long's learning the technique that marked his career was an accident.

———————

Like his grandfather, Long began his art career at the Art Students League in New York. He first studied at the University of North Carolina at Chapel Hill, as had his father and great-uncle. He enrolled in the university's writing and literature program. Interested in figurative and realistic art, he felt no affinity for the university's art department, then marching, as were art departments all over the country, under the banner of the current orthodoxy, Abstract Expressionism.

In the mid-1960s, Long was aware of the burning issues that attracted the energy of many of his fellow students: civil rights and Vietnam. But he was for the most part uninvolved. He was a fraternity boy, a member of Phi Delta Theta, a hell-raiser who enjoyed drinking and partying. Bright, with a love of words and of reading, he was nonetheless an indifferent student.

In January of 1965, the second half of his sophomore year, he took a writing class taught by a young visiting professor from Duke University in nearby Durham. Reynolds Price had written *A Long and Happy Life*, his first novel, and *The Names and Faces of Heroes*, a book of short stories, the initial steps in a distinguished career. It was his practice to invite students to his home for a picnic-type meal and informal socializing. Price's house was filled with paintings and drawings, the kind of figurative work he liked. As a young man, he'd done a great deal of drawing and painting and for a time thought art, not writing, would be his life's work. When he was fourteen and in the eighth grade, he studied with a teacher named Crichton Davis who had been at the Art Students League and also wrote fiction. She encouraged Price in both pursuits.

Seeing Price's art collection, sensing he was a kindred spirit, Long told Price he was interested in painting and drawing. Price asked to see some of his work. That spring, Long brought him several sketchbooks full of drawings, mostly portrait heads. Price was amazed that a shy, almost taciturn young man who looked like a football player could produce such "enormously impressive drawings."

Long, who had drawn steadily through college, realized by his junior year that writing was only a substitute for what he really wanted to do.

Price's encouragement gave him the push he needed. What immediately came to mind was studying where his grandfather had, but he didn't even know if the Art Students League still existed. A call to his Uncle Tommy in New York confirmed that it did. Despite the dismay of his family and the objection of his father, Long left Carolina before getting a degree and, with about seventy-five dollars in his pocket, headed north.

In the half-century since McKendree Long had been a student at the Art Students League, the American art world had changed drastically. Yet by the mid-sixties, the league was not substantially different. The Ashcan painters had looked to Europe, France in particular, for inspiration. But after World War II, the mantle of the avant-garde had passed to American artists, and New York, not Paris, was the new art capital. Now, abstraction for the most part had run its course, and the beginnings of a comeback of sorts for figurative and realistic art appeared in movements such as Pop Art and Photorealism in the 1960s and 1970s. Long, however, still felt himself an outsider. He disliked abstract art, felt no affinity for its aims and methods, and considered masters such as Jackson Pollock and Robert Motherwell little more than frauds. Neither did the latest turns of contemporary art impress him. He felt comfortable with the traditional methods taught at the league, although the kind of solid training he sought eluded him during his year in New York.

He studied with two teachers, Robert Beverly Hale and Frank Mason.

Hale taught anatomy. After his hour-long lecture, a model posed for the rest of the morning and Hale critiqued students' work. Hale knew his subject from the bones outward. Never, he told his students, trust the nipple or the navel: "Like traveling salesmen, they're all over the place." Rather, students should base the proportions in their drawings on a fixed point such as the trochanter, or hipbone.

Long found Mason's rather romantic painting style congenial and approached him outside of the classroom, trying to attach himself to him as an apprentice. Mason was lukewarm about sharing his hard-won knowledge, but he was looking for someone to help him build a bathroom and kitchen in his studio. He would exchange lessons for carpentry skills.

Long made one other attempt to connect with a teacher. He was attracted to the work of Edward Hopper, an artist in the realist tradition whose cityscapes echoed with the alienation of modern times, a far more substantial body of work than, for instance, Wyeth's. Working nights as a doorman at a steakhouse uptown, living with his uncle in an apartment near Washington Square, Long hardly had money enough to buy clothes. Being a properly raised Southern boy, he borrowed a tie from his uncle to go with his battered seersucker jacket and arrived unannounced at Hopper's apartment.

A woman wearing a faded pink bathrobe answered the door with a smile. Long explained his mission. The smile disappeared. "You have a lot of nerve, coming into a famous artist's studio," Long remembers her saying. Before the door slammed, he caught a glimpse of the sickly looking artist lying on a couch. Hopper died in the spring of 1967. As with Wyeth, Long again failed to connect.

Before he could get much more out of New York, Vietnam intruded. An artist he met who'd had an unusual career swimming against the modernist tide offered a suggestion. Harry Jackson had been a protégé of Jackson Pollock and a fixture on the New York art scene. But he had become a pariah by turning against abstraction and making figurative sculpture based on Western motifs. Jackson had been a combat artist in the marines during World War II, and he suggested Long do the same in Vietnam. If he had to go, at least Long could have some control over what he did in the military.

But when he arrived at Parris Island, South Carolina, in October 1968 for basic training, Long found the marines wanted riflemen, not artists. Vietnam was heating up. In 1967, the United States had 480,000 troops there. By 1969, the number was 543,000, the highest level of the war, reached after grim milestones such as Khe Sanh and Tet.

Before his induction, Long was scared. A friend, a member of his high-school class, had died in Vietnam. Yet he never seriously considered using the means employed by so many of his generation to avoid service. He had a sense of duty rooted in the honor of his family. His father and grandfather

had fought in their wars. He would fight in his. But he was no rabid supporter of the war, no gung-ho soldier. In late-night bull sessions, he and a few of the other young officers he met in Vietnam came to an agreement on why they were fighting. "You're not doing it because you want to go to war," Long recalled their concluding. "You're not doing it to win medals. You're not doing it because you're smarter than anyone else. You're doing it because somewhere down the line, you might be able to save some lives. That was the idea. And the majority of marine lieutenants that I knew—one or two were gung-ho assholes that you could do without—but the majority of them were trying to take care of their men."

Long led a combat platoon in the Third Marine Division near the demilitarized zone and the Ashau Valley, at times in contact with the enemy every day for months. After serving a thirteen-month tour, he could have gone home honorably. But he extended his time, serving a total of two years and three months, stubbornly hanging on until, at the end, he got several months as a combat artist. He did closely observed and finely wrought drawings such as *Snipers in Hedgerow*—now in the United States Marine Corps Art Collection in Washington—depicting a tense radioman and another soldier in a shallow foxhole scanning a line of trees and a machine gunner about to fire. It was only as a combat artist traveling with a company in the Ashau Valley that Long was wounded, hit with shrapnel in his right arm, for which he was awarded a Purple Heart.

Not only the desire to be a combat artist held Long in Vietnam. "I loved it in a funny way," he recalled. "It was so extreme, such a different test of reality for me." He also had little use for the parade-ground marches and the polishing of belt buckles and shoes he knew would be his lot if he went home waiting for discharge.

Finished with Vietnam, Long took several portrait commissions in North Carolina to supplement the money he had saved and in April 1971 headed for Florence, pursuing his dream.

———

Chuck Kapsner, who arrived in Florence two years after Long, got there by a different route. He did not go through Vietnam. And he was interested

in fresco from the outset. He never expected, however, to go all the way to Italy only to learn the technique from a fellow American.

Seven years younger than Long, Kapsner grew up in Little Falls, Minnesota, a small city in the middle of the state best known as the boyhood home of American aviator and hero Charles A. Lindbergh. Kapsner's father was part-owner of a road-construction company. As a child, Kapsner would come home from the quarry and exercise his love of drawing and fascination with things mechanical by making pictures of the trucks and machines.

A Catholic, he was introduced to Renaissance art as a first-grader at St. Mary's School. To teach Bible stories, Sister Mary Altar would pass out illustrated cards. Kapsner well remembers his first card: a reproduction of Fra Angelico's *Annunciation*, a fresco on the second floor in the dormitory of the Dominican monastery of San Marco, now a museum. When he got to Florence, he bounded up the stairs to see it.

Kapsner went through a phase of drawing monsters and of Surrealism, when he was enamored of the work of Salvador Dali. Yet his work always was anchored in the real. Because of that, he found the environment unsympathetic when he entered the art department at St. Cloud State University. He wanted to learn how to draw but could find no one to help him. Soon, he was thinking of Italy. Correspondence with the Italian government yielded the addresses of nine schools in Florence, Rome, and Perugia. One, the International University of Art in Florence, answered his query in English, French, and Italian. He decided to go there.

Kapsner looked at the school as a way of getting his feet wet in Italy, learning the language, and seeing what opportunities were available. His course of study was restoration, for the most part the techniques perfected after the 1966 flood. Kapsner built a firm technical foundation, learning from experts such as Eva Macini and Umberto Baldini, who had worked on "The Great Age of Fresco" exhibition, and Gianluigi Colalucci, who in the 1980s headed the restoration of the Sistine Chapel. Later, after assisting Ben Long, Kapsner did his own frescoes in Italy, Minnesota, and Glendale Springs, North Carolina.

They met in the fall of 1973. A friend told Kapsner about nighttime drawing sessions at Long's studio. Through friends, Kapsner also learned of the Studio Simi, an atelier run by a small, birdlike woman named Norina Simi. There, he found his *maestra* and fulfilled his ambition to learn how to draw. "The Signorina," as Kapsner always referred to her, had a studio near Via Tripoli where perhaps forty students gathered each day. Her father, Filadelfo Simi, had studied in Paris with Jean-Léon Gérôme, a pillar of the art establishment and opponent of the Impressionists, imbibing from him the tenets of the French academic system.

The Signorina's classes were strict and structured: a nude model in the morning for three hours and a portrait model in the afternoon for three more. The pose stayed the same for two weeks. Using charcoal for the wide variety of tones it produced, students were expected to do one detailed drawing in each class.

They learned how to see and reproduce what they saw, to measure, and to use shading to capture light and form. The Signorina had little interest in individual expression, certainly not until a student had worked at the basics for several years. Students, she believed, should not be too precious about their work. Laura Buxton studied at the Studio Simi in the early 1980s, briefly overlapping Kapsner's stay. The Signorina, she remembered, would walk through the forest of easels to look at what students were doing. "She'd come along with her shaky hand and stick her little finger out, and she'd go like this, and her finger would smudge all down the bit you'd just spent hours working on—I mean with such intensity. I often used to end up in tears."

Kapsner was a favorite of the Signorina. He studied with her for seven years, and when he mentioned painting, she'd tell him to wait, to first build a firm foundation in drawing. How skillful he became showed in the beautifully shaded charcoal drawing of a cape and walking stick he did for the *Agony* portion of the St. Peter's fresco. His art outside his work with fresco consisted of portraits and meticulous still lifes.

Kapsner had a sense of the tradition of figurative art reaching back to the Greeks and felt part of it. Like other members of the fresco team, he had

great respect for technique and the hard work it took to master it. He saw
figurative and abstract art coming from two different views of life, almost
from two different views of the world. Those who asked why he didn't do
more contemporary or abstract work, he thought, didn't understand the
difference in temperament and commitment involved. He felt some artists
were more interested in playing a role than being artists. He dismissed them
as being "artsy-fartsy."

Long would agree. But within the figurative tradition, his approach
differed from Kapsner's. His draftsmanship was looser, more spontaneous
and free. Simi's exacting approach, he thought, threatened to squeeze the
life out of a piece of art. At the nighttime sessions in his studio, he did
twenty-minute drawings, working quickly to get down the sense of his
subject. Long believed in the importance of technique, but he found the
Simi approach too tight, too restrictive.

Long and Kapsner differed in other ways. Kapsner was more organized
and always on time. Not at all shy, he was comfortable dealing with people.
A flashy dresser, he favored brightly patterned shirts and boots made of
ostrich leather and calfskin. In a celebratory mood, Kapsner would light a
Hoya de Monterey Excalibur, a cigar seemingly the size of a baseball bat.
Kapsner liked cars, while Long was content to bum a ride in whatever was
handy. *

Kapsner was Long's alter ego. To get through to Ben, it was often wise
to talk to Chuck, something the priests at St. Peter's learned. Knowing
Long was unable to say no, Kapsner would do it for him, at times telling
a telephone caller "Ben's not here" when Long was standing next to him.
Kapsner was one of the few people who could tell Long—who does not like
criticism—that he was wrong.

Kapsner paid attention to his career, did things such as produce a
brochure about himself and his work. Long neglected career basics such as
keeping a record of his work in photographic slides—of the dozens of
drawings he did for the fresco, for instance. Kapsner took slides for him. In
addition, Kapsner had a patron, Laura Jane Musser, the daughter of a

timber tycoon. She had studied music and lived in New York before returning to Little Falls, where she used her inheritance to further her interest in classical art. She sponsored several projects Kapsner was involved in, including portraits and other paintings commemorating the exploits of Lindbergh, which hung in Little Falls and in Paris.

Long and Kapsner also were opposites when it came to handling money. Kapsner, who'd spent a semester in business school, managed his carefully. When Long had money, he spent it. When he didn't have money, he spent someone else's. He would rather pick up a tab than hassle over who owed how much. After meals, Kapsner always got a receipt for his tax files. Long couldn't be bothered. He paid Kapsner ten thousand dollars for his services on the St. Peter's fresco, leaving Long with ninety thousand. Yet when the project ended, Long complained that he was broke, could not understand how Kapsner had managed to buy a second Mercedes sedan while he couldn't pay his bills. At times, the two felt some rivalry and resentment: Long over how Kapsner made art pay, Kapsner over the attention given Long. Yet their differences, as well as a brotherly love and mutual respect, drew them together.

Ben Long's first studio in Florence was on Via Degli Artisti, in an apartment block built as artists' studios. It was a large, open room with a small bathroom and a kitchen area, tall windows, and a high ceiling. It served as both studio and living space, occupied by Long and Diane Griffin, a pretty woman with reddish hair and blue eyes who came to live with him. They met where many a Carolina romance begins: at the beach. They later married. On Via Degli Artisti, Long eagerly began to make himself into an artist.

It was a magic time. He had made it through the war in one piece. Florence was filled with art and inspiration, shops selling the necessary materials, cheap places to live and eat, and many a good bar. There was time to learn without the pressure of having to be an immediate success. There was joy at the freedom to finally pursue his heart's desire after what had felt

like several false starts. Looking back, even through the hurt and bitterness of a broken marriage, Diane recalled with respect Ben's hard work and dedication when he first arrived in Florence.

His day began with strong Italian coffee, sometimes two pots of it. When Tony Griffin, Diane's teenage brother, lived with the couple while attending art school, it was his job to put the coffee on. Most mornings, Long went to Annigoni's studio on Borgo Degli Albizi. Annigoni had plaster casts of classical heads and hands in the attic, and Long would draw them.

When Long ran into a problem he could not solve, he asked Annigoni, who in particular helped him with his drawing and gave him advice: "You must work and work and work and draw and draw and draw." Later, Long would say what he got from Annigoni was an attitude: "His was a profound seriousness that you don't get in the States. He felt a moral obligation. He was a great practical joker, but deadly serious about his work. No matter how late he'd stay up drinking the night before, he'd be up early the next morning, hard at work."

For the most part, however, Long was on his own. He taught himself how to be an artist through books, constant practice, and trial and error. He devised a rigorous course of study. Each morning, he did anatomical studies at the drawing board and a quick sketch in oil. In the afternoon, he set himself another kind of problem, such as painting a nude or a self-portrait. Several nights a week, there were the sketching sessions with friends, each chipping in a couple of thousand lira for the model and, if necessary, the "gas a bombola," the bottle of propane needed to heat the studio when a cold wind blew off the Arno.

Long and his friends also took sketching trips into the countryside around Florence, looking for scenery to draw—art in out-of-the-way places—and a trattoria where the food was plentiful and cheap. On one such excursion, they stopped near Arezzo to see a little-known masterpiece in a cemetery chapel outside the small town of Monterchi, Piero della Francesca's fresco *Madonna del Parto*, the "Madonna of Childbirth." Best known for his fresco cycle "The History of the True Cross" in the Church

of San Francesco in Arezzo, Piero here depicted the pregnant Virgin standing in a blue gown and flanked by two attendants, with her left hand at her side and her right hand gently touching her swollen belly.

After just a few months in Italy, Long almost self-consciously transformed himself into an artist in appearance. He began to wear smocklike shirts, a vest or scarf thrown across his neck or shoulders, his pants tucked into his boots, and, in warm weather, a broad-brimmed straw hat. His dark, ginger-colored hair grew long, and he eventually added a beard to the mustache he'd had in Vietnam.

In the spring of 1974, Bo Bartlett met Long. Just eighteen years old, James W. "Bo" Bartlett III was fresh out of high school in Columbus, Georgia, and determined to be a painter. He had no training, had heard only of Norman Rockwell and Pablo Picasso, an unlikely duo. But he did know of the Renaissance, and with money he'd saved working after school, he went to Florence.

Bartlett spent his time visiting museums and sketching. One day, he was drawing a sculpture of a saint in a niche outside a church. He'd spent what he considered a long time on it—an hour—but noticed that while the Italians passed him by with barely a glance, they stopped to look at the work of an artist sketching a statue a few steps away. Bartlett introduced himself and asked the artist how long he'd been working on what he could see was a beautiful drawing. "Four months," came the reply.

Lance Bressow was an Australian, one of many English-speaking artists in Florence at that time, all of whom eventually met at one bar or another. "Who is the best artist in Florence?" Bartlett wanted to know. "Ben Long," replied Bressow.

Visiting the studio on Via Degli Artisti, Bartlett was impressed with the paintings he saw, several large nudes with the figures foreshortened. Expecting Long to be an old man, he was surprised to find a young American, only twenty-nine years old and a fellow Southerner. Long wanted him to pay for lessons. Bartlett couldn't afford to. Instead, he helped with chores around the studio. Bartlett studied with Long for less than five months. But it was an intense time. And although the two later

had a falling-out, Bartlett never forgot or failed to recognize Long's impact on him.

The first lesson was that an artist must respect, even love, his materials and tools. Bartlett could see everything in Long's well-organized studio was in its proper place. His assignment was to wash some bristle brushes. Dissatisfied even after several washings, Long told him to wash them until the soap bubbles were white. Then Long needed a perfectly clean and dry jar to make varnish by pouring turpentine onto crystals. Bartlett worked to remove every speck and blot every drop of water. "It was like beginning to learn everything from the bottom up," he recalled.

At that time, Long began his day early but usually would procrastinate, would not settle down to work until afternoon. Mornings, he'd walk through Florence at his usual fast pace with Bartlett in tow, searching for a particular brush or special kind of cheesecloth. While they walked, Long would tell his student how he'd told Diane when she moved to Florence that art was first with him. If she wanted to come along for the ride, fine, as long as she understood that. When Long got a studio near Santa Croce, he had Bartlett sweep it and mop it several times and let him work there.

Long told the young man he must learn how to draw. He gave him assignments—told him to draw a gnarled root or a goat's skull—and reviewed the finished work, writing suggestions on the drawing. Feel out the drawing first, Long taught him; don't just start drawing with a hard edge. Don't outline the subject. Don't work off your conception of it; really look at it. Start with the darks. After you place the darks, move up from there.

"Patience and will," Long wrote on one of Bartlett's drawings in his careful hand. The words became Bartlett's motto, his understanding of what it took to become an artist. Long had both, Bartlett believed, and also the talent to match his commitment. Later, Bartlett studied at the Pennsylvania Academy of the Fine Arts in Philadelphia and launched a successful career, showing in galleries in Philadelphia and New York. Yet he always listed Long as his first teacher, considering him his strongest influence.

After he left Florence, Bartlett began using patchouli. Especially when he faced a tough day in the studio, he would put it on. The scent reminded him to take his work seriously.

Long's sense of identification with Pietro Annigoni was strong. He did a drawing of himself wearing a beret pulled back on his head the way Annigoni wore his. He hung his glasses around his neck on a cord, as did his maestro. Long began dating his drawings with Roman numerals, as did Annigoni. And he picked up Annigoni's love of eating out as well as eating late.

By the time Long met him, Annigoni was a famous artist, although all his life he had felt pangs of self-doubt. Thick-bodied and strong, his black hair combed straight back, his face often serious—even somber—Annigoni had built a career as a portrait painter of the famous. Yet he felt trapped by that image.

He was born in Milan. His father, a mathematician and engineer who loved to draw, recognized his second son's ability. Annigoni studied art in Milan and Florence before World War II and fell rather willingly into a bohemian life. He was a well-rounded artist. He did a great many drawings, both painted and drew landscapes, and made paintings of allegorical and realistic subjects. Influenced by Rembrandt as well as the Renaissance masters, he did a fair number of self-portraits. Dissatisfied with oil painting, Annigoni discovered a formula through a Russian painter who had studied the techniques of the Old Masters. Annigoni made it his own. What he called "oil tempera" involved mixing pigments with egg yolk, egg white, stand oil, and mastic varnish. He made etchings. He also did sculpture. And he painted in fresco.

Besides his technical skill and reverence for the Old Masters, the defining characteristic of Annigoni's career was his opposition to Modernism. For instance, he and two other artists established a group called "Modern Painters of Reality" against what he saw as the insidious forces of abstraction. Rather than take the course of nonobjective art, he believed it was every artist's destiny to try to say something new with an old language.

Critics for the most part viewed him as an anachronism—or worse, a painter with great technique who had nothing relevant to say. But while the critics disdained his work, the mass of people liked it.

In 1954, having gotten his name around in London through exhibitions and portraits, he was commissioned by the Worshipful Company of Fishmongers to do a portrait of Queen Elizabeth II. Annigoni recognized it as the opportunity of a lifetime and approached it with his customary dedication. Unveiled in 1955, the portrait of the young queen in the blue cape of the Order of the Garter was a great success. It was reproduced in *Life* and other American magazines. Shown in the summer exhibition of the Royal Academy, it was seen by three hundred thousand people over three weeks. Annigoni, who "signed" the work with a tiny portrait of himself in a fishing boat in the background, greatly regretted not copyrighting the image. He did not repeat that mistake when he did the portrait of the duke of Edinburgh, the queen's husband.

Annigoni went on to do portraits of such notables as the Shah of Iran and John F. Kennedy. But while he enjoyed the fame and success, Annigoni did not like being pigeonholed as a painter of the wealthy. He used the money he made to free himself to do the work he considered his most important, most demanding, and best: his religious frescoes.

Annigoni grew up in a nonreligious household. Both parents were strongly anticlerical. Yet all his life, he felt a longing for faith, even viewing his struggle as an artist in religious imagery. As a student in Milan, he was called "Canonicus"—"member of the clergy" in Latin—a name inspired by his heavy frame and serious demeanor. He signed his early drawings "Canonicus" and later signed his work with a *C* followed by three crosses. For him, they represented Via Crusis, the hard road to the cross the artist must travel. Annigoni's student days were miserable, the time he developed his feelings of inferiority and self-doubt.

In 1937, Annigoni did his first religious frescoes at San Marco, a heady environment. Beginning in 1438, Fra Angelico with his assistants had frescoed the monastery's chapels, refectory, cloisters, and dormitory. Each

cell had one window and one fresco as a window on the divine. Annigoni's composition eventually filled five panels. In the arched central panel, he painted a Deposition scene, the lowering of Christ's lifeless body from the cross. Using gray tones, he depicted the broken body suspended by a cloth under the arms to support it as it is lowered by unseen hands. The painting is stark, simple, and effective.

Annigoni painted fictive architectural columns to separate the two flanking paintings, one with St. Dominic and St. Catherine and the other with St. Thomas and Girolamo Savonarola, the monk, reformer, and martyr who for a time ruled Florence before he was taken from his frescoed cell at San Marco in 1497, tortured, and then hanged and burned at the stake.

Annigoni again turned to religious frescoes in the late sixties, painting them in Maria Santissima del Buon Consiglio, the church in Ponte Buggianese, a small town west of Florence. His effort to cover the walls and dome of the church took years, so Long arrived in Florence in time to help. On these fresco projects, Long was Annigoni's apprentice, doing everything from crushing chunks of limestone and grinding white to mixing colors and applying paint to flat areas.

Annigoni had confidence in Long's ability. When he was commissioned in the early 1970s to do a fresco for investor and philanthropist Chauncey Stillman at his estate, Wethersfield, in Dutchess County, New York, he took Long. Stillman, who knew of Annigoni's portrait work in England, had a narrow room with a vaulted ceiling added to his house. He wanted it to be a "gloriette," a highly decorated room.

Annigoni did a classically derived, faintly mythological scene with male and female nude figures around the vaulted ceiling. He also frescoed three shallow niches on one wall, painting a fictive drapery in the central niche to frame Stillman's prized painting, the *Halberdier*, a portrait by Jocopo Pontormo of a young man holding a pike. After Stillman died in January 1989, the Getty Museum in Malibu, California, bought it for forty million dollars.

Annigoni did woodland scenes in niches flanking the Pontormo. In the right niche, he painted a handsome young hunter in the foreground and had Long paint Stillman, his butler, and Annigoni in perspective, each gesturing to the other to be still, except for the figure of Annigoni, who appears with his familiar beret and glasses and both hands raised, as if creating a disturbance. This inside joke offended Stillman, who apparently felt he had been portrayed in an undignified way.

Ben and Diane spent the summer of 1973 in a cottage at Wethersfield as a kind of honeymoon. They'd been married that spring in the North Carolina mountains, with the bride and groom dressed in Renaissance garb and friends performing music and bits of plays during a seven-course Italian meal.

By this time, Long had developed the outline of his career, spending most of the year in Florence and summers in North Carolina. He'd established a relationship with Anne McKenna and Kitty Gaston and sought, through them, portrait commissions to support himself. In this, he was lucky. Because of the hold of tradition and family, portraiture was more popular in the South than any other part of the country.

In 1974, at a ceremony in Ponte Buggianese marking the completion of another Annigoni fresco, Long got a surprise, one arranged by his maestro. The monsignor asked if he would like to do a fresco in the church. Long decided to do a trompe l'oeil work, a portrait of a man seeming to enter the church, titled *Wayfarer Entering into Church*, on the left side of the altar. It is balanced on the right by a tromp l'oeil portrait of an old woman by Silvestro Pistolesi, also an Annigoni student.

Modest and simple, Long's first fresco has a certain sincerity and conviction. It stands out in a church where almost every surface is covered with images. Behind the altar is Annigoni's *Last Supper* and in the dome his *Pentecost*. The surreal flavor of these works is even more pronounced in the *Deposition and Resurrection* on the rear wall. The figure of the dead body of Christ being lowered from the cross is the same image Annigoni used at San Marco. But here, angels lower the body as others blow trumpets. Above is a risen Christ outlined in gold.

Annigoni's frescoes are dramatic, theatrical, and at times overdone, as are others by some of his students. Pistolesi's old woman with a rosary is sentimental. Long's *Wayfarer*, as well as *St. John the Evangelist*, painted in one of the pendentives of the dome, seem more quiet, more focused.

Over the next several years, Long did other frescoes in Italy. In 1975, with Chuck Kapsner grinding lime and colors, Long did *The Miracle of the Eucharist* at a Franciscan church in Montecatini Terme, a resort city near Florence. His subject was a story about St. Anthony, how an old farmer tells the saint, "I'll take your Communion if you can make my donkey fall on his knees." Shown the bread and wine by Anthony, the beast kneels. Long perfectly captured the shock on the man's face.

Long, also with Kapsner, later did a triptych on John the Baptist in the chapel at Montecassino, the ancient Dominican monastery rebuilt after being destroyed by Allied bombing during World War II. The three panels depict John kneeling in the wilderness, baptizing Christ at the Jordan River, and about to be beheaded outside the wall of a city. Long also did an outdoor fresco, one of the fourteen stations of the cross, for a church in Buriano, outside of Florence. Kapsner also did a fresco there.

Long enjoyed these commissions and profited by the experience artistically, if not always financially. But what excited him from the beginning of his fresco work was the thought of doing one in the United States.

———

The model for the fair-haired "wayfarer" in Long's first fresco was Richard Fremantle, an English-American writer and art historian who has lived in Florence since the early sixties. Fremantle was Long's good friend, a collector of his work, and godfather to his first son. Fremantle also served as Long's artistic conscience, someone the artist trusted to give him the unvarnished truth. Constantly surrounded by companions who often were admirers, Long recognized his need for such a person. "Benjamin knows I'm his worst critic," said Fremantle. "That's because I believe in him."

Fremantle knew most of the other English-speaking expatriate artists in Florence, among them Richard Serrin, Charles Cecil, Daniel Graves, and Richard Maury. They tended to have similar backgrounds, such as study at

the Art Students League or a grant from the Greenshields Foundation in Montreal, which aids figurative artists. Long had both. Fremantle considered Long and Richard Maury the best of this group. Ten years older than Long, Maury—from Washington, D.C.—came to Italy in 1960 and studied briefly at the Accademia delle Belle Arte in Florence. Dissatisfied, he taught himself, producing nudes and interiors with a Vermeer-like clarity.

Not only was Fremantle the model for Long's first fresco; in a way, he also owned it. Fremantle lives in a converted medieval tower offering a splendid view of the Duomo and Florence's red rooftops. One night, Long came over and gave him a "fresco," a portrait he had done on a piece of roof tile filled with plaster. "This is in case you ever have a leak," Long told him. Fremantle believed Long's drawings for the Ponte Buggianese fresco, done after two years of hard work in Italy, marked a leap forward. Something clicked, and Long was a different artist.

However, in Fremantle's view, Long got hung up on his search to be an artist. Annigoni was not the kind of teacher he needed, could not teach him about subjects such as composition and color. If line and form are the strongest parts of Long's art, color is the weakest. Also, Long got caught up in technique. It became almost a distraction, an end in itself, and he had trouble getting past it. Finally, he'd developed a reputation in Florence, become in Fremantle's phrase "the captain of the football team." He was Ben Long, at the top of the heap of the English-speaking expatriate artists. Fremantle thought that became a hindrance.

"What happened is he came up against the business that drawings weren't enough anymore, that he had to do good paintings, and he had terrible trouble. He doesn't make on the whole very good paintings. I've seen good pictures by him, but most of them [are] not. And he struggles, and that's why he runs away from the studio."

Fremantle remembered a time he went to New York with his former wife, Chloe, an artist. They saw drawings by Hans Holbein in the Morgan Library. "I said, 'Some of Ben's drawings are as good as these,' and she

looked at me and said, 'Some of Ben's drawings are a lot better than these.' But that doesn't mean you know how to compose an oil painting, that doesn't mean you know about color. Those are things you can go out and learn. It's like a singer who can't carry a tune. You can learn how to carry a tune. Ben's a bit like that. For him to learn color at his age, go and study a color chart, is very painful for him to do, very difficult. And he struggles with that problem. The same with composition. You study. For him to go and do that, especially because he's captain of the football team, is very difficult.

"I just keep hoping Benjamin's deep love, which he has, will slowly make him realize that he's got to do a few little moves in order to liberate all that stuff."

It isn't enough to wait for the membrane to break. An artist must go into the studio and work to break through. Fremantle thought Long was in a good position to do it. He was in better shape physically than he had ever been, Fremantle thought. And the fresco in Charlotte was a big undertaking, the kind that could give an artist confidence. "Ben would like to make something beautiful, if he could," said Fremantle, who had not seen the St. Peter's fresco, "and maybe someday he will."

———————

It proved surprisingly difficult to find a wall to fresco in the United States. Long asked around, talked to people at churches in Statesville and several other cities. He was willing to do the work for free if the church would provide the materials. But he found little interest. In the summer of 1973, Long attended a party in Blowing Rock given by Philip Moose, an older artist who had befriended him. Also at the party was a young Episcopal priest named Faulton Hodge. Moose tapped Hodge on the shoulder. "See that man over there?" he asked, pointing across the room at Long. "He would like to paint a fresco in your church." Hodge allowed as how the congregation could barely pay the light bill, let alone buy a fresco. He brightened when Moose explained Long wanted to donate the work. "Great, we'll take it," said the priest. "But tell me, what's a fresco?"

A native North Carolinian, Hodge had gone to live in New York and after a spiritual experience decided to become a priest. After serving briefly at the Cathedral of St. John the Divine, he was reassigned back home. In his early forties in the summer of 1972, his hair and beard long in the fashion of the times, Hodge roared into the predominantly Baptist mountains on a Yamaha motorcycle with great hopes and enthusiasm. His parish had thirteen members and two small church buildings, one in a near state of collapse. He was interested in the arts as one way of adding to his flock.

In the summer of 1974, having done his first Italian fresco in the spring, Long began his first American fresco at St. Mary's Episcopal Church in the community of Beaver Creek, near West Jefferson. The unplastered chestnut walls of the tiny nineteenth-century church—it has only fourteen pews—would not support a fresco. Besides, Hodge wasn't sure how his parishioners would react and didn't want it to be permanent. Long figured a way to do a fresco that could hang on the wall, painting on plaster over an iron lath set in a peaked iron frame. *Mary, Great with Child*, 6½ by 3 feet, depicts the pregnant Virgin standing, her right hand on her stomach and her left hand lifted. Above her is a portentous sign: the sun in eclipse.

Hodge, with his intuitive sense of public relations, told people that when Long visited St. Mary's and said he felt "a great expectancy" about the church, he—Hodge—had suggested the subject. Long went along with that but later, when he and Hodge were no longer friends, said the story was not true. What Long had in mind was the fresco by Piero della Francesca he'd seen at Monterchi.

The fresco caused a stir in the mountains and created ripples beyond. For *Mary, Great with Child* and the Ponte Buggianese fresco, Long, with Annigoni's help, won the Leonardo da Vinci International Art Award, given by the Rotary Clubs of Athens, Florence, Tours, and Venice.

The next summer, Long did another fresco for the right side of the altar in Beaver Creek, a portrait of John the Baptist. Bo Bartlett worked with him and served as the model for John. Long wanted him to pose nude, but an embarrassed Bartlett wore his Jockey shorts. Depicted holding a staff and

pointing to his head with his right hand, John has the fanatical look of a desert holy man. One night as he was finishing the work, Long noticed a dead bee in the church and added a portrait of it to the fresco, a reference to the honey John ate.

Because of a problem with the plaster, Long had to remove and repaint the head three times. The joint between the head and body became rather obvious, a coincidence Long thought funny, given the method of the Baptist's death. Later, a story circulated of a rainstorm with lightning flashing near the church and moisture so great that the plaster dampened and the crack appeared. It was one of a net of stories that began to be woven around the frescoes, well-received by the growing congregation of St. Mary's and a growing public traveling to see them.

Long and Hodge decided on a more ambitious project for the summer of 1978, what Long for five years had longed for: a true fresco on a wall. The church scraped together enough money to build a brick wall out from the altar wall to support a fresco. Long had done drawings of a nude male model hanging from a cross for an aborted fresco project in Italy. He was familiar enough with the scene to do a Crucifixion out of his head. Titled *The Mystery of Faith* by Hodge after a phrase in the Episcopal communion service, the painting clearly was modeled on Annigoni's work at Ponte Buggianese. Behind the crucified Christ on the cross is the risen Lord painted in shades of gray. Long dedicated the fresco to his grandfather, McKendree Long.

Bartlett helped, grinding lime and colors. Long let him paint the left hand of the crucified Christ. Bartlett remembered Long saying as he worked that he didn't believe in what the painting represented. "But here he was, doing a painting with all this power," Bartlett recalled. He had a hard time reconciling what Long was saying with what he was painting. He realized he had to find his own way, to move out of the shadow of an artist he idolized.

Eight miles from St. Mary's was Holy Trinity in Glendale Springs, a white clapboard church on a hill, shrouded by trees and flanked by a graveyard.

Unused since 1934, it was filled with stored furniture and hymnals when Hodge arrived in the mountains and was in such disrepair he considered having it demolished. One day, he was standing there thinking about just that when a white-haired man and his wife drove up. The man, whose mother had attended the church as a child, asked how much it would take to repair the drooping chancel wall. Hodge pulled a number out of the air: "Fifteen hundred dollars." The man wrote a check. The repairs came to fourteen hundred dollars, with a hundred dollars left over to buy supplies for Long's final and most ambitious mountain fresco.

"The Great Blue Ridge Fresco Experience," proclaimed the back of the blue T-shirt Long designed for his helpers, with "Hot Lime" and the outstretched fingers of God and Adam from the Sistine on the front. Great experience it was. Long's previous frescoes had taken about a week. This one took three months, June to August. On the others, he'd worked with a helper or two. At Glendale Springs, he had twenty-three. His hope was that by teaching fresco, he would help keep it alive. Most of those who came were taking a course through a community college, although he also had experienced artists with him such as Chuck Kapsner and Jeffrey Mims. Both would later do their own frescoes at Holy Trinity.

On this one, Long hoped to make money and encouraged Hodge to get some grants. Wilkes County Community College chipped in three thousand dollars for Long to teach, and the North Carolina Department of Cultural Resources added ten thousand dollars. As usual, Long let Diane handle the money. Since he arrived only with an idea and none of the preparatory work done, he quickly plunged into twelve-hour workdays.

Long had decided to do a Last Supper, what the Italians called a "Cenocolo." Many people believe only one was done, Leonardo's famous painting. Actually, it was a popular subject. Ghirlandaio did one at San Marco that includes the traditional conventions for a Cenocolo; Judas, for instance, is depicted without a halo and sitting on the opposite side of the table from Christ and the other disciples.

Long used local people as models, a farmer for Matthew and a pharmacist

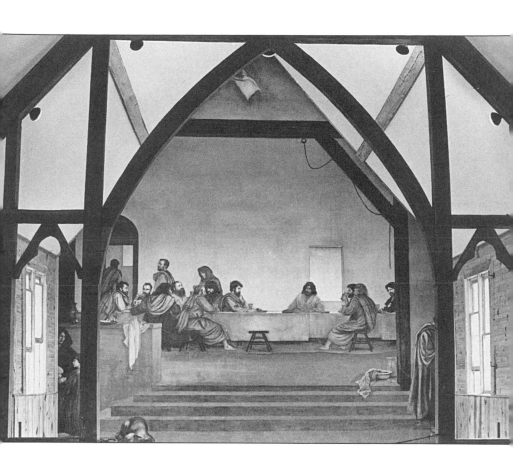

Ben Long's Last Supper *covers the altar wall
at Holy Trinity Episcopal Church in Glendale Springs.*

CHARLOTTE OBSERVER

for Andrew. A notice was posted to stay out of the church when models were posing nude. Soon, a rumor went around that the artist was doing a nude Last Supper, and Hodge faced some hostile stares. But when people began to visit the church and see what was going on, attitudes changed. Soon, crew members were being given baskets of homegrown corn, tomatoes, and squash.

Long's complex scene, measuring 17½ feet by 19 feet, works on several levels. The overall mood is quiet, elegiac but not somber. Long focused on the moment after Christ proclaims the Eucharist, saying the bread is his body and the wine is his blood. The elements are on the table before him. On the extreme left, Judas leaves the room by a door, and nearby, a few of the disciples at the table continue to eat and drink. But Peter stares at Jesus, as if questioning the meaning of his words. On the other side, John drinks from the cup as he looks at Christ, his attitude more accepting.

Long left Jesus' features deliberately vague, as he did at St. Peter's. He said he didn't want the viewer to get too focused on a single portrait. But the decision also can be read as the disciples' inability, to the end, to bring Christ into focus—and of Long's inability to do likewise. At the extreme right of the table is Thomas, the features of the doubter based on a Long self-portrait, his first appearance in one of his frescoes. Thomas looks out of the painting at the viewer, Long said to include those who might have doubts, but probably also to express the artist's. Over the figure hangs a rope, a symbol, Long said, of how by the time he finished the fresco, he was at the end of his rope.

There are two inside jokes aimed at Hodge. The priest is depicted as a servant in the foreground on the extreme right, carrying away plates from the meal. Hodge collected mountain pottery; having had more than a few pieces broken that summer when the crew partied, he seems in the fresco to be hurrying to hide what is left. In the left foreground is a sleeping dog, a portrait of Shamus, a taffy-colored mutt owned by one of the student helpers. Hodge would not allow the dog in the church. Long, by putting him in the fresco, ensured he would be in the church forever.

Long envisioned Christ's final meal as a Seder, the traditional Passover dinner, and so as a family affair. On the left is a family group, a mother and two boys. It is a portrait of Diane, with Tolly clinging to her gown and next to her a stunning, almost life-sized portrait of Angus, then six years old.

Two days before Long was scheduled to finish the fresco, his father died. He continued working before going to Statesville for the funeral. He added a tribute to his father in the fresco, painting a small scrap of paper with these words:

> I will remember forever
> The silence of your unknown dreams
> And will see you circling always
> High in a storm like a falcon.

Following tradition, Long put Judas's chair on the side of the table opposite the other disciples. It is empty, waiting for the viewer to symbolically take a seat. The night the fresco was finished, as the sun dropped behind the mountains, a beam of light slid under the door and, as the artist and others watched, moved across the floor and onto the wall to hover for a few seconds above Judas's chair.

The Last Supper got a great deal of publicity and attention. Hodge saw to that. Appearing in magazine articles and tourist brochures, it began to attract thousands of visitors. Long announced it would be his last fresco. There were no more walls to cover in the mountains. Besides, he felt he had not made money on his frescoes and that with two children he must. Also, he'd seen how Annigoni had been typecast as a portrait painter. He didn't want to be cast as a religious painter. He was an artist who worked in oils, and, after six years of frescoes, he wanted to get back to that.

Instead, he began a confusing and difficult time. His father had died. His apprenticeship with Annigoni, his second father, had ended. He had become a father himself. He and Diane had never had a smooth relationship, and now, under pressure, it became more jarring for both of them.

About that time, Long did a painting of the two of them, he looking at the viewer and Diane looking to the left. The growing distance between them was palpable. By 1982, they formally separated.

Having left Via Degli Artisti, Long was down and out in Florence, sleeping in parks, sleeping on benches. His drinking increased. He offended friends such as Fremantle, who cut contact with him for two years. Hearing he had stopped painting, Bartlett wrote Long, relating how he was looking for a kind of harmonic flow in his own life. "Fuck harmonic flow," Long wrote back, saying he'd take primal raving any day.

His savior was another American in Florence, a writer named Priscilla Buckley, who became his companion. The daughter of a former senator from New York, James Buckley, and the niece of conservative columnist William F. Buckley, Jr., she, in the view of Long's friends and family, pulled him out of the gutter. Later, Long moved to the south of France, a discovery he made while visiting Fremantle, and rebuilt the house in Pougnadoresse. Angus came to live with him, and eventually Long moved to Paris with yet another woman so Angus could attend better schools.

When Long again turned to fresco with the St. Peter's project, he had Annigoni in mind as a model. Annigoni had made his frescoes pay. They were unveiled with great fanfare, and the preparatory drawings were always framed and ready for exhibition and sale at the same time, the better to profit from the publicity. Long, still carrying the idealism of his grandfather, tried also to adopt Annigoni's entrepreneurial spirit. The result was less than satisfactory.

CHAPTER EIGHT

Hot Lime

Rue Caulaincourt, named for one of Napoleon's generals, is a broad, tree-lined street running through Montmartre not far from the bulbous towers of the basilica of Sacre Coeur. Long before Ben Long came to live there, the street had a diverse artistic presence. Toulouse-Lautrec had a studio on Caulaincourt, as did Renoir and Georges Braque. Picasso, who with Braque would forge the new style of Cubism, was just a few days shy of his nineteenth birthday in the fall of 1900 when he spent his first night in Paris in a hotel on Caulaincourt.

Before it became part of Paris in the late nineteenth century, Montmartre was a village. Until the ascendancy of Montparnasse on the Left Bank in the 1920s, Montmartre was the center of the city's artistic life. When

PHOTOGRAPH BY MARK B. SLUDER

Toulouse-Lautrec, Renoir, and others came, Montmartre still looked like a village, with vineyards and windmills. By the 1980s, the dance halls, bars, and artists' hangouts were faded memories or tourist traps. The most visible artists in "the Butte," as it was also called, were the third-raters hawking street scenes and doing portraits at the Place du Tertre near Sacre Coeur. Paris no longer dominated Western art as it had from the end of the nineteenth century until World War II. Except when friends were visiting, Long worked in virtual isolation.

With his love of history and of walking, Long knew all the points of interest in Montmartre: the one remaining windmill; the last vineyard in Paris, still producing a symbolic 125 gallons of wine a year; the statue of St. Denis, the first bishop of Paris, who was beheaded by the Romans in about 250 A.D. and who, led by an angel, walked north carrying his head to what is now the suburb of St. Denis. His martyrdom, according to one theory, gave the area its name.

By the time Long arrived in the mid-1980s, much of Montmartre had become solidly, respectably middle class. The clutter of seedy hotels and bordellos along Caulaincourt was long gone. Its limestone-fronted buildings had apartments on the upper floors and offices for doctors, dentists, and psychologists on the ground floors. In between these buildings were bakeries, cafes, and flower shops with blooms spilling onto the sidewalk in water-filled plastic buckets. In the gathering light of a Paris evening, the bourgeoisie walked home from the metro stop with baguettes and bouquets in hand.

Long liked the neighborhood, particularly its variety of restaurants—Spanish, Middle Eastern, and Australian—where he would eat his fill and wipe his plate clean with a last crust of bread. Down a flight of stairs connecting Caulaincourt with Rue Lamarck was a favorite bar, Le Refuge, presided over by a congenial owner with a handsome handlebar mustache and a large dog that slept near the cash register.

Long's studio was in Pigalle, more than a mile away. He almost always walked, taking one of several routes. Going up over a steep hill, he would come down Rue Ravignan and past the spot where Picasso's best-known

studio, Le Bateau-Lavoir—"The Boat-Washing House"—stood until it burned in 1970. He would continue down Rue Houdon, nodding hello to a knot of transvestites, or down Rue Des Martyrs, past a pet store with birdcages hanging outside, the customary station of a brassy prostitute with blond hair and red lips.

Another route took Long down Caulaincourt to Rue Lepic and across Montmartre until he turned downhill toward Pigalle. On Lepic, a market street, he would walk past open stalls piled with chickens, fish, cheeses, vegetables, and fruit—their aromas mingling on pavement wet from being hosed down—and past wine shops and bakeries and shops selling pastries heavy with icing and fruit.

One Friday in May of 1988, Long took Lepic because he had an errand to run. May 28 was Cary Lawrence's twenty-fourth birthday. A party for her offered not only a chance to celebrate with food and good company, but also a needed break from the intense preparations for the *Pentecost* side of the St. Peter's fresco. Long stopped at a shop and ordered three chickens. The owner plopped the plucked carcasses on the counter, their heads dangling like commas. Come back in forty minutes, he told Long, and they'll be cut up and ready. Long had time for a glass of Muscadet at a cafe and a chance to admire and sketch a few Gallic faces, particularly a fastidious old "professor" in a black coat maneuvering with his dog through the jumble of humanity.

Long and Lawrence had met in February the previous year. She'd answered an advertisement at the American Church of Paris: "Wanted, Live Models, Wednesdays from 7 to 10." Both the money and the chance to do something different appealed to her. After success as a student and an actress in Canada, she'd come to Paris to study at the Ecole Jacques Le Coq, an acting school well-known for its emphasis on movement. The adjustment proved hard. She found the French stiff and snooty, especially after the friendly informality of Canadians. On the day of her first modeling session, she made a decision: she was going home.

Biff Atlass, another American artist who had studied in Florence, had placed the ad. At the first session, Lawrence had taken a back pose, her face

to the wall, when she heard the doorbell. "Cary, I just want you to know that Benjamin and Joshua have just come in," said Atlass. "Hi, Ben. Hi, Josh," she called over her shoulder. Having just ended a relationship, Long didn't feel he needed another. But Lawrence, he noticed, had the milky, translucent skin he found so attractive. "If this girl turns around and has a pretty face," he thought to himself, "I'm in big trouble."

At first, they were artist and model, Lawrence posing at Long's apartment. They became friends. He was a calming influence, helping her to see the value of coping with school and staying in Paris. She did both. And after a trip home to Canada, she moved into the apartment on Caulaincourt.

During the spring of preparation, Lawrence modeled for the fresco. Long used her for Elizabeth, one of three women on the upper floor. Hers was a standing figure next to the seated figures of the Virgin Mary and Mary Magdalene. Long did an oil study of Lawrence wearing a light blue gown and yellow mantle, her wispy blond hair peeking from beneath. His use of friends, relatives, and lovers in his work was partly an urge to record his autobiography in paint. It also was a practical matter. Using friends and lovers as models saved money. And they tended to be more reliable.

Long had not wanted to leave Pougnadoresse, where he rested after *The Agony,* telling Lawrence, "I don't want to do this. I'm too tired to do this." His was not the best frame of mind or condition of body as he moved toward what would be the most exhausting and turbulent part of the fresco project.

By the time Chuck Kapsner came over, Long already was several weeks behind in preparation. As always, Kapsner got things organized. He timed his trip to arrive in Paris on Long's forty-third birthday, May 9, 1988. Long, Laura Buxton, and Josh Rosen, who was living in Long's studio, went to the airport, bringing along two bottles of champagne. The plane was late. Buxton pointed out that it would be a shame to let the wine get too warm. So they drank one bottle. Then they drank the other. Kapsner had a bottle of white wine with him, so once his plane touched down, the rather tipsy reception committee used that to mark his arrival. Kapsner dropped off his bags at Long's apartment and went to work. Paris at that

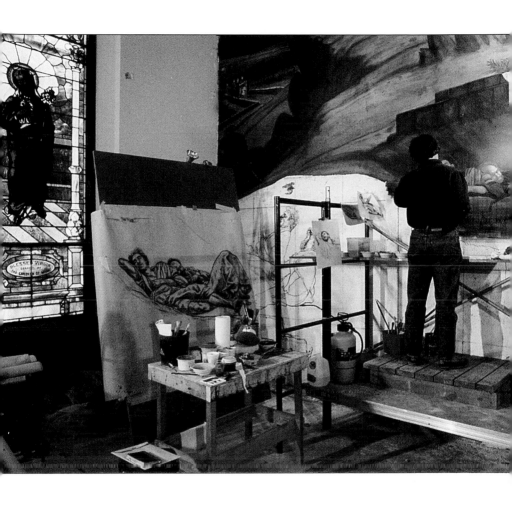

Coming down the wall, Long paints a sleeping disciple in The Agony.

MARK B. SLUDER

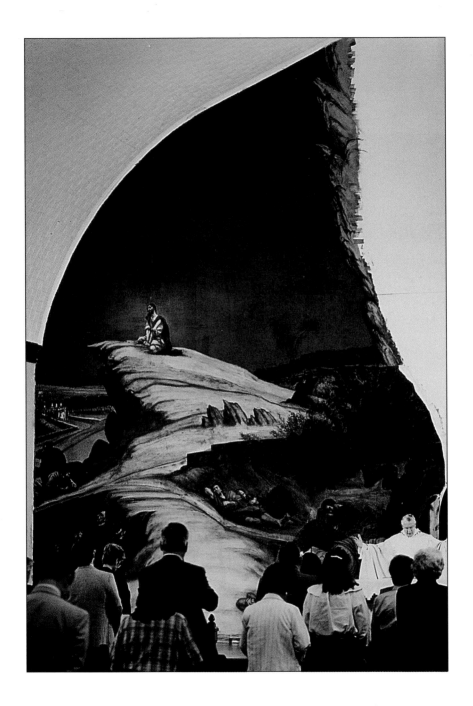

Father Gene McCreesh celebrates mass before the completed Agony.

FRED WILSON
Charlotte Observer

*McKendree Robbins Long set a Revelation scene,
with blood dripping from the sky, in the North Carolina mountains.*

COURTESY OF MAX JACKSON

*For a fresco in a Franciscan church in Montecatini,
Long painted* The Miracle of the Eucharist *with St. Anthony.*

RICHARD MASCHAL

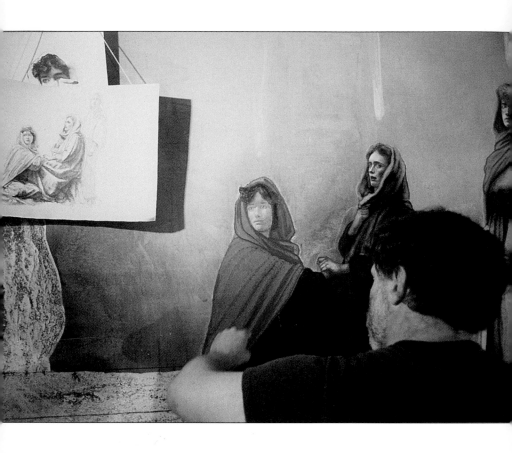

*Long puts the finishing touches on the cloak of Mary Magdalene,
who kneels before the Virgin Mary in* The Pentecost.

MARK B. SLUDER

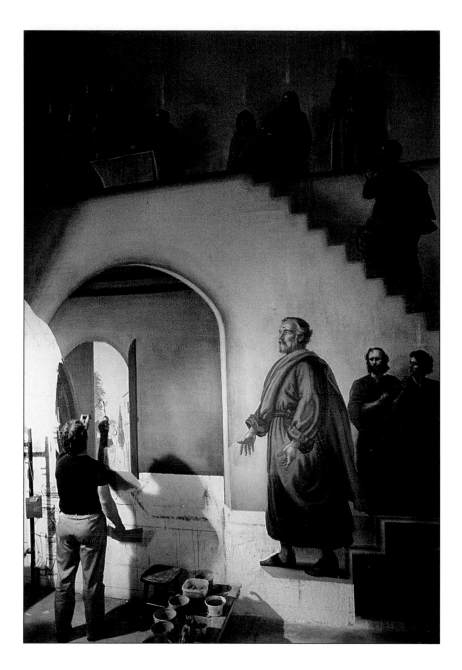

*Long included a self-portrait in the doorway scene
in* The Pentecost, *while disciples modeled on Chuck Kapsner
and Josh Rosen stand behind St. Peter.*

MARK B. SLUDER

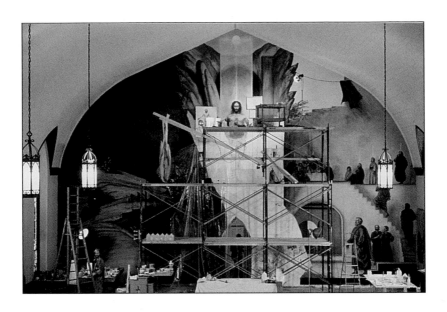

With the portrait of Christ completed,
The Resurrection *is almost halfway down the wall.*

MARK B. SLUDER

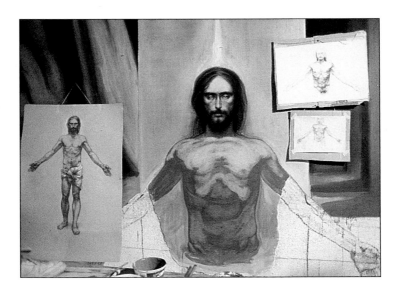

*Long consulted several preparatory drawings
as he painted the resurrected Christ.*

MARK B. SLUDER

The first panel of the NationsBank fresco
focuses on "making and building."

COURTESY OF NATIONSBANK

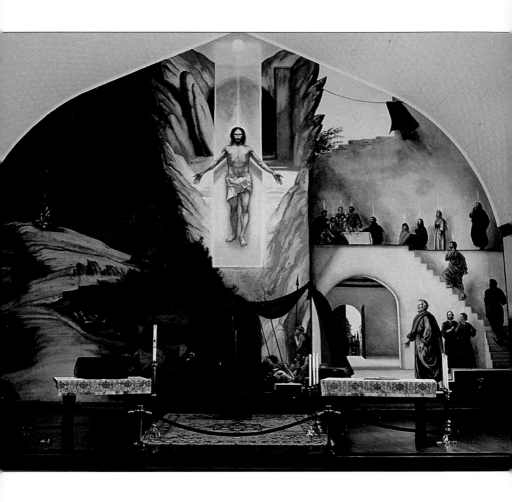

*With the fresco completed and new altar furniture installed,
the renovation of St. Peter's was finished.*

BOB SERVATIUS

time of year stays light until nine, even nine-thirty. The artists had drawing sessions with two models into the evening.

In some ways, the preparations for *The Pentecost* were more difficult than for *The Agony*. *The Pentecost* has more figures, fifteen in all. It also is a more animated scene, with the figures not sleeping but moving. That meant, for instance, a need for drapery studies. For a thousand dollars, Long ordered an articulated wooden mannequin from Milan. Its movable joints allowed it to be put in any pose, so the artist could draw how a gown or a mantle would look on a figure. During sessions with live models, the mannequin stood in a corner of the cluttered studio with a sombrero on its head.

Most of the models for *The Pentecost* were Lawrence's fellow Le Coq students. For the Virgin Mary, Long chose Siobhan McCormick, a twenty-nine-year-old Canadian actress with flaming red hair, believing she projected a certain vitality. Arriving at the studio to pose, wearing a black leather jacket, red high-top sneakers, and an onyx-and-silver earring in her nose, McCormick did give off a certain glow. With her was Beatrice Pemberton, an English Le Coq student who posed as Mary Magdalene.

Having removed their shoes and put on gown and mantle, they took their places on the model stand, a small stage beneath the large north window. McCormick sat while Pemberton knelt by her, placing her hands in McCormick's lap. After adjusting Pemberton's mantle, Long sat in an orange chair he'd scavenged two nights before on the streets of Montmartre. Taking a stick of charcoal in his left hand, he began to draw, pausing occasionally to sip black coffee from a bowl. Rosen and Kapsner took places nearby and began also to draw.

Time on the model stand passed slowly, even for fifty francs an hour for modeling nude and thirty-five francs for a head pose. McCormick and Pemberton got a break every twenty minutes during a two-hour session, whispering "Merci" when finally they could stand and stretch. Music helped pass the time, everything from Henry Purcell to Ry Cooder. One day, to break the boredom, the two spontaneously broke into song, joining in on the chorus of Lou Reed's "Walk on the Wild Side."

The original painting schedule for the St. Peter's fresco called for moving left to right across the wall, going chronologically from *The Agony* to *The Resurrection* and ending on *The Pentecost*. Long decided instead to do *The Pentecost* second and *The Resurrection* last. For one thing, the predominant color tones on the two sides were very different, dark blue on *The Agony* and a bright salmon pink for *The Pentecost*. By leaving *The Resurrection* in the center for last, Long thought he'd have a better chance of harmonizing the painting. He was not ready to do *The Resurrection*, his ideas not firm. Also, he had not wanted to do *The Pentecost*. Better to swallow the bitter pill and conclude with *The Resurrection*.

Despite his continuing doubts about the subject, Long was determined to do his best and worked hard on *The Pentecost*. His struggle to bring it into focus consumed a dozen pages in his fresco journal, far more than he had devoted to *The Agony*. In addition to notes on books he'd read, Long filled pages with stream-of-consciousness musings, interspersed with observations on making art:

> So what am I after with this wall? So many directions, statements, oaths, conclaves, cliques, schools, etc. . . . fumbling with that odd word, art, like some red hot bolt flung to me, teetering unsteadily on the high beams. . . . The sensation is so simple—or should be.

> the mysterious poetry of a painting may well be held in the awkward element; to "make right" that element could destroy the magic of the painting. truth comes free in the error, by grace, not by our own work or will.

> Pentecost: fear of a true pause/risk of real peace confronted/scorn nothing/the fire of an angel's breath/the freedom of new wine.

Long also contrasted *The Agony* and *The Pentecost*: "From the silence of the garden, the weight of the void, the unanswered prayer, the acceptance of fate in dreadful loneliness, to an all embracing mystical experience of the

Pentecost: from the contemptuous angel of the void to the joyful effusive spirit, drunk and fat with light, washing the whole roomful with stunning ecstasy, spellbinding them all to the very end of their lives."

Through his research, he learned the Christian Pentecost grew out of a Jewish Pentecost, Shavuot, which comes fifty days after Passover, as Pentecost comes fifty days after Easter. Originally an agricultural festival, Shavuot became associated with God's giving the law to Moses on Sinai. The disciples were pious Jews. Besides clinging together after the horror of the Crucifixion, they may have been gathered for Shavuot when "suddenly a sound came from heaven like the rush of a mighty wind."

Long decided to use poetic license, to depict that wind in the billowing garments of the disciples and to try to create "a central motion" animating the room with energy and light. Each figure would have over his or her head a kind of exclamation point painted in white, representing the tongues of flame. All this would be held in the tight architectural frame of the interior of the house, with its two levels and doorway and stairs to the upper level, where Mary and the other figures were. To relate *The Pentecost* to *The Agony*, Long put Mary at the same height as Jesus in the Garden of Gethsemane, sixteen feet above the altar. Each would wear red and blue, the only two figures wearing that shade of blue. The low wall from the *Agony* side would be reflected in the foundation of the house on the *Pentecost* side, as would a red cloak on the *Agony* side in a billowing red curtain on the *Pentecost* side.

Behind schedule when Kapsner arrived, Long worked hard to catch up. One night at about two o'clock, while working on a drawing of a disciple ascending the stairs, Long realized he'd made a mistake, that the figure was about six inches off. Rather than discarding or redoing the cartoon, he redrew the leg and foot, dropping the foot back to a lower step. Instead of standing, the figure now lifted off his toes, looking no longer tentative but excited. "God did it," Long said of the happy accident.

Long finished the first cartoon on May 22, Pentecost Sunday. On May 28, the day of the birthday party for Cary Lawrence, he finished the second cartoon. The party was a success. On a low roof outside his studio

window, Long barbecued the chickens amid the flower boxes and chimney pots of Montmartre. In *The Pentecost*, to represent the harvest celebration of Shavuot, Long wanted to paint shafts of wheat. Laura Buxton arrived with some in hand, found in a shop specializing in dried flowers. In the waning light of a Paris evening, Long beamed.

———

In Charlotte, even before Long left Pougnadoresse for Paris to begin the preparatory work, the net of good feelings surrounding the fresco began to shred. Kitty Gaston, one of Long's agents, had notified Father John Haughey of her desire to renegotiate the contract. She was concerned about Ben Long in a way her sister and fellow agent, Anne McKenna, was not, worrying about his career almost like a mother. She'd decided Long should own the copyright to the St. Peter's fresco. Realizing she might need legal advice, she asked her husband, a judge, what to do. Hire a lawyer, he suggested, and she did, an affable man with an interest in the arts named Edgar Love.

The letters and phone calls between Love and the church's lawyer went on for months, negotiations at first delayed by the illness of the church's lawyer and then by his procrastination. Not until *The Pentecost* was on the wall and *The Resurrection* almost begun would the second contract finally be signed. By then, feelings were strained, particularly those of Father Haughey. For one thing, he did not like lawyers getting involved. He and the agents had talked as friends; one of them, McKenna, was a parishioner. He also felt pressured. And he disagreed with what Gaston proposed, believing the church, not the artist, should have the copyright. The church had commissioned the work and paid for it. Physically, it would be part of the church. He didn't see why a nonmember, Long, should have that kind of claim on the church.

Later, when relations between Long and Father Haughey were strained, the artist put the onus on his agents, saying it was their idea to go for the copyright and that he, always steering clear of business matters, was a pawn between the contending parties. But his own deeply ambivalent views about money contributed to the stress and tension that developed.

Gaston did take the lead in securing the copyright. But she was well aware of Long's feeling that others had profited from the frescoes in the North Carolina mountains, particularly *The Last Supper*, while he had not. Doubtless, he had told her of the mistake Annigoni felt he'd made by not copyrighting his portrait of Queen Elizabeth.

Long's feelings on the purity of art were genuine. But he also wanted and needed to make money. Unable to resolve his conflicting views, he would pressure his agents to "be more businesslike" while retreating into his pose of the above-it-all artist. He'd seen how Annigoni made his fresco projects profitable and wanted his to be. But he didn't want to get his hands dirty.

Through the summer and into the fall, the letters and phone calls continued. Gaston began to deal directly with Father Haughey, and their relationship became tense. She was hurt, feeling that the priest did not recognize she was just doing her job. But she was undeterred. In July, while Long painted *The Pentecost* and the negotiations dragged on, she considered having him stage a strike to force action on the contract.

As it turned out, the copyright would have been Long's in any case. In June of the following summer, the United States Supreme Court ruled in a case titled *Community for Creative Nonviolence v. Reid* that artists retain the right to copyright what they create as long as they are not in a conventional employment relationship with the organization that commissions their work. The legal battle was between Baltimore sculptor James Earl Reid and a Washington advocacy group for the homeless over the right to publish reproductions of his *Third World America*, a sculpture of a Nativity scene depicting the Holy Family as homeless people warming themselves on a street grate.

By the time the ruling was announced, the disagreement over the second contract had ended. Yet bad feelings lingered. They were bad enough in the summer of 1988, when Long returned to Charlotte to paint *The Pentecost*. The fact that he had not sent Father Haughey the preliminary drawings for approval, as stipulated in the first agreement and by the priest's insistence in the second contract, did little to defuse the tension.

The summer of 1988 was hot, and not only in Charlotte. Stories about the greenhouse effect in the press and on television examined whether some great change had altered the earth's climate, causing soaring temperatures around the world. The high in Charlotte in July reached 99 degrees. During seventeen days that month, the mercury hit 90 or above. For August, the highest temperature was 101 degrees. On twenty-one days, it was 90 degrees or more. The humidity made the days difficult enough. But the nights, when the still air barely cooled, were especially oppressive. Long hated being hot. But the heat was only part of his troubles that summer.

He arrived in late June, Kapsner soon after, and then Rosen and Buxton. They had a week to prepare before starting on the wall. The crew's first job was to snap the lines, putting the checkerboard grid on the wall. That done, they pounced the tracings and created the sinopia, a full outline of the fresco in red. That the crew was off showed immediately. The group of figures at a table on the upper level was two feet too far to the left and had to be redone.

Kapsner had given Rosen a list of things to do before he left Paris, principally tracing cartoons. Rosen had not done them. Kapsner, already feeling ill, would have to. That left Rosen and Buxton to grind white and mix colors. After several days of work on the tracings, Kapsner was so sick he had to see a doctor, and the project temporarily lost its organizer. Anthony Panzera did not arrive until the work had been under way for more than two weeks. He and his wife, Marie, had taken a long-planned three-week trip to Italy to celebrate their twenty-fifth wedding anniversary. Panzera was missed not only for his hard work, but also for his steadiness.

Roger Nelson, around more during *The Pentecost* than *The Agony*, gave the crew a needed lift. Easygoing, with a quick wit and smile, he nonetheless was a hard worker who was used to taking care of himself. For a time in Minneapolis, he had been a night clerk over the weekends at a seedy downtown hotel. Several patrons—a pimp, a janitor, an ex-convict who liked to play chess—had commissioned him to draw them at twenty dollars per portrait. Nelson had also worked for a public art program in Minneapolis, painting huge murals on the walls of buildings. He covered

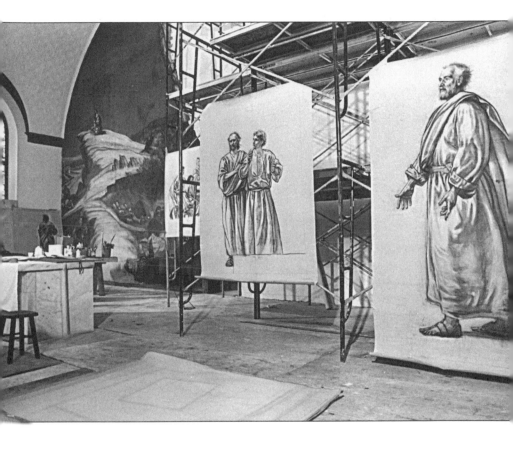

The cartoons of St. Peter and of two disciples
were put up at the beginning of The Pentecost.

MARK B. SLUDER

Ben Long's portrait of St. Peter
in The Pentecost *looks like Robert E. Lee.*

MARK B. SLUDER

nearby streetlights with blankets, projected his images on a wall with an overhead projector, outlined them, and sprayed them on. The process in some ways was akin to fresco.

He'd moved to North Carolina six years before, buying a house on the brow of a mountain outside Blowing Rock. During *The Pentecost*, he'd work in Charlotte for three days and go home, leaving behind the friction and hassles among the crew members. Those left in Charlotte, Nelson thought, were "roller-coaster people," their feelings going up and down depending on the fortunes of the project and Long's moods.

Despite what some might see as a disheveled look, Nelson was a self-proclaimed "clean freak" who liked things organized. During *The Agony*, he'd gotten into a brief row with Laura Buxton when he rearranged the bowls on the color-grinding table; she'd let him know that while the table looked messy, she knew where everything was. That summer while *The Pentecost* was under way, he became the cleanup man, picking up and discarding the empty plastic water bottles hurled from the scaffold and washing brushes at the end of the day.

Tony Griffin, who was Long's brother-in-law and who had lived and studied with him in Florence as a teenager, joined the crew. Buxton's impression was that he would be working regularly, helping with the lime and the colors. He did contribute that summer and during *The Resurrection*, but not as much as was hoped. He'd just moved to Charlotte after studying at the Pennsylvania Academy of the Fine Arts and living in Philadelphia for a total of eight years. He needed time to get settled. Besides, he had a troubled relationship with Long—a "love-hate" relationship, as he described it—and at times felt uncomfortable around him.

After a week of preparation, the colors still were not ready. Anxious to get started, Long began painting anyway. Soon, he was hollering from the scaffold for more color. The smoothly functioning crew of *The Agony* was splintered. Kapsner, still miffed about the cartoon tracings, thought Rosen was shirking his duties. Rosen's behavior also upset Buxton. Rather than pitch in with whatever needed doing, Rosen would finish a chore and climb up the scaffold to watch Long paint. Frustrated, Buxton said so.

Broke that summer, disdainful of working a regular job, Rosen was hungry for commissions. He, Buxton, and Panzera sacrificed financially to work on the fresco. All of them hoped to get portrait commissions or perhaps sell work. An aunt of Long's did commission work from Buxton to help pay for her transatlantic flights. The church and Long's agents, Gaston and McKenna, paid for some of Panzera's plane tickets. But while Buxton and Panzera had limited success selling work, Rosen managed to get a few commissions.

Everyone liked Josh. It was impossible not to. But his absences were noticed and felt. Irritated, Long said of him one day, "As soon as he has something to eat, he thinks the work is over." Kapsner felt Josh had gotten too big for his britches, was in too much of a hurry on his career. He did not doubt the young man's talent. But he sensed a lack of commitment about him, the reason he had warned Long against bringing him along. The youngest crew member and the artist with the least experience, Rosen seemed to feel in competition with the others, particularly with Long. He would frequently tease him, grabbing him around the shoulders or punching him in the arms.

Once, at a Japanese restaurant, Rosen slipped a piece of green mustard into a bit of Long's already heavily spiced sushi. Long coughed and sputtered. Ever protective, Kapsner scolded Rosen, saying Long could have gotten sick. A few nights later, when the crew ate at a Middle Eastern restaurant, Long pulled the waiter aside, telling him to put a lot of harissa— a potent condiment made of cayenne pepper, oil, garlic, coriander, and cumin—on the bottom layer of Rosen's meal. When he got to it, Rosen's face turned red, but he manfully continued to eat and, with the aid of several glasses of water, finished the dish.

A few weeks into *The Pentecost*, Kapsner put up a hand-lettered "Order of the Day" in the sacristy, where crew members would see it before going through into the church. It read, "Keep all tools clean, work space clean, palettes and colors clean and stirred daily. Brushes Clean Always. Drawings kept in order and protected, tracings protected. Do not run out of needed colors."

The sheet with rules was a badge of lost innocence, a sign of how far the crew had come from the efficiency and camaraderie of *The Agony*.

Panzera felt badly when he finally arrived. He had not been there to help when his fellows faced hard times. And his mood, in contrast to theirs, was buoyant after his trip to Italy. He saw right away the changed attitude among the crew and the overarching technical problem pressing on them: hot lime. The plaster on the wall was overheating, and the colors were not taking correctly.

About half the altar wall of the church was backed by the sacristy, a later addition. But the upper half of the wall was unprotected and faced southeast. The sun, as it moved around the sky through the afternoon and into the evening, beat down on the wall. The rays that made the stained-glass windows flame also heated the bricks to as high as 140 degrees—the estimate of Charles Carmichael, the contractor. The hot nights hardly cooled them. Carmichael later realized a hose rigged to spray water on the outside of the wall would have cooled the bricks. But no one thought of it at the time.

The heat caused the intonaco, the damp plaster, to dry unevenly or too quickly. As a result, the color flaked off, streaked, bled, or became mottled and stayed on the surface rather than being absorbed. Starting on the upper part of the wall near the curved ceiling, it took three days just to get the first figure on the wall. Long and Kapsner hardly improved the work atmosphere, stinking up the scaffold one day by eating raw Vidalia onions and tomatoes washed down with wine.

On the far right of the wall is a figure going up the stairs, seen mostly from the rear. The crew called the bearded figure "Jesse James," after the Missouri outlaw. For his robe, Long experimented, using a new color called "thalo" green. Derived from copper, phthalocyanine, as it was properly known, was invented in 1938, centuries after experience with fresco had been codified by Cennino Cennini and other masters. A strong, rich color with hints of peacock blue, it had worked on the *Agony* side. But on the hot lime of the *Pentecost* side, it streaked or stayed on the surface. Jesse James had to be cut out twice and repainted three times.

In one week, Long and the crew cut out four of the six sections they'd done. The wall had been an ally during *The Agony*. Now, it had turned unpredictable and hostile. Fortunately, the interior of the church was air-conditioned. But Long wasn't referring to heat alone when he said he and the crew members felt as if they were in hell—a hell of frustration. The worst thing for a fresco painter is to lose ground. His every effort is directed toward covering the wall, toward slowly and steadily completing giornata after giornata. Retreating, cutting out finished work, eats at morale. After working for hours, Long would leave the wall, throw his arms to his sides, and say, "Fuck it, tear it down." With all these technical problems, he knew *The Pentecost* would require a great deal of retouching.

During their late-night reviews of the work, Long and Kapsner sat in the church and seriously considered a drastic option: tearing the whole wall out and starting over, perhaps with the Crucifixion.

————

As the crew progressed down the wall, the technical problems caused by hot bricks and hot lime lessened. They were on that part of the wall covered on the outside by the sacristy and so less affected by the heat. Still, this section of wall was never uniform. Perhaps a few of the underlying bricks had been fired differently, affecting how the plaster dried or took paint. A junction box buried in the wall could have had the same effect. Covered by lime and the ever-growing painting, the wall was disappearing. Nonetheless, it made its presence felt. Part of the charm of fresco is the cracks in the wall. Visible in photographs of the Sistine, for instance, they usually appear after a good many years have passed. Long noted the fast-drying *Pentecost* already "had cracks you could hide money in."

On July 26, Long painted Josh Rosen as one of the disciples. Rosen had not been a model for a figure on the *Agony* side, but Long told him in Paris he must model for *The Pentecost* so there would be at least one authentic Jew in the scene. To make him look more "authentic," Long gave Rosen's ruler-straight nose a pronounced bridge.

The figures of Rosen and Kapsner appear together, just behind

the larger figure of Peter. Rosen is pictured with his hands up, his head turned as if he is talking. Kapsner, with a firm yet kindly look, seems to be directing Josh to work. Kapsner's robe is green, Rosen's a russet brown. Brawley, watching Long paint, asked Rosen, "That you over there?" "Yeah," Rosen replied. "You would be wearing a dress," countered Brawley.

The Pentecost wasn't all hard work. Some nights, a special friend of Long's visited. Hugh L. McColl, Jr., was chairman and chief executive officer of NCNB Corporation, one of the largest banks in the Southeast. He was the kind of aggressive entrepreneur who had always found a home in New South Charlotte. He and Long had met ten years before when the artist did his portrait. The long sittings had given them time to talk. Although McColl was ten years older than Long, the two shared small-town Southern backgrounds, McColl's in Bennettsville, South Carolina, ninety miles south of Charlotte. Both had gone to the University of North Carolina at Chapel Hill.

And they shared a special bond: both had been in the marines. A hard-charger, called by *Forbes* magazine "the George Patton of banking," McColl jogged to a tape of a marine drill instructor giving commands. He collected Long's work, had several watercolor landscapes of Pougnadoresse, which he had visited, in his office.

McColl once asked Long to do a commission—"the only thing I've ever asked him to do," said the banker. He wanted a triple portrait of himself, his father, and his grandfather. It would have required working from a photograph of the grandfather. "I don't do that," Long told McColl, with nary another word of explanation. The sound of those words rang in McColl's ears for a long time. "There's something in Ben that wants to go his own way," he said.

McColl would roll off the interstate in his black BMW sedan at night and stop at the church. He'd either invite the crew out for a late meal or send one of them out for a six-pack. That summer, he regaled them with his plans to acquire First RepublicBank Corporation in Texas, a coup for NCNB and

a tribute to McColl's daring. Within a few years, the organization he headed, newly named NationsBank after more acquisitions, would become the fourth-largest bank in the country.

Interested in the fresco, McColl brought friends to see it. Already, he was thinking how Long's skill and talent might find a place in a new company headquarters building announced for Charlotte. McColl's interest in the arts made his bank an important patron in Charlotte and other cities. He contributed to the fresco fund and encouraged others to. Seeing the project as good for Charlotte, he also went before the city's umbrella arts organization to support the church's request for money for the fresco, his appearance assuring the $15,000 grant. Father Haughey, who'd taken over fund-raising for the fresco from a committee into his own hands, counted McColl's help as crucial. Said the priest, "He's got energy and he's got guts."

The week Long and the crew cut out plaster for a record four out of six days brought the artist another burden. He and his wife, Diane Griffin Long, had been formally separated for six years. She'd begun divorce proceedings and one day came into the church with a young woman from her lawyer's office to serve legal papers on her estranged husband. Seeing her in the sacristy, Chuck Kapsner went into the church and, in Italian, called to Long on the scaffold, "Benjamin, your wife is here." Angry at the intrusion, Long refused to come down from the scaffold, telling the woman if she wanted to serve the papers, she could climb up. The next day, a sheriff's deputy came to the church and found Long on the ground.

Long's personal problems angered and distracted him. Not wanting to burden his crew, he said little about them. Kapsner, in whom he did confide, saw this as an expression of Long's character, his willingness to try to continue his work without complaint. But the crew members had an idea of what was going on. And Long's decision to be stoic left them wondering, making matters worse. Long's drinking increased. His time was taken up by attending meetings with his lawyer or giving a deposition to his wife's lawyer. Some days, with plaster laid and the crew waiting, he

failed to show up. One unintended result was that with him absent, several of the crew members got valuable experience laying in color and painting on the wall. But overall, morale suffered.

Others were touched by the divorce. Kitty Gaston was called to give a deposition on Long's finances. Father Haughey appeared to discuss what the church was paying the artist.

Burdened by technical problems with the wall and the searing emotions of a difficult divorce, Long began calling Cary Lawrence in Paris each day, "just," he told her, "to hear a happy voice."

———

As *The Pentecost* spread across the wall, Father Haughey made his views of the work known. He was not pleased with what he saw. The priest did not like Long's portrait of the Virgin Mary, did not like her red hair or the look on her face. He did not like the artist's conception of *The Pentecost*, believing the scene needed much more joy and a greater sense of a blowing wind. He expressed his displeasure to members of the crew and to Long's agents.

Acting as a middleman, Kapsner talked with Haughey about *The Pentecost*, about how hard it would be to have the Virgin Mary stand out in such a large scene. He suggested that Haughey wait until the process was finished before making a judgment. Kapsner asked him to be patient "because right now it's unfair to Ben, it's unfair to me, and it's unfair to the wall."

The priest was undeterred. He felt left out of the process and had a valid complaint. The first and second contracts called upon Long to submit preliminary ideas to the priest for his suggestions and approval. Long had not done so. Feeling *The Pentecost* could have been improved if Long had followed the contract and had the benefit of his suggestions, Father Haughey was not going to back off now.

By the time the priest's complaints filtered back to him, Long heard them as carping rather than the support he felt entitled to during a difficult time. What finally broke it for him was the priest's objection to the dog. Long, as he had in Glendale Springs, painted a dog in the fresco, this one in the

lower right-hand corner. The portrait of the mutt did several things. It filled a dead spot in *The Pentecost*. With his upturned snout pointed toward the figure of Peter, the dog seemed to sense the surprise of the Pentecost. Also, as used by artists such as Rembrandt in biblical scenes, dogs were a reminder of the humble and everyday. Ghirlandaio included in his *Last Supper* at San Marco a cat looking at the viewer. In his *Last Supper*, Titian put a dog gnawing on a bone.

Father Haughey, however, did not like the dog and wanted it taken out. He thought it was "hokey."

As was becoming clear to the crew members and the agents, the artist and the priest could not communicate. They did talk face to face several times during *The Pentecost*, but each seemed unable to explain himself so the other could hear and understand. Much of the time, their communication was through others, maximizing the possibility for misunderstandings. Long and Haughey genuinely liked and respected each other. Somehow, they could not make those feelings the basis of their relationship. Kitty Gaston, in the middle between the two—as was her sister, Anne McKenna— put it this way: "John says all the time to Anne, 'I'm crazy about Ben Long. I think he's a wonderful person.' And Ben says to me, 'I'm crazy about John Haughey.' But they can't seem to be crazy about each other with each other."

They saw the Pentecost differently. For Haughey, it was a moment of great joy, when the promised Holy Spirit descended on the disciples and the church was born. To him, it had great symbolic value. Long saw it in more human terms. The disciples had deserted their leader and run like cowards. Now, their lives were changed. Long wanted the emotion to grow as it moved across the painting, with the disciples in different states of recognition. Haughey wanted the face of Mary to be more spiritual and joyful. Drawn to her humanity, Long thought about how she had recently seen her son crucified and so would have had a more tempered reaction. To Long, the complaint about her red hair seemed irrelevant. Previous artists with no idea of what a first-century Palestinian woman looked like had

variously depicted her as a blond Dutch girl or a dark-haired signorina. What did it matter?

Haughey had a point. The scene did lack joy. Long is at his best when he feels an emotional connection with his subject. He felt none for the Pentecost. Also, joy was not an emotion Long was comfortable with, one he could easily express or depict. *The Pentecost* had some excellent portraits. Overall, however, it was wooden, lifeless.

The Pentecost shuddered to a conclusion the first week of August. One of the last parts painted was the scene in the doorway, of the people looking in after they hear the disciples making a commotion and speaking in tongues. For the small crowd, Long did freehand portraits of friends such as his yoga instructor in Paris and photographer Mark Sluder, who'd been hired by the church to photograph the process. He also included a warm portrait of Anthony Panzera from a sketch done just before Panzera departed and an affectionate look at Roger Nelson, his hair going every which way. Long's portrait of Laura Buxton was one of his jokes. He gave her a kind of supercilious look, with her nose in the air and her lips pursed, more an American's view of a Britisher than an expression of Buxton's personality. He also put a baby in her arms, its bare bottom turned to the onlookers.

The final touch was a self-portrait of Long as a cripple hanging on a crutch, with a humped shoulder, open mouth, and lolling tongue. It was a portrait of the artist as a tired and bruised man, an accurate image, Long said, of how he felt as *The Pentecost* drew to a close.

He had not wanted to paint *The Pentecost*. Long felt he had compromised his artistic integrity by agreeing to it, had sold out. He viewed the priest's legitimate concerns about what was being put in his church as interference, even hectoring. He was hurt, feeling he had not been taken seriously as an artist.

It rained one night toward the end of *The Pentecost*, a welcome relief from the heat. Long and Buxton lay on their backs on the huge, sloping

lawn in front of the house where he was staying, getting soaked and watching the lightning.

Long felt up the next day. He did a one-legged jig to the music of Tracy Chapman as he painted; Buxton, gently swaying with her eyes closed, mouthed the words. *The Pentecost* was almost over, as was his marriage. "I can be divorced by the end of the week if I want to pay through the nose, the ass, and other orifices," he said.

By the next day, when he did the last giornata of *The Pentecost*, the billowing curtain on the left, Long was more subdued. "I think the real thing is not to do a fresco in the heat of the summer," he said. He and the crew had been working for thirty-seven days. "It's been a real trial by fire." He put down a bright yellow base coat, hoping it would glow through the red of the curtain and give a sense of light. He and Kapsner were gone for several hours getting Long a driver's license. When they returned, the plaster was too dry to work. They had to cut it out.

The next day, Kapsner taped a note to Brawley on a piece of scaffolding: "Finally, the last day." They painted the curtain, Long lying on his stomach as he put the last strokes on the bottom left corner of *The Pentecost*. In just a few days, he had to fly to California to resume work on the Danielle Steel portrait, then return to Paris to teach students from Meredith College and begin work on the preparations for *The Resurrection*.

The color put down that last day on the billowing red curtain did not take. In January, Long and his crew would have to cut it out and paint it yet again.

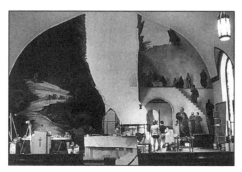

MARK B. SLUDER

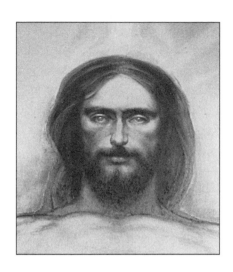

Resurrection

The scaffold was shaky. A framework of interconnected pipes, it rose four levels, more than thirty feet, reaching the peak of the altar wall. But its instability had less to do with its height than with how poorly it had been put together. It was also too far from the wall, and the verticals and cross braces were arranged so that Long had to reach around them to paint the sinopia of the resurrected Christ. Long, at times worried about falling, grunted with effort as he extended his brush to outline Christ's outstretched arm.

Falls from scaffolding are part of fresco lore. They have been caused by instability, accident, or the artist's forgetfulness in his desire to get back far enough to see his painting. Michelangelo fell while painting *The Last*

PHOTOGRAPH BY DON STURKEY

Judgment. Barna da Siena, according to Vasari, died after a fall. A tumble from the scaffold in Ponte Buggianese injured Annigoni. Because he hadn't fallen during his first fresco, Mexican Diego Rivera gave a party to celebrate. A print made in Florence in 1500, one of several on miracles of the Virgin Mary, illustrates the fresco painter's fear. It shows an artist on a wooden scaffold cluttered with the familiar brushes and paint pots. He's falling, pulled by a nasty-looking demon with wings. In the nick of time, the Virgin, whom the artist has just painted on the wall, reaches out to grab his hand.

Ben Long did not believe he could count on the Virgin he'd painted to save him from what he said repeatedly was the scariest scaffold he'd ever worked on.

The sinopia went up on January 18, a Wednesday, two days after Long arrived in Charlotte. The outline in red pigment on the long, narrow central section reaching thirty-five feet to the peak looked faint compared to the flanking scenes in vivid colors. The altar again looked like a Renaissance workshop, with the table for grinding colors in front of *The Agony in the Garden* and two for grinding white in front of *The Pentecost.* The scaffold, over the door to the sacristy, required those going in and out to duck.

The Resurrection was the last section. After a year of investing time, talent, and spirit, the crew was excited. Panzera caught the feeling in a journal entry as he traveled to Charlotte: "I can feel my enthusiasm building. I truly love the work, I love the medium, I love the joint effort and I have come to love the church. Being involved as I am, I have become part of the church and the idea that a portion of my labor, my will, my spirit has become part of something greater, something permanent . . . makes all of this worthwhile."

In the portfolio of drawings Long brought with him from Paris was the design for another T-shirt, to commemorate the fresco's end. Instead of Masaccio, this time he turned to Michelangelo for a theme. In *The Last Judgment* in the Sistine, the Florentine included a disguised self-portrait. Near Christ sits St. Bartholomew, depicted as saints traditionally were, with the attribute of martyrdom: he holds his flayed skin. Michelangelo painted

his own face in the skin, complete with the mashed nose broken in a fight with a fellow apprentice in Ghirlandaio's studio. Unrecognized for years, the portrait expressed Michelangelo's idea that he would not be one of those given a new body at the Last Judgment, but would remain outside of paradise, sinful and so not reconstituted. Long's design added the words "Old Lime In New Skins" beneath. With the eruption of open conflict between Long and Father Haughey that left *The Resurrection* teetering on the brink, the T-shirt soon was forgotten.

Long hoped to put the first color up by that Friday. That left four days for preparation, hardly enough even though the crew was assembled and working. Long wanted *The Resurrection* to be bright with light. That would require a lot of white. The figure of Christ, the largest in the fresco, would consume many bowls of flesh-toned pigment.

Mindful of what had happened in July when they began painting before preparations were completed, Panzera and Buxton told Long that Friday was too soon. He reassured them, saying they needed only a small amount of pigment to begin and agreeing to start in the afternoon rather than the morning. Emboldened by their year of experience, Buxton and Panzera pressed their point, Buxton climbing the scaffold to talk with Long directly.

Panzera, standing near the altar table, spoke: "As long as you understand the fears we're working with, the ability to keep up the color."

"No, I understand that," Long replied. "But tomorrow is an easy day." He was in a hurry.

The figure of Christ was the most important of the fresco, central not only to the middle section but also to the entire composition. Larger than life, the figure would begin four feet above the arched door to the sacristy and stand ten feet tall. Long understood how much rested on the figure, as he revealed in a notebook entry made in Paris on December 11, 1988: "Chuck is here, the scaled paper is on the wall, and the anatomy sketches have begun. The model's name is Mark Parody. (later: Marc Paradis . . . even better.) My thoughts turn around this one large central figure, about which I can expect hard, spinning winds of resistance. It is the hub of this whole project, and if the whole is to work, function, this figure must be

sound, magnetic; it will be through this figure that the true communication of energy will pass, attract, embrace."

Long chose a traditional posture for the figure, a frontal pose with left foot forward. It was a stance that in Western art went back to the "kouros"—the Greeks' statues of male figures—even to the Egyptians. Piero della Francesca used that same frontality in his fresco of the Resurrection in the town hall of Borgo San Sepulcro. Christ, wrapped in a cloak, stands with the solidity and power of a column, his left foot on a low wall. He holds a white flag with a red cross, a symbol of the church triumphant. Before him against the wall sleep the four guards left at the tomb.

The arms of Long's Christ are in the "orant," a posture with the arms held out to the sides. It is a gesture so old it can be found in second-century Christian frescoes painted in the catacombs of Rome. The motif of an upright figure with spread arms, apparently reflecting the standard attitude of prayer adopted by the first Christians, was read as a symbol of faith, or of the church itself. Priests of the Roman Catholic and other liturgical churches still use the orant during the celebration of the Eucharist.

To model the body of Christ, Long used Marc Paradis, a twenty-five-year-old Canadian writer he'd met through Cary Lawrence and whose name, as it was pronounced (Parody) and spelled, he found intriguing. The only change was to elongate Paradis's body into a powerful torso covered only by a knotted loincloth low around the hips. Long invented the face he used for Christ, striving to fill it with forgiveness, serenity, and love. It is a stunning face, its beauty centered in the eyes. The first time Anne McKenna saw it, she burst into tears.

Long had done several portrait drawings of the face, as well as nude drawings of the Christ figure. The cartoon was the most complete rendering, made of three sheets of gray paper taped together, and a second version of the loincloth taped over that. On this drawing, he pushed out the chest and shortened the neck, so the body would be in the correct perspective when viewed from below. Anxious to see how this most important figure would hold up in the space it would occupy, Long had

Josh Rosen tape the cartoon to the wall first thing Tuesday morning.

The preparation of drawings and cartoons for this side of the fresco had been the lightest of the three. Besides the Christ figure, Long did studies of the four sleeping guards at the tomb. In Paris, he had laid out a schedule of fourteen painting days to include not only *The Resurrection* but also redoing the billowing red curtain and a still life of a table with bread and wheat on the *Pentecost* side. He planned to be finished by early February.

Father Haughey wanted Long to return earlier, to finish the fresco by Christmas, or certainly by the end of the year. However valued, the project disrupted the church and interfered with the use of the sanctuary. The priest was not pleased to learn Long's plan called for finishing on February 4, the day a wedding was scheduled. Burned out by his difficulties with *The Pentecost*, Long had left in August saying he had no idea when he'd be back. To make him come back, Father Haughey cut his monthly payments. Long countered that he had to get his crew together, could not possibly return until mid-January, when Bud Panzera had a break from his college classes.

Other unfinished business between the priest and the artist hung in the air. The disagreements over the face of Mary and the dog in *The Pentecost* were unresolved. Haughey signed the second contract the week before Long arrived, although in his heart he did not want to. Long still felt the tensions of the previous summer, the feeling that he was not appreciated. He was in agony over *The Pentecost*. Back in Paris that fall, he'd talked on the telephone with Kitty Gaston about it. Feeling he had compromised his integrity by agreeing to do it, and dissatisfied with the outcome, Long had wept. In anguish, he decided to act on a thought he'd had during the summer: he would persuade Father Haughey to allow him to cut out *The Pentecost* and put in its place a Crucifixion, the scene that Long felt should have been done in the first place. That his proposal was far-fetched, that he and Father Haughey hardly were able to communicate over small matters, let alone one this big, did not loosen the artist's fix on the idea.

Another element added to the tension: Long knew his representation of the Resurrection would be controversial.

He had decided to add a long, narrow rectangle to the scene, putting it

behind the figure: Christ's burial shroud. The idea had struck him in the spring, before he did the *Pentecost* preparations. Musing about it in the fall in Paris, he wrote a free-verse poem about an "old cloth" in his journal, reading in part,

> lost eyes
> lost eyes look at old cloth
> think of dead man
> dead God
> old grit old blood wounds
> wounds

The artist wanted the shroud for several reasons. While it would be more transparent than solid, the shroud's geometric shape would relate to the angles of the stairs and architecture in *The Pentecost*, helping to pull the three parts together. This rectangular plane between the figure and the tomb would push the Christ figure off the wall, into the space of the church itself. The cool gray of the shroud would also separate the chromatically similar flesh tones of the figure and the earth tones of the rocks.

The shroud also had symbolic value. It would recall the stage between Christ's Passion and Resurrection not narrated on the wall: the Crucifixion. It would serve as a reminder he had died before being raised from the dead. The strong vertical of the shroud, combined with the horizontal formed by the figure's outstretched arms, would also echo that most precious Christian symbol, the cross.

There was more. Writing in his journal, Long turned over in his mind several ideas about what he wanted to portray in *The Resurrection*. Most definitely, he wanted his risen Christ to be a man, not a spirit. He also sought a deeper level of meaning. He grabbed onto a phrase from the Gospel of John: "Except a man be born of water and the spirit." Long identified water with the female and spirit, or fire, with the male. Above the figure, he planned a sun, with light pouring down on the head of Christ, light that looked like water, images combining fire and water. The circle of

the sun (a feminine image) and the rectangle of the shroud (a masculine one) would reinforce the idea that nature combined masculine and feminine qualities into a perfect unity.

Leonardo painted Christ's face in *The Last Supper* as both masculine and feminine, demonstrating the universality of the Savior, how in his person he united seeming opposites.

In an undated but starred entry in his notebook, Long wrote of "this mixture of symbols in this composition; male, female, convex objects, concave ones, sun as fire, cloth and light like water, the interwoven forms of the cross, etc." Long had never wanted this fresco to be merely an illustration. The shroud, he believed, would give his painting deeper meaning.

By this third section, the crew was experienced. The preparations in the church moved along steadily. Laura Buxton taped the color study to the scaffold so she could see what needed to be mixed and make test dabs if necessary. In addition to the colors on the study, she had to mix a good quantity of "greeny gray," the color that would be used for the compittura. Anthony Panzera, wearing his brown apron over his jeans, put patties of lime on the steps of the sacristy to dry in the mild, sunny weather. Chuck Kapsner checked supplies, including the jugs of distilled water filling the sacristy. Roger Nelson ground white, as did Tony Griffin. Long worked on tracings and, in his continuing search for the ultimate hot sauce, bought a bottle of greenish goop from Mexico.

Josh Rosen was in and out. He had with him a new girlfriend, a beautiful black-haired Basque woman he'd met in Paris named Itziar Aperribay. He was further distracted by a portrait commission. During *The Pentecost* that summer, he'd been in a shop buying colors when a woman saw a drawing he'd done for the fresco and asked him to do a portrait of her family. Kitty Gaston negotiated a contract for several thousand dollars, Rosen's first big commission. In January, he began the work, and before long, he was busy scheduling sittings and working out ideas. Two other volunteers took up the slack: Ben Schroder, a retired chemical salesman and painter, and

Gerald Steinmeyer, a North Carolina artist who wanted to learn fresco.

Hoyle Brawley, a toothpick in his mouth, arrived at eleven o'clock Friday morning to put up the first plaster. "You married yet?" he joshed Buxton as he mixed it. The wobbly scaffold didn't faze him. With Griffin and Panzera helping haul the bucket, he climbed to the top. At ten minutes to one, he put the last finishes on the intonaco. The plaster would be ready in about an hour, after lunch.

Long had been in Charlotte for four days, and he and Father Haughey had not talked. Long had not gone to the rectory. Father Haughey had not been to the church while Long was there. It was clear to everyone: they were avoiding each other. Kitty Gaston thought they were acting like two little boys. That morning, before Long arrived, Father Haughey came into the church, looked at the drawings, and paused before the color study taped to the scaffold. He was not pleased with what he saw, and he told Panzera to have Long come see him before he put any paint on the wall.

After lunch, Long asked Chuck Kapsner to join him and went to the rectory to see the priest. Father Haughey was displeased that Long had started working before seeing him and showing him the drawings. The shroud was a complete surprise. It seemed to him a contrivance, something stiff standing in the middle of nothing that did not explain itself. Long made his case for the shroud as a compositional tool and a symbol. The priest shouldn't judge how the shroud would appear from the color study. It would be lighter, more transparent, like a column of light that would remove Christ from time and history. "I'm sorry," said the priest. "I don't see it that way." The work could not go forward until this disagreement was straightened out.

By two-thirty, Long was back in the church, his face flushed with anger. Calling the workers into the sacristy, he told them of the priest's objection. Finding Anne McKenna sitting in a back pew, he said to her, "Don't throw me to the wolves like that again," his voice heavy with emotion.

The workers milled around for some minutes not knowing what to do before Kapsner told Panzera and Rosen on the scaffold, "Take it down." They climbed to the top and scooped out the plaster with trowels, lest it

harden. From that height, the damp clumps hit the floor with a sickening whap.

———

The "hard, spinning winds of resistance" Long forecast in his journal had blown the project off course, leaving it dead in the water. He bore a good deal of the responsibility. He had not told the priest in advance about the shroud, missing a chance to fully explain his ideas. He'd mentioned it only briefly in a letter. And Kapsner, arriving in Charlotte early to do a workshop, had shown the priest drawings and photographs of *The Resurrection*, including a depiction of the shroud. But that was not the level of consultation Father Haughey expected, spelled out in the just-signed second contract: "The artist will submit his preliminary drawings to the Church for its approval prior to the commencement of each stage of the fresco."

In fact, Long had never abided by that agreement. He justified his failure to present preliminary drawings by saying that he had shared his first sketches of the entire fresco with the priest, and that what he'd put on the wall departed little from them. But the shroud did not appear in any of the sketches.

It was in some ways like the episode over the dog, except more serious. Haughey had told Long he did not want the dog, yet the dog remained in the picture. When the priest saw the plaster going up on the wall Friday, an indication the work was about to begin, he concluded Long again was going to bulldoze his way and paint whatever he wanted.

Father Haughey was angry. The shroud seemed surrealistic to him, an addition that made no sense. He had another problem with it. Long's shroud obviously was based on the Shroud of Turin, a piece of linen fourteen feet long and four feet wide kept for four hundred years in a silver casket in the Cathedral of Turin and believed by many to be the burial cloth of Christ. Photographic negatives revealed that the cloth bore the image of a man with wounds like those described in New Testament accounts of Jesus' death, proof for many of the reality of Christ's Resurrection.

But in October, just three months prior to the confrontation

with Long, the Catholic church had announced the shroud could not be authentic because scientific tests showed the cloth itself was created between 1260 and 1390. Laboratories in Great Britain, the United States, and West Germany dated postage-stamp-size pieces of the shroud through radiocarbon tests and independently reached the same conclusion. Haughey did not, in his words, want "an anachronism" on the wall of his church.

The conflict between the artist and the priest had been escalating steadily. Long had gone along when they first discussed the fresco, agreeing to a subject matter he had doubts about. He felt he had violated his artistic integrity, and the outcome of *The Pentecost* confirmed that feeling. Haughey at first let slide Long's refusal to consult with him and then tried to press his points on *The Pentecost*. It became clear to him Long simply would not listen. Meanwhile, Long's agents and lawyer pressed the priest on the contract. In their push-pull struggle over subject matter, scheduling, consultation, and approval of drawings, Long held a strong hand. Once begun, the fresco could not be left half-done, and only he could finish it. But the priest, feeling pushed to the limit, had begun to get tougher. To get Long to come back after *The Pentecost* when he threatened not to, Father Haughey had cut his salary payments. Now, the priest was determined to put his foot down.

As their disagreements accumulated, the two had communicated through intermediaries. Now, they stood face to face, two men with strong egos who were as different as fire and ice. A sensualist, Long loved food, wine, color, was excited by the richness of a purple shadow on a wall. Meeting a woman he knew, he'd lift her off the ground and twirl her around, or even throw her over his shoulder and whack her behind. His strong emotions often overrode his judgment. He raged when he felt thwarted. Haughey, the intellectual, lived the life of the mind, was excited by learning, writing, and expressing his ideas. In tense moments, Father Haughey's voice got softer, only a tightness around his mouth revealing his true feelings.

Long, moreover, had a problem with authority. He could turn against a person, writing him out of his life. Faulton Hodge, the mountain priest, had given Long his long-sought chance to do a fresco in the United States.

But later, when Hodge in Long's eyes debased the fresco at Glendale Springs by putting in a recorded message with organ music and an appeal for money, the artist turned against him. Hodge, before he left Glendale Springs, also threatened to move the churches and the frescoes within, over the complaints of the townspeople who benefited so much from them. Long was acidic in his comments about Hodge.

Yet for all their differences, Long and Haughey were alike in crucial ways. Each was a perfectionist. Each was creative. Most important, each believed passionately in the worth of his own ideas, a quality Father Haughey understood they shared but Long did not.

For the artist, the shroud felt right. The priest thought about it and rejected it. When they talked, Long was passionate. Father Haughey was cool. Compromise would be difficult for these two.

After the blowup, the church was empty except for Bud Panzera grinding white. It was either that or pack his bags and go home. Father Haughey, Father Gene McCreesh, and Father Vince Alagia, who had been temporarily assigned to St. Peter's, came into the church to look at the drawings and share their impressions. Father Haughey asked Panzera to stay. Believing the priests needed to be alone, he declined and went outside, sitting on the back steps of the sacristy. But it was cold. After half an hour, he went inside to get his coat and say good-by. Again asked to talk, he stayed.

All three priests objected to the shroud. They wanted Panzera's opinion. What did he think?

Panzera was someone the priests trusted. They would not have asked for the thoughts of any of the other crew members. Panzera was devout, soft-spoken, mature. He loved the priests and the church, but he also respected Long. He felt caught in the middle. He could understand both sides, the priests' feeling of responsibility for what was put in the church and Long's sense of artistic integrity. Panzera had looked at Long's drawings and considered his arguments. Nonetheless, he thought the composition would be stronger without the shroud. He did not say that to the priests, however. Feeling obliged to defend Long's ideas, he explained them on

compositional and aesthetic grounds. Father Haughey listened and then said he couldn't see it. There was a way to avoid such difficulties, he added, and that was to share the preliminary drawings.

However, the first communication between the two sides had been made, the first thread of a bridge across the chasm. Panzera felt good about that as he put on his coat and left the church.

————

That night, Long's frustration and anger boiled over. With Kapsner, Panzera, Griffin, Nelson, and Rosen, he went out to eat but mostly to drink. Griffin and Kapsner had seen Long like this, but Panzera hadn't, and he was shocked. Long raged. His face darkened. His eyes burned. Wings of flesh stood out on his forehead just above the eyebrows, and a furrow of two horizontal lines appeared at the top of his nose. He spewed obscenities at the Catholic church and those Irish priests, banging the wall of the restaurant with his fist. He threatened to quit the project, to walk away from the whole damn thing.

Again, Panzera found himself in the middle. He told Long about his talk with the priests, how Father Haughey had wanted to discuss the shroud. Long's rage turned on Panzera. He said he knew Panzera would be with those priests. Panzera explained how he'd fallen into conversation because he needed to get his coat. He hoped Long didn't misunderstand where his loyalties lay. Cooling for a minute, Long assured Panzera he understood. When Long left the table briefly, Kapsner told Panzera how impressed he was with his calm demeanor and how he had not gotten angry and retaliated when Long raged at him.

When he finally got back to his room that night, Panzera noticed the moon was full. What he had witnessed, he thought, was the madness of the full moon.

Somehow, a compromise between Long and Father Haughey had to be found. With grim humor, Roger Nelson suggested one: Long would take out the dog if Haughey would let him keep the shroud. Through the weekend, the outlines of true compromise began to form. On Friday, Father Haughey told Anne McKenna he thought the shroud could be

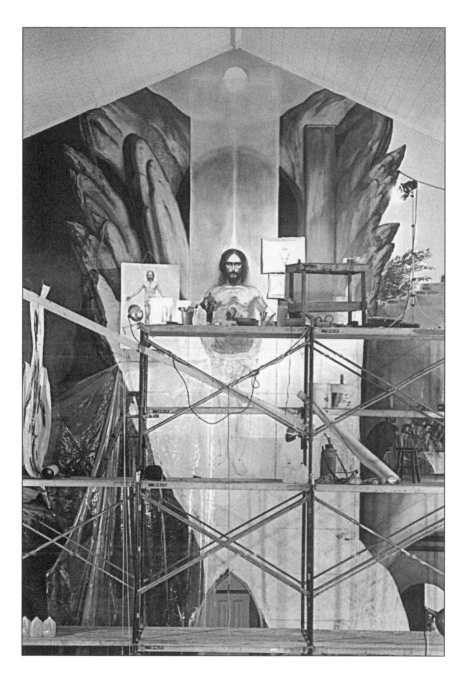

*With the portrait of Christ finished and the top level
of the scaffold removed,* The Resurrection *moves to completion.*

MARK B. SLUDER

reworked as a column of light, with the hard edges softened and the bottom tapering and fading into the rocks of the tomb. He said the same to Long during a Saturday-morning telephone call that seemed to calm the artist. Father Haughey had to go out of town. Long wanted to talk to his crew members. They would talk again Sunday. Father Haughey flew to Texas for a church conference. Long went to Chapel Hill to see a basketball game with Kapsner and Clayton Lineberger, the longtime friend with whom he was staying.

Father Haughey was reconsidering and, as was his wont, seeking other points of view. He'd talked to his fellow priests and Panzera. Before leaving town, he called Charles Hastings, the architect of the renovation. Hastings, who came down to the church, said he liked the shroud, thought it helped pop the figure off the wall. Father Haughey asked Hastings's wife, Adele, for an "unbiased view." She thought the shroud looked like a "sliding board."

Long ran into Hastings at the church Sunday when he came to retrieve his drawings and bottle of hot sauce. The architect was supportive but told the artist he was wrong not to have talked with Father Haughey. Long had held against Hastings what he saw as interference when the architect, at Father Haughey's request more than a year before, had drawn an alternative to *The Pentecost*. Now, Long appreciated Hastings's support. As they talked about the priest's objection, they began to refer to the shroud as a column, or shaft, of light. Increasingly, Long spoke about it in those terms, as if he and the priest only disagreed over semantics. The bone of contention became, as Father Haughey later said with a wan smile, "the shroud that was not a shroud."

Long, Kapsner, and Panzera gathered at Clayton Lineberger's on Sunday night. Panzera, still left cold by the shroud, argued for making the rectangle a column of light by softening the edges. Long defended his idea. From her home, McKenna talked by telephone with Father Haughey in Texas. She then called Lineberger's and spoke with Panzera, who relayed messages to Long. It was an awkward way to communicate, but it insulated

the two principals from each other, kept emotions and voices down, and made compromise possible. The two sides agreed on four points, and Panzera, feeling relieved, wrote them down:

1. Rectangular shaft/source of light—softened above tomb edges.
2. Sun is needed—just as edges are needed but edges are softened. Plane of light more transparent.
3. Both are needed as compositional elements.
4. Light around figure is stronger—as if it emanates from Christ.

The project had gone to the edge. But a way out had been outlined, the project resurrected. Long could keep the shroud if he softened it, particularly around the edges, and made it more transparent—essentially made it look more like a shaft of light.

Work could resume on Monday. But would the spirit be the same? That's what worried Long now. His workers, who were paying their own way, had been sitting around for days wondering what would happen. Could he get them up for the hard work ahead? Could he get himself up? The Christ figure was crucial to the fresco. Could he bring to the painting of it the kind of confidence and commitment required?

Monday had been the day scheduled for painting the face of Christ. Now, they were three days behind, leaving little margin for error. While trying to find Brawley so he could put up plaster, the crew worked on preparations. Rosen and Panzera ground white. Burton and Griffin mixed pigments. Kapsner and Long worked on drawings and tracings, Long taking time to find another bottle of hot sauce, this one Jamaican. The eruption had an unintended benefit, giving them time to complete the preparations so they would not be caught without enough color and white, as they had been in July. Long and Haughey, who was back in town, were still talking. Reluctant to do any studies based on the points of compromise,

Long instead wanted to put up the painting, and if it wasn't acceptable, take it down. He continued to pitch his ideas. "You haven't convinced me yet," Haughey told him.

That Monday, the fresco project reached its nadir. Spirits sagged. Brawley could not be found. There would be no painting. Panzera wrote in his journal, "I ground white all day long again and it finally got to me. Everything ached and my spirit was broken. I had to leave about 4:30 to come home, go for a run and exercise a little."

At five o'clock, Laura Buxton, wearing a paint-stained blue shirt of Long's, worked at the grinding table as the stained-glass windows grew dull in the fading light. She'd been there since before nine that morning. Her neck and shoulders were stiff, her blue eyes flat. She cut her finger with the palette knife, devilishly sharp from being honed on the grinding glass. Before she staunched the flow of blood with a paper towel, a few drops fell on the glass.

—————

Brawley was at the church by seven o'clock Tuesday morning, the plaster up by nine-thirty. He brought it down from the peak to past where the head would be, so the crew could cut a clean day mark for the head of the all-important Christ figure. "Ben's going to work his ass off today," said Panzera, sipping his morning tea.

Arriving just after ten, Long was full of energy, telling the crew to get shaft #1 and shaft #2 colors up the scaffold—the drawings, too—and to resnap the lines. Josh Rosen sprang forward, not bothering with the ladder on the side of the scaffold but going directly up the front hand over hand.

The waiting was over. Back in touch with the wall, the crew felt released into action. Just the sight of Brawley's matter-of-factness as he went up the shaky scaffold improved morale. Drawing on his experience, his incredible stamina, and his ability to concentrate, Long attacked the wall with a will, lifting the entire project on his shoulders. A fresco artist must paint with confidence. Long stepped into that role and never looked back.

In two days, he and the crew finished the top of the center section, the patch of sky, the sun and the top of the shroud/shaft, the rocks, and the

opening of the tomb. The work was hard, the conditions difficult. It was so hot at the peak Long stripped above the waist to a black T-shirt. The top level of scaffold was a small, wobbly platform that shook every time he moved. With either Rosen or Panzera assisting, Long spent hours there, his face dripping sweat, his T-shirt blotched with lime.

On Tuesday night, Long paused to write a dedication on a patch of yellow sky near the peak, so high it could not be seen from below: "In Memoriam, Al Mio Grande Maestro & Amico, Pietro Annigoni"—"In Memoriam, To My Great Master & Friend, Pietro Annigoni." He had died the previous October, and Long, in Pougnadoresse with a group of students, had driven through the night to Florence to make the funeral.

When he got to the top of the shroud, he painted several layers of white in vertical strokes underneath the horizontal line, hoping that as it dried, this underpainting would come up and soften the top edge. He'd done the same with the face of Christ in *The Agony* and the face of Peter in *The Pentecost*, but without much effect.

By early evening Wednesday, they were able to take down the top level of the scaffold. As Long looked at the wall from below, Josh Rosen, on the scaffold, stuck his head where the head of Christ would be. "Got some nails, Anthony?" called Chuck Kapsner. Charles Carmichael came to check the scaffold. At last, it would be reconfigured, made stable and accessible to the wall.

Thursday, another clear and warm day, brought them to what they'd been waiting for: the face of Christ.

After a good night's sleep, Long brimmed with energy, telling Buxton he'd need five flesh tones. Kapsner, who had been uneasy on the shaky scaffold, seemed more relaxed. Panzera, reminded by his wife in a telephone call that he'd forgotten their twenty-sixth wedding anniversary, could not believe his oversight. He hastily sent her a dozen roses and, in the spirit of the day, endured some good-natured teasing. "You're on everyone's ca-ca list," Kapsner told him.

Surrounded by drawings of the Christ figure hung on the wall and the scaffold, Long applied the greeny gray compittura shortly before one

o'clock, making vertical and then horizontal strokes with a two-inch brush. But the plaster was too damp. "It's interesting how the wall dictates the time," said Panzera. "You have to stop and let it rest."

Lunch was Caribbean chicken, greens, and a shared bottle of red wine on the steps of the sacristy, Long adding hot sauce to an already fiery meal. He opened a letter from Cary Lawrence containing another from Sandra Mladenovitch, an instructor at the Ecole Jacques Le Coq who had visited Long's Paris studio just before he left for Charlotte and seen the Christ-figure cartoon. Lawrence's translation read like blank verse:

> Monsieur, we had the honor last night, and you seemed so tired that I did not dare address you on the "throne" in your studio, where suspended a man of our past, spiritual, religious even.
>
> I discovered "Your Christ" two days after the Orthodox New Year. Do you know the gift that you have made for me? (What egoism, you might say?) Well, let it be so! I loved your solitude. I looked longingly at your drawing that you measured and then amplified into your work of art.
>
> I loved your demeanor, yes, last night, also silent/mute along with this man with open arms—a loin-cloth covering and he watches us, he speaks of your responsibility in having "confectioned" this particular head and rightly not another.
>
> I thank you for his eyes, for his "regard"—he seemed to be the "good man" in that space (in your studio) though he ventured much farther in space with his "regard."
>
> He put us in our place, he forbade us speech/he left us speechless. And of his open arms, those still opened/unscarred wounds.
>
> Monsieur, you seemed to be, last night, the scar of his wounds. . . . Since it is thanks to you that HE still walks among us, we have the memory of him.

When Long returned to the scaffold, his crew—along with Kitty Gaston—climbed up to watch. The scaffold, at last stable, seemed to tingle

with expectation. The ever-present rock music was turned off. The crew held its breath. With his feet spread wide like a gunslinger's, his right hand on his hip, Long began applying the color with his left hand. Almost one year ago, he had painted a Christ of pain and suffering in *The Agony*. This was a different Christ, with his "regard," his "loving gaze." The face began to appear, created by Long's confident movements. It was a sacramental moment. Everyone felt it as Long, in the silence and the light, painted stroke after stroke.

———

The next week flew. Energy was high; spirits, too. The figure of Christ came down the wall easily, expressing the power and beauty Long had hoped for. Long was in his element, happy and cheerful. Spying a nick in Christ's hair caused by the plasterer's trowel, Long joked, "Mr. Brawley must have hiccuped." Another night, he noticed one of the drawings had a footprint on it and, to find the culprit, demanded each crew member show his or her shoe, only to discover—with a laugh—that the footprint was his own.

The crew worked well. Josh Rosen got a plum, a chance to do his own fresco. A replastered wall between the men's and women's restrooms in the basement was the unlikely site. Charles Carmichael told Chuck Kapsner about it, and Kapsner suggested Rosen be given the chance. The young Californian chose a subject appropriate to the site: Adam and Eve.

Rosen was able to give Long what the artist liked least: criticism. On the night the head of Christ was finished, he pointed out what the other crew members had noticed but not mentioned: the eyes of Christ seemed to be closed when seen from any point past the middle of the church. But with his own fresco and portrait commission, Rosen was less and less involved. At the end of *The Resurrection*, an incident pushed him farther to the fringe. Up late one night at Clayton Lineberger's, he and Long began to wrestle and knocked over a table, breaking an expensive Chinese vase. Furious, Lineberger threw them out of his house at five o'clock in the morning. Long, at least equally at fault, initially defended Rosen. But

Rosen took the brunt of Lineberger's ire. Long backed off from Rosen, and the bond between them finally broke.

It became clear as the figure of Christ and the shroud appeared on the wall that Long had no intention of abiding by the compromise. He had given it lip service while trying to convince Father Haughey of the rightness of his idea. The elongated rectangle behind the Christ figure did not look like a shaft of light but like a shroud, hard edges and all. Long had his vision, and he stuck with it. He had been wrong not to tell Father Haughey beforehand of his idea. Most of the responsibility for the eruption lay with him. But he was right about the shroud. Compositionally, symbolically, it made *The Resurrection* stronger.

Long's composition pushed the figure of Christ off the wall and into the space of the church. It made a statement about the Resurrection, that it had not just happened but continued to happen in the lives of those who believed. Long's Christ was a man, but not the man of *The Agony*. He had been transformed by a supernatural event and by love.

After three weeks in Charlotte, Anthony Panzera was at the end of his winter break from college. Because of the delay over the shroud, he would not be there for the final days of the fresco. Panzera, the steady worker, the man in the middle who had helped with the compromise and the revival of the project, would to his regret miss the work's final moments. He got a compensation of sorts, the opportunity to paint a vase in *The Pentecost* below the billowing red curtain. At a farewell dinner in his honor, he also got a gift from Long and Kapsner: a pot of white, freshly ground.

Before it was finished, the fresco put Ben Long on his knees. On the last day, February 7, three days late by the original schedule but one day less than the fourteen painting days allotted, Long put the final touches on the sleeping soldiers at the tomb. A perfectionist, he spent a thirteen-hour day applying glazes and the last bit of modeling.

A fresco painter begins in the air, high on the scaffold. Then he comes down to earth. To get to this last bit by the sacristy door, Long crouched uncomfortably on a low stool. "It could be worse," he quipped. "I could

be buck-naked on broken glass." Then he dropped to his knees.

The wall, the great white wall now completely covered, had absorbed so much: blood, sweat, beer, great quantities of wine, love, anger, frustration, untold gallons of plaster, water and pigment, skill, hours of work, laughter, and tears. When it seemed it couldn't take any more, Long coaxed on the last dabs of color, and the wall, drinking it in, sucked the juice out of him.

Panzera telephoned from New Jersey. "Anthony," said Laura, pronouncing it Ann-tony, "I miss you so much, I can't tell you."

Chuck opened a bottle of wine.

"Spray," said Long at 9:22 P.M. "I need to do some spray."

Jeffrey Mims, Long's friend and one-time student who had helped at Glendale Springs and done his own fresco there, appeared to mark the occasion.

At 9:40, Long stood and bent over to touch his toes. "Is that it?" asked Buxton. "Unh-unh," he replied.

At 9:55, they removed the last bit of scaffold, Mims and Kapsner, Roger Nelson and Tony Griffin.

More spraying and more glazes.

Long couldn't seem to let go.

At 10:21, he dropped on his stomach and wrote a final dedication: "To Chuck, Laura, Bud, Josh, Tony, Roger, Gerald, Anne, Kitty and Mr. Brawley."

Wiping the plaster from his arms, he picked up a glass of wine.

"It be done," he said.

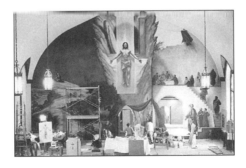

MARK B. SLUDER

CHAPTER TEN

A Ruction

Preparing to leave Charlotte after finishing *The Resurrection*, Ben Long got some shocking news: Father Haughey would not make the final payment on the fresco, the $13,975 owed Long. This he learned from his agents as they drove him to the airport. Tired, fatigued from the work, Long wasn't sure what they meant. Would the money be coming when he was back in Paris? Transatlantic telephone calls among the artist, his agents, and his lawyer made it clear: Father Haughey would not make the final payment until the retouching was completed that summer.

Shock turned to anger. Long, his finances tight as always, needed the

From the "Chaos and Creativity"
fresco panel at NationsBank
PHOTOGRAPH COURTESY OF
NATIONSBANK

money to pay his bills. He couldn't understand why the priest had taken this position, what it said about their relationship and the work he had done in Charlotte.

Father Haughey saw his action simply, clearly. The retouching, in his understanding, was part of the fresco process, when changes could be made, mistakes corrected, and the whole brought into harmony. The fresco was not complete until the retouching, or secco, was finished. Denying final payment was no whim. Haughey had made his intentions known by adding a clause to the second contract, that *The Resurrection* in January was "to be followed by retouching and finishing (SECCO) in the month of July, 1989."

Edgar Love, Long's attorney, spoke with Father Haughey in mid-February 1989 and wrote Long the same day: "[Haughey] feels . . . he has given on every point so far and does not intend to give on this one." The lawyer had proposed a compromise to the priest: pay the artist in installments, with the final one due after completion of the secco. "He said he had bent all he was going to bend and would not do so," Love reported.

Once again, Long and Haughey were ensnared in disagreement, their positions clouded by poor communication. The bone of contention was not just the function of secco. Technically, secco, from the Italian for "dry," is the process of painting on plaster that is not wet but dry. As such, it requires a binder to fix the pigment, most often egg tempera, and comes after work with fresh plaster is done. More than the process, what Father Haughey and Long truly argued about was who was in control and how their ongoing dispute would be resolved.

This time, they communicated directly. Long fired off an angry letter to the priest. He wrote of how badly treated he felt, of how he felt he was being denied what was truly his, and of how desperate his finances were. Father Haughey responded. Long replied. The last two letters in particular were revealing and characteristic. Haughey wrote two well-considered pages, honest and evenly pitched. Long's sixteen pages brimmed with emotion.

"I have mulled over your letter a number of times," Haughey began his letter of March 15, 1989.

It has been the cause of sadness to me for several reasons. The most serious one is it gives evidence of your ability to forget or misshape whatever facts you choose to justify whatever position you wish to argue for at a given time. I will leave it at that without raking through the particular forgettings or misshapings. Additionally, there are places in the letter that are thoroughly unintelligible leaving me to wonder whether anger or booze were at work in you at the time of the writing.

It also smacks of self-pity. Its occasional lamentations of victimization are out of character with the mature parts of you and are out of whack with your gifts and what it is you have been called to do in this world.

On a more positive note, these things should be said. The work you have done is bearing much fruit. An increasing number of people come to the church and your gifts are frequently lauded by the beholders. It is a shame, as I told you when you were here, that you can't hear some of this commentary so that you would have the satisfaction of knowing the appreciation that so many have for your work.

Haughey brought up the issue gnawing at him: "The second contract is something I have a resentment about, to be direct with you, Ben. I felt the gun was put at my head right before you came back for the third part of the work. The implied threat was that either I sign or the work doesn't get done. Since it was necessary for the church that the work be done, I felt I had no other recourse but to sign. The threat was not explicitly stated but the threat was unmistakable. I am unaware of its source."

The copyright, Haughey still believed, belonged to the church. "The point is not the money but the freedom of the church about something that is so intrinsic to its very being. Someone who is not a member of it should not have that hold over it."

Then he made clear his understanding of the impasse over the retouching:

I put the line in [the second contract] about the secco being part of the fresco because in numerous discussions with you and with Chuck it was so obvious that to you the secco coat was not an addendum or something like maintenance as you now choose to call it but that it was part and parcel of the artistic process itself. How can you so conveniently forget our conversations about what you would change in the secco portion of the work? Explicitly you said you would change anything I wished changed. Both of you said that the purpose of the secco coat is to make sure that the whole thing hangs together and that "what you didn't think worked" and what I didn't like, you would change. You explicitly asked me to list those things so that you could change them since my pleasure and acceptance was very important to you.

I do not want your resentment towards me and towards the church here to grow. Nor do I want to develop any resentment towards you. So far I can say, clearly that not only do I not have any resentments but a real affection for you and I identify with you in many ways. From things I have learned about past injustices done to you, I'm sure that I'm being asked to bear the brunt of some of the ire others have deserved. This includes the matter of the copyright. I had thought we could amicably work out the matter of the copyright dispute together without all the legal intrusions which ended up causing this rift.

The implication in the letter is that I tricked you. That hurts. I changed the contract in the full light of day for your lawyer and you and anyone else to read, a contract I repeat that I didn't believe I should sign, so that you would know clearly when I was going to pay you the full amount.

Looking for a resolution, Haughey proposed a compromise:

It bothers me that I am over here sitting with money that is eventually due you while you are over there in need of this money. Let me "bend" a bit, therefore. If you agree to secco Mary's face and

hair, Jesus' eyes in the Resurrection scene and re-examine his upper
torso (which is different than your cartoon), and bring out the temple
dome slightly, I'll relent on the asshole dog and advance you half of
the money once you assure me by letter that these changes will be
done in July. The rest of the money will be given when you finish in
August.

As I told you when I first saw the sketches of the Pentecost scene,
I thought it needed more wind and more joy. I continue to think this
is the case but I am unsure how much you can change when
you secco so I cannot insist on this. I have been told that you are
not satisfied with the scene. I continue to believe that if you had
followed the letter of the first contract and had given us a chance to
see some of these things that the scene would have been better. I also
continue to think that the bottom hem of the shroud that you say
isn't a shroud would be better if it faded as the top did, this time
following the contours of the rocks. I am suggesting these things
without making them part of the stipulations contained in the
previous paragraph.

On the back of Haughey's letter, Long jotted ideas for his response,
using a Victorian-sounding epigram worthy of his grandfather: "Discour-
tesy in any form offends." His reply to Haughey, dated April 18, rolled on
for page after page in his precise script.

"One thing I should like to make perfectly clear is that my letter to you
was indeed written fueled by anger, but mainly hurt, and in one furious
moment," he began.

> I agree on re-reading one overly long sentence, there were some very
> clumsy and out of place phrases, enough to mangle and garble the
> sentence—but not the idea. The fact that you chose to insert the
> inference to booze simply means to me you meant it to sting, and
> to belittle the letter, and if you wish to read the pain in the letter as
> self-pity, then obviously we have a problem of understanding. . . .
> I am sure you will agree that sometimes the purity of the moment,
> with all its rough edges, can best reflect the truth of the matter.

He continued, "The point—and anger—of my letter, regardless of how poorly written it was, was that I had finished the fresco and expected payment; no one told me I was not going to be paid even a cent of the remaining sum owed me. . . . To be blunt, I found it not only wrong in how all this was handled, but somehow, dishonest."

Long knew the second contract still stung, but put the hassle over it and money onto his agents:

> I am not interested in the politics that have been going on, and of which I have been made an unwilling pawn. I have always wanted to be able to concentrate entirely on my work and earn my living in the simple manner of a craftsman.
>
> Communication is decidedly poor, and understanding of the process of the work is abjectly pitiful, even now it seems, and most of the blame for that must be mine; I assumed too much with my agents, and apparently explained too little, even with Chuck's stalwart assistance, to the principals concerned. Be all this as it may, I have finished the fresco, it is indelibly in situ, no longer mine to give or take away, and you now have all the marbles, including some that are mine.
>
> What it comes down to is that the muck in which I find myself wallowing self-pitifully, is made up of large debts and bills, schools payments, child support, daily existence payments, etc. etc. . . . all of which I cannot pay.
>
> All this is a money thing, to which I have always been loathe [*sic*] to pay much attention (hence, my complete trust of my agents), and in which I have found it more than slightly detestable to justify my needs for such a thing that so obviously divides and separates. It has an ugly power.

Long recognized what he saw as a Southern trait—his unwillingness at times to make himself clear, his tendency to give an appearance of agreement while withholding it. As in the discussions over scheduling before the fresco began, this trait had brought him grief.

"I am sorry that you feel I misshaped and forgot facts that you regard differently," he wrote. "From my point of view, it seems there are definitely instances where you have taken in only what you wanted to hear. . . . But no matter what, John, I do not hold any resentment against you and certainly not the church! Obviously, my powers to explain, or describe seem to have been quite dim, and, as you indicate, misled you. . . . My circumlocution is bred, perhaps a Southern trait, to spare embarrassment and dodge vulgarity."

After saying he had no resentment, Long acknowledged he did. "The anger and resentment comes from never having been treated like this, as well; this business is new to me. Of course, there is pride in having always made my own way and having fulfilled my responsibilities, [in] no matter how unorthodox a manner, so it is particularly offensive to be made to scramble for a dangling carrot that should already be on my plate."

Long presented his view of secco, trying to sound accommodating while holding his ground:

> Now, again, this secco routine; it is not fresco, it is a helpful, often necessary process that must always be used as a spare tool, to adjust, cover blunders, polish and sometimes—very rarely, and always in small ways—change details in the fresco. Too much secco changes the fresco to a tempera wall painting, and the fresco luminosity and magic is lost.
>
> What I explicitly said to you was that I could change what you wished, and would, if it was possible, and the right thing to do. I never said I would change what you did not like, as blindly as that! Never in my life as an artist have I said that to anyone.

He would not agree to a list of changes, the proposed compromise consisting for the most part of keeping the dog and changing Mary's face. "I will do for you what I think can be done and will do the best I can."

Long never understood Haughey's position, why he withheld payment. He turned it over in his mind, tried, as he said repeatedly, to give the priest

the benefit of the doubt, became obsessed with it, and for months continued to vent anger and rage. He seemed incapable of understanding how his own behavior—his refusal to abide by the contract and offer preliminary drawings for approval, for instance—had contributed to the standoff. Actually, Father Haughey's action was simply understood. The priest had tried to compromise on aspects of the fresco but had seen how Long, no matter what, went his own way. Father Haughey wanted the work finally finished and changes made. And he realized he now had some leverage. The threat, even if only implied, of stopping work on the fresco was no longer there. The shoe was on the other foot. Finished with the largest commission of his twenty years as an artist, Long was broke. Nonetheless, he held stubbornly to what he saw as his artistic integrity. He would do the retouching, but as much as possible on his terms.

———

Arriving at St. Peter's in late July, Long cracked two dozen eggs into a bucket and added a gallon and a half of water. Using a cherry picker, he and Anthony Panzera applied this solution to the wall as a base. Egg tempera is an ancient technique, used for wall murals as well as for paintings on canvas, linen, or wood for centuries before being superseded by oils. Anyone who has ever tried to scrub dried egg off a breakfast plate can understand its success as a binder.

But tempera is organic. Over time, it will change, darken, or even flake off. In older frescoes, those by Giotto, for instance, where it was common to do some areas "a secco," sections of color are gone, the blue robe of an apostle reduced to the pink undercoat. Unlike true fresco, where the paint soaks in, tempera sits on the surface. It has a matte finish, dull compared with the luminosity of lime. As Vasari explained in his technical writing,

> Exposed to the air fresco throws off all impurities, water does not penetrate it, and it resists anything that would injure it. But beware of having to retouch it with colours that contain size prepared from parchment, or the yolk of egg . . . as many painters do, for besides preventing the wall from showing up the work in all

clearness, the colours become clouded by that retouching and in a short time turn black. Therefore let those who desire to work on the wall work boldly in fresco and not retouch in the dry, because, besides being a very poor thing in itself, it renders the life of the picture short.

The challenge of buon fresco, the technique Long used, was precisely to avoid too much secco. To cover the fresco with tempera was to change its fundamental character and to deny the heroic efforts made on the scaffold painting against the clock.

The wall looked as Long expected. The day marks bordering the giornate in all three sections needed retouching. Two dark spots in the sky of *The Agony* would have to be fixed, along with the branches of the olive tree. Dry for only six months, *The Resurrection* looked fine. *The Pentecost* was another matter. In fresco, colors dry lighter. Parts of this side, however, had not lightened. In other areas around the figures, such as shadows and drapery, the colors had bleached out, causing Long to recall how that summer "the wall cooked right beneath our brushes." There were also matters of interpretation on which Long and Father Haughey disagreed, such as the face of Mary and the eyes of Christ. Stowing his anger, Long was not looking for a fight. Father Haughey, too, had reached out, relenting on the money. Kitty Gaston had convinced the priest in May to release three thousand dollars.

Long had a certain idealism, tinged with naivete. Even the confrontation of January, when the work on *The Resurrection* stopped and the fresco hung in the balance, had not destroyed Long's hope he could somehow persuade Father Haughey to let him take out *The Pentecost* and replace it with a Crucifixion. But Long never brought it up. Hearing about it, Father Haughey passed back through the informal network of communication his reply: "Not while I'm alive." Perhaps, Long thought, the change could happen if Father Haughey left St. Peter's. He asked his agents to notify him if that ever became a possibility.

As usual, Long went right to work without meeting with Father

Haughey. But when the priest came over in the mornings, Long was cordial, and the two talked.

The plaster around the olive branches got so saturated from reworking that it had to be dried with a hair dryer. Long made several attempts to fix the dark spots on *The Agony.* He applied the tempera solution—a mixture of egg, water, and white wine—and crosshatched the spots with white chalk to lighten them, blending the chalk with his fingers. That trick, one he'd picked up from Annigoni, didn't work. Finally, he used tempera and pigment to cover the spots as best he could, leaving these and other rough spots as reminders of the process and the charm of fresco.

On *The Resurrection,* Long did little. He did not change the torso of the Christ figure, but used a yellow ocher glaze to "soften" it. Glazes are preferable to secco because they do not change the character of fresco. He also used a glaze around the eyes of Christ when he saw that the eyelids had lightened. But he would not rework the eyes to make them seem more open. As a communicant came down the aisle to receive the Eucharist, the aspect of the eyes changed, and it became clear they were open. Liking that element of mystery, Long decided to keep it. Feeling it was "right," he also did not soften the lower hem of the shroud/shaft.

The Pentecost took a lot of work. Almost all the figures needed painting to give them definition and modeling. The tongues of flame over their heads were punched up. Glazes softened the hot pink of the wall. The face of St. Peter, despite its undercoats of lime, had to be lightened considerably. Most of this work was done by Laura Buxton and Roger Nelson. Other crew members were in and out of Charlotte: Chuck Kapsner, Josh Rosen, and Tony Griffin. For the most part, they were busy with their own projects.

Long attempted to change the face of Mary. In early-Renaissance depictions of the Pentecost, Mary is at the center of the apostles, the huddled group with their tongues of flame looking like candles on a birthday cake. Long's Mary was not at the center, did not have the spotlight on her as Father Haughey wanted, and Long could do nothing to change

that. He did lighten her face. A slight dip in the wall at her cheek gave her a hollow look, and he compensated for that. He tried to make her more joyful, changing her expression by upturning the corners of her mouth. The results did not satisfy. While not ecstatic, *The Pentecost* has a definite emotional pulse, a sense of growing wonder moving from the figure in the upper right across to Mary and the other women and down to St. Peter, increasing in intensity as it goes. Mary's new smile disrupted the flow and the scene's emotional balance. Besides, her new face looked like a mask. After repainting the face, Long wiped off the smile.

The retouching took far longer than it should have, vexing the priest, who wanted his church back. One day, Father Haughey came into the sanctuary and, seeing only Buxton at work, said, "Is anybody ever going to do any work in here?" Buxton had been hard at work for three hours. The priest's abruptness could sting.

Changes were made, but Haughey did not get the changes he wanted. Busy with portrait commissions, Long came to the church less frequently as August drew to a close. Father Haughey came up with more tasks for Long, such as consulting with the lighting technician. Long would show up late or not at all. The project ended with a battle of wills. Long last touched the wall at the end of August. Father Haughey noticed shiny areas from the tempera base. As if bathing a baby, Long gently wiped the fresco with a sponge and bucket of water. It was his baby. But by this time, he felt little pleasure in his creation.

He had delayed signing *The Pentecost*, not wanting to claim it as his own. Finally, he added his initials and the year in Roman numerals. Under the tail of the unwanted dog, he fired a parting shot at the priest. "Caveat canis," he wrote in Latin under the mutt's rump: "Beware of the dog."

Long's anger and resentment washed back over the fresco, coloring his feelings for what had happened. He felt as if he had been treated badly, and he could not let go of it. It was different for the others. They shared a sense of accomplishment, relief that it was over, pride in what they had done. They had learned much, about fresco and themselves. Anthony Panzera

had achieved his dream of twenty years. Laura Buxton thought she'd like to do another fresco, if the work was hard and the project better organized.

Kitty Gaston and Anne McKenna were unsung heroes, pleased at the outcome but feeling bruised. They had pushed the project into being, reduced their commission so as not to take advantage of the church, and contributed their own money to the fresco. But they'd been caught in the middle, taking heat from Long and from Haughey. Glad he had started the project, Father Haughey used an old-fashioned Irish word to describe what had happened. It had been a "ruction," he said, but "every day confirms the value of having done it."

Because of his "good nature," the priest said with a self-deprecating smile, the project had concluded successfully. Long had been for the most part right about the wall, about the artistic decisions he made, Haughey about the schedule and adherence to the contract. But as Panzera had realized during the *Resurrection* breakdown, the priest—more mature, more sure of himself—was more able and willing to compromise than was the artist. Despite Haughey's vow not to bend, he had compromised at the end.

The crew last came together in October of 1989 at a special service and celebration dedicating the fresco and marking the renovation of St. Peter's. With plane tickets paid for by the church, they assembled to see afresh what they'd done and taste the old times. They sat in the back pews, Long fidgeting with his program, uncomfortable lest the spotlight fall on him. In the aisle up front, Father Haughey thanked a long list of people who had helped. Laura Buxton stood unexpectedly. Feeling the priest had forgotten two important contributors, she in her lilting accent added Charles Carmichael, the contractor, and Hoyle Brawley, the plasterer, to the list of honor.

The crew members then went their separate ways. Panzera began a fresco of his own, *The Battles of the Vices and Virtues*, in the garage behind his New Jersey home. Tony Griffin and Gerald Steinmeyer each did a fresco in a small North Carolina church, continuing the tradition begun by Long. Laura Buxton went back to Paris to paint. Josh Rosen went to Spain with

Itziar, his girlfriend, to try his luck, eventually returning to California. Chuck Kapsner taught at Meredith College in Raleigh and worked on a tentative fresco project in Minnesota. Nelson returned to the mountains.

Long returned to Paris and finally cut the albatross from his neck, finishing the Danielle Steel family portrait.

Back in his studio in Pigalle, he hung a bright orange African pepper over the easel for good luck. Still, the work dragged until his California agent, Cheryl Wicker, arrived in Paris in the fall of 1989 to encourage him to finish. Long had no feeling for this group portrait, no emotional connection to it—except a negative one. He hated it. "Sometimes, I think I don't hate it enough," he said.

He gave Wicker a beautiful drawing of Steel's youngest child to mollify the author and finally, reluctantly, finished.

The St. Peter's fresco had not gotten the attention Long hoped. But within a year of its completion, it did lead to something bigger through his friend Hugh McColl. The banker wanted an expanded headquarters for his growing and renamed NationsBank, a building expressing the ambition and stature embodied in its new name. He and his partners chose a major architect, Cesar Pelli, to design it, getting in return a silvery sixty-story tower recalling the romance of 1930s skyscrapers. McColl wanted an artwork by Long for the lobby, on the three large walls of the elevator banks.

The first proposal was for large oil paintings that could be affixed to the walls. They could be done in the studio, eliminating any problems with scheduling. Realizing the site was perfect for fresco, Long said no, holding out for his medium. The bank agreed, giving him what he had long wanted, a chance to do a fresco on a secular subject. Each wall was twenty-three feet tall and eighteen feet wide. The three together would be his largest fresco. The amount of his commission, closely guarded by the bank and by Long and his agents, would far surpass the hundred thousand dollars from St. Peter's.

In some ways, Long's attitude toward the NationsBank fresco was the reverse of what it had been at St. Peter's. Where he had wanted to

determine the subject matter at the church, Long insisted the bank supply a subject he could then interpret. Through his agents and lawyers, who made good use of what they'd learned at St. Peter's in their negotiations with the bank, he agreed to a rigid schedule with deadlines, just what he had abhorred at St. Peter's, although this time he took care to give himself breaktime in the painting schedule. He also gave the bank the right to approve or reject his ideas at several points during the process. He delivered preliminary drawings on time. And he made changes the bank requested, for instance adding a woman to a group of construction workers in the first panel, deleting a hooded Ku Klux Klansman from a crowd scene in the second, and adding a black man and a woman to a group of business executives in the third.

This time, he was dealing not with a priest but a businessman, and a formidable one at that. McColl left the bank's side of the negotiations to others but made no secret of his attitude. "If Ben thinks he had a hard time with that priest," he told Long's agents before negotiations began, "wait until he deals with me."

On the NationsBank fresco, Long had the time and resources to get it right. The bank's commitment to doing the project first-class allowed him to use gold leaf on the fresco. Long had Roger Nelson put in lime pits at his home in Blowing Rock a year ahead so the lime would be properly aged. With his jack-of-all-trades skills and good humor, Nelson was in on the project. So were right-hand man Chuck Kapsner and Laura Buxton, for her experience mixing and keeping track of colors. After what was viewed as his lax attitude at St. Peter's, Josh Rosen was out.

So was Anthony Panzera, although Long had wanted him involved. Panzera had stifled his ego to work on the St. Peter's project, had agonized over the financial sacrifices, and had felt guilt over what his participation demanded of his wife, Marie. On this project, he wanted to be treated as an equal and to be paid. He and Long and the agents tried, but they could not agree on terms, a cause of disappointment and pain on both sides.

The bank insisted Long choose the subject of the fresco. After months of thought, Long settled on an idea. In a reference book, he came across

an ancient Oriental philosophy he'd once heard of called Shingon—"True Word" in Japanese. Three monks brought this esoteric form of Buddhism from India to China in the eighth century. It retains a large following in Japan to this day. Obviously needing three related subjects, Long was intrigued with Shingon's belief in three mysteries associated with three attributes of mankind: body, speech, and mind. These he developed into three themes: making and building, chaos and creativity, and planning and knowledge.

Long wanted the three to relate compositionally, with simple forms and simple colors—no thalo green this time. He decided to make them more symbolic—even surrealistic—than strictly representational. Characteristically, he also wanted some ambiguity in the work. Believing people bring their own experiences to a work of art, he wanted his images to be so open that different viewers could find different meanings in them.

The first panel, "making and building," picks up on the construction of the sixty-story tower. At the bottom of the high, narrow panel, he put a row of workers holding shovels that can be viewed as spears or shields, especially when covered with gold leaf. At the top is another worker, a leader, a black man holding a shovel as he gazes into the distance. Another large figure in the upper left appears to be sleeping on a hill, representing the potential unlocked in building.

The chaos in the second painting centers on a jostling throng in the lower portion holding blank placards and banners. Here are figures from every day's newscast: a pregnant woman, a street person, a black man with his arms spread as if in crucifixion, a priest, and a figure in the protective garb of a toxic-waste-disposal worker. Above the crowd is a circle of nude figures eleven feet by eleven feet that seems to spin. Emblematic of the creativity of humanity, the male and female figures are anatomically detailed but painted so they are transparent, and surrounded with gold leaf.

The third panel, "planning and knowledge," has on the left a staircase that is strongly geometric yet looks jerry-built, cardlike. Balancing the stairs on the right side is an eleven foot high portrait of a young boy representing innocence. Behind him stands a pyramid, a traditional symbol of perfec-

In the third panel of the NationsBank fresco, "planning and knowledge,"
Long included a portrait of his son, Tolly.

NATIONSBANK

tion. In the lower left is a group of business people in conference, set off by gold leaf.

It was a bold scheme, far more ambitious than any he had done before. Typical of Long's work, it is also full of biographical references, portraits of friends, jokes, and puns. Kapsner, Nelson, Richard Fremantle, and Laura Buxton appear in the fresco, she in profile again looking supercilious. Long put himself among the workers in the first panel, holding a wrench painted green. "If there was going to be a monkey wrench in this project," he said, "I wanted to have it in my hand." He also appears in the crowd in the second panel, wearing a hat, goggles, and overcoat, looking like either a turn-of-the-century motorist or a mad bomber.

The huge portrait of a young boy in the third panel is of his second son, Tolly, a match to the portrait of number-one son Angus in Glendale Springs. Clayton Lineberger, Long's wealthy friend, appears as a street person; Kitty Gaston as a nun. The pregnant woman in the central panel, her red hair flowing from beneath a green hat, is Ella Quinn, who was Long's new companion. In May of 1992, just before Long came to Charlotte to paint the fresco, she gave birth to their child, Aiden Gabriel.

Long arrived looking thicker than he had during the St. Peter's fresco, his hair grayer and beginning to thin in front. With a lucrative commission fattening his bank account, he'd already bought a dog and another, larger house in the south of France at Foissac, about a half-hour's drive from Pougnadoresse.

The NationsBank work went off with few hitches and little of the drama involved at St. Peter's. Working without benefit of wine or rock music on the scaffold, Long and his crew finished by the October 1992 deadline.

The fresco commands the three-story marble-clad space with vibrant color and images. The second panel in particular seems to draw on Long's experience and emotions. Yet none of these paintings is as personal as the *Agony* portion of the St. Peter's fresco, a subject with which Long connected on a deeper level.

Charlotte now has two major Long frescoes on either end of its main

street. That he successfully completed them had to boost his confidence. These works might have pushed Long on one possible career path, making him a nationally or even internationally known creator of large murals. Probably, he would have had to keep painting portraits to pay the bills. Yet another road beckoned, one that had pulled at him for a long time. That was to get into the studio, to work, to confront himself, and to try to pull out of himself whatever it is he has to say, to above all learn to take risks.

"It's a lot harder for people who are interested in technique to dig in," said Laura Buxton, who understood Long's struggles as an artist. "Technique can hide, can hide a lot. And everybody sneers at technique nowadays, and says it's too impersonal and doesn't show enough emotion, et cetera. But I think if you're really good, you should finally at the end of your career combine the two [emotion and technique]. But it's so much harder if you're using such a strict tool. And a lot deeper, too. I think Ben will do it."

Father John Haughey left St. Peter's in the summer of 1990 to return to teaching, becoming professor of religious ethics at Loyola University in Chicago. The relationship between him and Ben Long had been strained but not broken. The artist gave him a drawing from the fresco as a parting gift. Father Haughey's imprint remained on St. Peter's and Charlotte. Father Gene McCreesh continued their work. The fresco was a popular success. So many people wanted to see the fresco that the church put in a separate telephone line to handle reservations and information.

An up-flowing of energy produced the fresco, a surge of creativity and inspiration that brought people together, pulling the best—and sometimes the worst—out of them. The project was a clash of wills, personalities, and honest differences. It involved great amounts of money, time, and sacrifice. All of this went into the wall. With its great capacity to absorb, to take disparate colors and forms and make them into a unity, the wall brought the "ruction" into a final harmony.

The fresco brims with the strength and beauty of men and women struggling to apprehend the divine, what Long had wanted to put into it.

It is, too, a religious painting full of power to inspire faith, what Father Haughey had sought. "It's done what the mysteries of God and Christ are always supposed to do: to make the remote proximate, the intangible tangible, the conceivable perceivable," said the priest. "That's what we were hoping; that's what it's done."

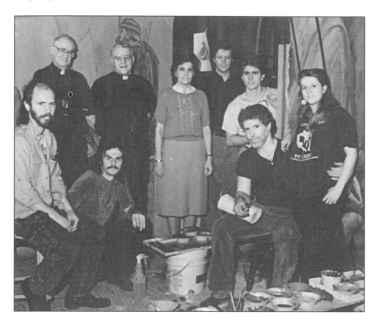

The crew and church staff gather on the last night:
Chuck Kapsner (seated), Father John Haughey, Roger Nelson (kneeling),
Father Gene McCreesh, Mary Ann Sullivan, Tony Griffin,
Josh Rosen, Ben Long, and Laura Buxton.

BOB SERVATIUS

Index